padlocked

Jane Austen
ROLEPLAYING SOCIETY

FORUM ON
GEORGIAN SOCIETY & ETIQUETTE

...FYI WE'RE MOSTLY ABOUT DARCY AND DR. WHO, WHICH IS ALSO BRITISH, SO IT WORKS.

THIBODEAU
&
SANCHEZ
CO.

M

TRADITIONAL 2D

与我们一起成长

BOOK talk!
AUDIOBOOKS

SINNLICHE
MATTHIAS

STARTEN SIE NOCH HEUTE

B

Dé a su sitio web super poderes!

LEHTOMAKI

SEARCH
START TODAY!

SPY
wear
style
EXCLUSIVELY AT
PIRATEZCOVE.CON

T0386806

?

COLORS BY
hen

dee
pix

TOO

WE'RE TRYING OUR BEST HERE
LOFTIS SOFTWARE
AVAILABLE ON A VARIETY OF PLATFORMS

THE COSMOS
in your hands...

• CONSTANTLY UPDATED
• ALL-SKY VIEWS
• CONSTELLATION LINES AND LABELS

DOWNLOAD FOR FREE ON

Big Jim
REARDON

THE STRONGHOLD OF
GUNTHOCK
THE RECARNAGE OF THE THOCCPICE

GEAR UP FOR SERIOUS MELEE

DOWNLOAD FOR FREE ON

Let us help tell your story.

M

WIMBERBO

Silver Lake
OUTDOORS
AUTHENTIC CONTENT

DOWNLOAD FOR FREE ON

THE FANG
FANGO. JANGO.

HUNT DOWN MALWARE NOW
ICU

GALAXY.ORG SEARCH

FOLLOW US ON
M

WAR
DURING VARIOUS
AGES

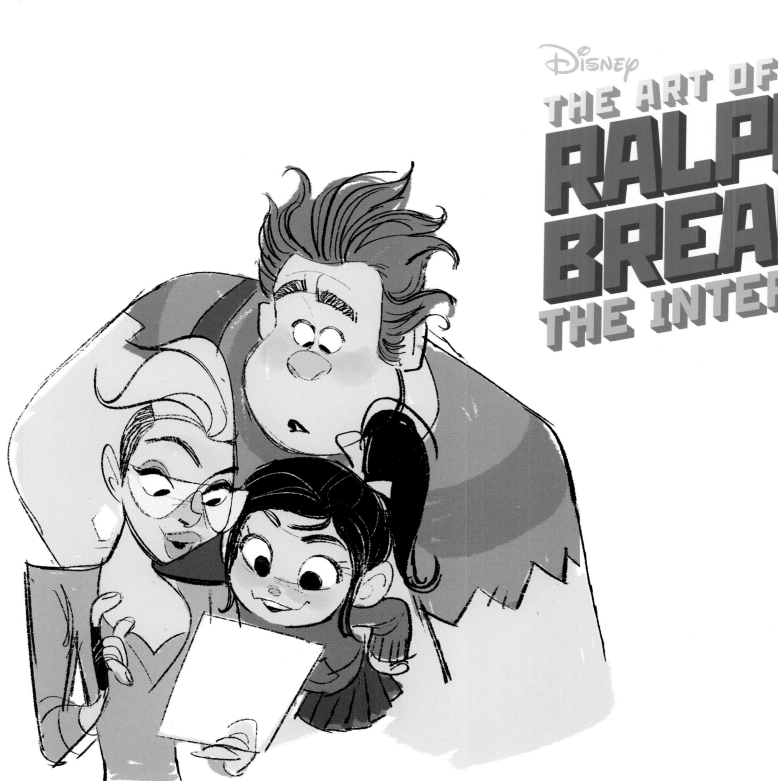

DISNEY
THE ART OF
RALPH BREAKS
THE INTERNET

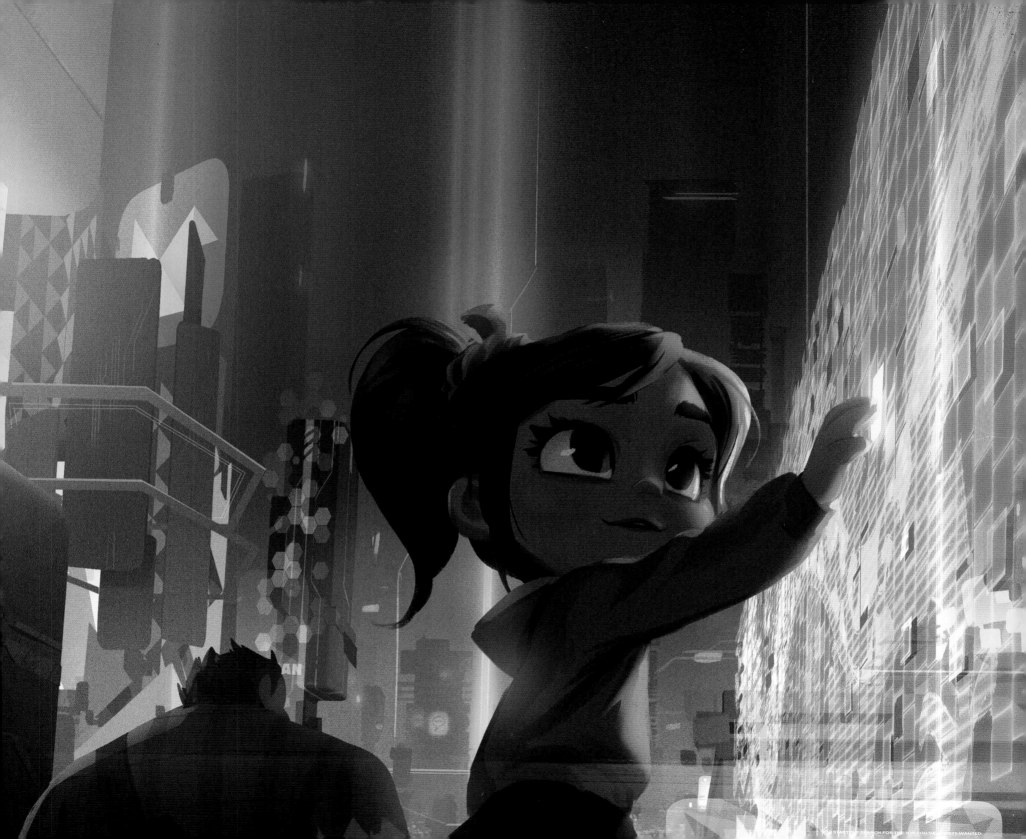

THE ART OF

Disney

RALPH BREAKS THE INTERNET

BY JESSICA JULIUS

FOREWORD BY RICH MOORE AND PHIL JOHNSTON

CHRONICLE BOOKS

SAN FRANCISCO

Library of Congress Cataloging-in-Publication Data
Names: Julius, Jessica, author.
Title: The art of Ralph breaks the internet: wreck-it Ralph 2 / by Jessica Julius ;
 foreword by Rich Moore and Phil Johnston.
Description: San Francisco, California : Chronicle Books, [2018]
Identifiers: LCCN 2018003808 (print) | LCCN 2018006895 (ebook)
 | ISBN 9781452164120 | ISBN 9781452163680 (alk. paper)
Subjects: LCSH: Ralph breaks the internet: wreck-it Ralph 2 (Motion picture)—
 Illustrations. | Animated films—United States.
Classification: LCC NC1766.U53 (ebook) | LCC NC1766.U53 R357 2018 (print)
 | DDC 791.43/72—dc23
LC record available at https://lccn.loc.gov/2018003808

Designed by Glen Nakasako, SMOG Design, Inc.
Manufactured in China.

10 9 8 7 6 5 4 3 2

Chronicle Books LLC
680 Second Street
San Francisco, California 94107
www.chroniclebooks.com

<Cover: Ami Thompson / digital>
<Front Flap: Jason Hand / digital>
<Front and Back Endpapers: Various Artists / digital>
<Page 1: Ami Thompson / digital>
<Pages 2-3: Mingjue Helen Chen / digital>
<Pages 4-5: Matthias Lechner / digital>

Creating a computer-generated animated film involves years of inspired collaboration. Before the final rendered images of *Ralph Breaks the Internet: Wreck-It Ralph 2* were seen on screens around the world, the following artists contributed their talents to the digital images included in this book:

Aaron Campbell, Adam Green, Adam Reed Levy, Adil Mustafabekov, Alberto Abril, Alena Wooten, Angela McBride, Avneet Kaur, Benjamin Min Huang, Brandon Lawless, Brendan Gottlieb, Bret Bays, Cesar Velazquez, Chadd Ferron, Chad Stubblefield, Chelsea Lavertu, Chris Anderson, Chris McKane, Christoffer Pedersen, Daniel Arata, Daniel James Klug, Dave Hardin, Dave Komorowski, Dong Joo Byun, Dylan Ekren, Dylan Hoffman, Dylan VanWormer, Fawn Veerasunthorn, Foam Natnicha Laohachaiaroon, Garrett Eves, Gina Bradley, Gina Warr Lawes, Glen Claybrook, Hubert Leo, Ian Krebs-Smith, Isaak Fernandez, Jack Fulmer, Jared Reisweber, Jason Figliozzi, Jason Hand, Jason Stellwag, Jay Jackson, Jennifer Downs, Jeremy Spears, Jesus Canal, Jim Reardon, Joaquin Baldwin, Johann Francois Coetzee Jon Krummel II, Jose L. Velasquez, Josie Trinidad, Justin Kern, Justin Sklar, Kate Kirby-O'Connell, Katherine Ipjian, Katie Fico, Kira Lehtomaki, Konrad Lightner, Larry Wu, Lauren MacMullan, Lissa Treiman, Luis Logam, Malcon Pierce, Mary Twohig, Matthew Schiller, Michael Anthony Navarro, Michael Talarico, Michelle Lee Robinson, Mitchell Counsell, Mo El-Ali, Nancy Kruse, Natalie Nourigat, Nathan Warner, Nicholas Burkard, Nicklas Puetz, Nicole Mitchell, Pamela Spertus, Paul Carman, Paula Goldstein, Qiao Wang, Reece Porter, Renato dos Anjos, Rich Fallat, Robert Huth, Ryan Tottle, Scott Kersavage, Sergi Caballer, Si-Hyung Kim, Simon Thelning, Stephen Ashby, Sylvia Hyo-Ji Lee, Timothy J. Richards, Tom Ellery, Tyler C. Bolyard, Vitor Vilela, Xinmin Zhao

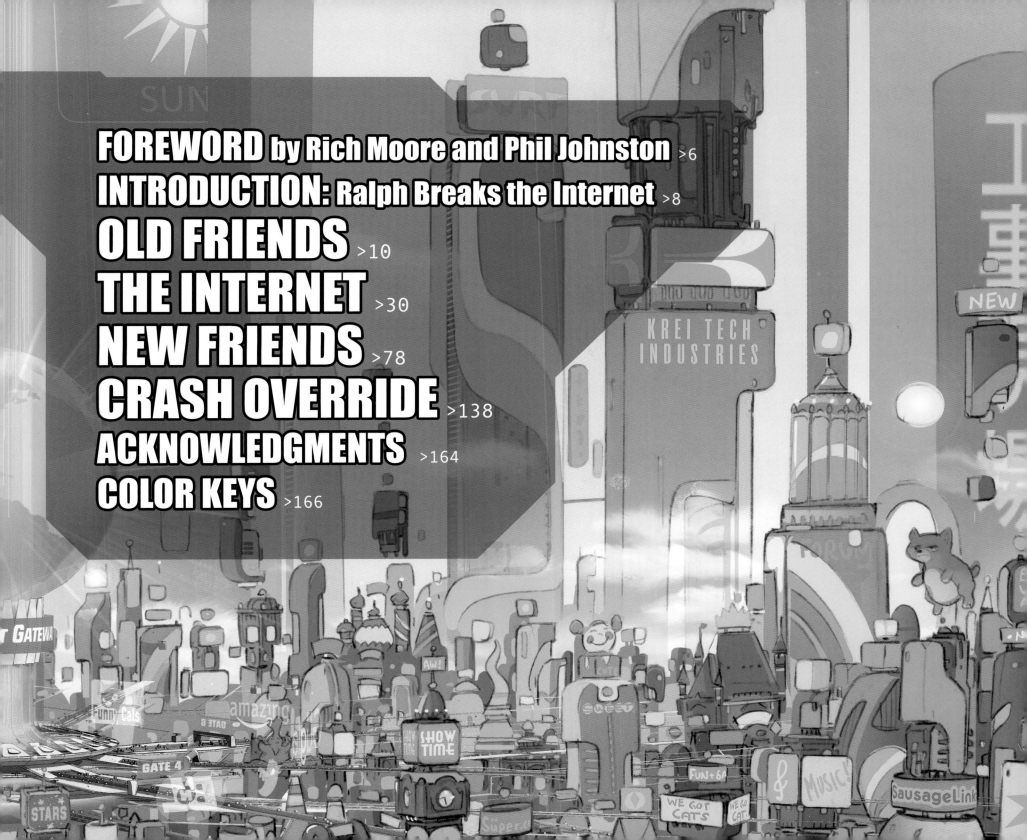

FOREWORD

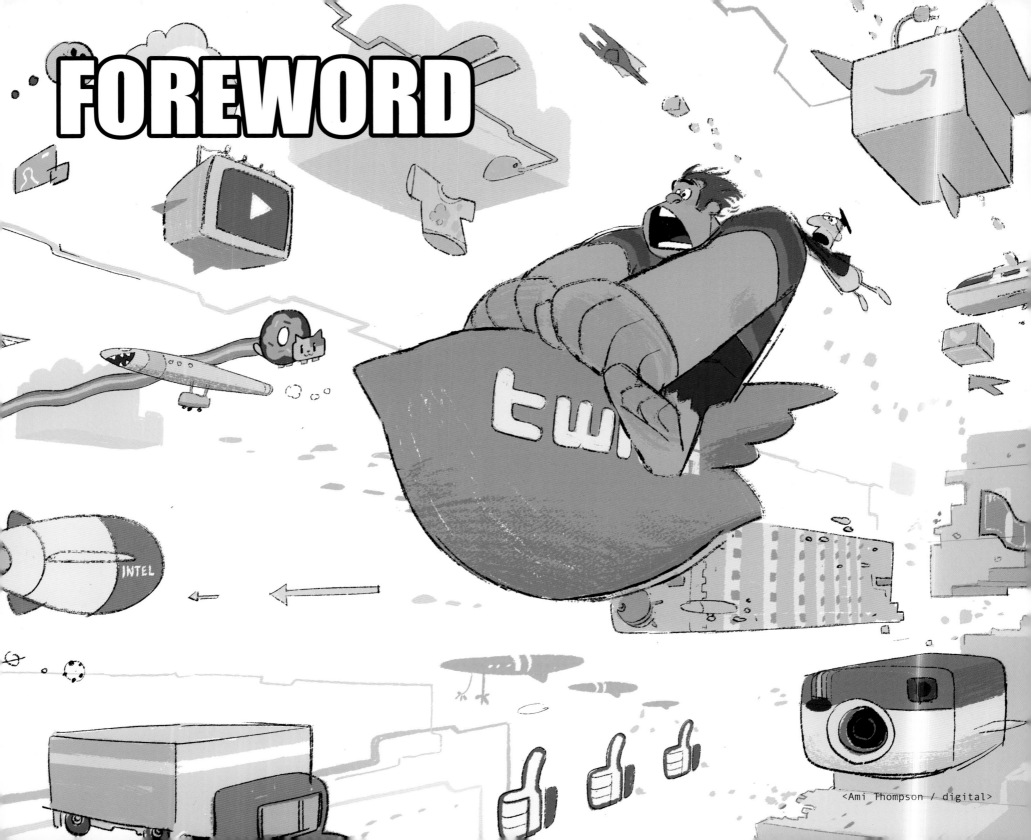

<Ami Thompson / digital>

Phil Johnston

 Hey, we have to write this foreword.

Rich Moore

When?

Phil Johnston

 Two days ago.

Rich Moore

Hmm. What's it supposed to be about?

Phil Johnston

 Why we wanted to make the movie, etc. So why did you?

Rich Moore

I needed the money.

Phil Johnston

 You realize this is going to be in the book?

Rich Moore

I was kidding. Jeez. Sarcasm gets lost in text, doesn't it?

Phil Johnston

 Apparently. Anywho . . . Sequels are so often terrible. Do you remember how we decided to do this one?

Rich Moore

I remember when we first started talking about this, we knew we wanted to send Ralph and Vanellope to the Internet. Visualizing the world of the Internet was exciting to me from the get-go. It's never really been done in film, at least not on this scale. When Production Designer Cory Loftis and Art Directors Matthias Lechner and Ami Thompson first started showing us images of what the Internet might look like in this movie, I was blown away. The work they and the hundreds of artists working on this film did to make the Internet feel like a real world is nothing short of a miracle. So having that as the backdrop where our story takes place was a big part of the appeal to me.

Phil Johnston

Agreed. But saying you want to make a movie about the Internet is like saying you want to make a movie about New York City. There are millions of stories that could be told. So it took a LONG time to come up with the right story.

Rich Moore

True. At first, we were only thinking of the Internet as a way to expand Ralph's and Vanellope's world beyond the arcade. The idea got much juicier when we realized that it also had to be a place that would really test their friendship and make things especially difficult for Ralph.

Phil Johnston

For me, once we started thinking of Litwak's Arcade as a small town and the Internet as a big city, I had my way into the story emotionally. I grew up in a small town in Wisconsin and eventually left for the big city (I've lived in New York and Los Angeles for almost 20 years). So I started thinking about my relationship to the town where I grew up and the friends I knew there, many of whom still live there. Just because I left for something different and some of my friends decided to stay doesn't mean we aren't still friends. We are, despite the fact that our lives are very different. As a new character in the film says to Vanellope, "Friendships change, and the good ones grow stronger because of it." That's the essence of this movie to me.

Rich Moore

Cool. So I guess we should write this foreword now.

Phil Johnston

 I think we just did.

INTRODUCTION:
RALPH BREAKS THE INTERNET

Hi, we're the team who made *Ralph Breaks the Internet*.
Ask us anything!

PRODUCER / DIRECTOR / CREW

Producer—Clark Spencer
Directors—Rich Moore and Phil Johnston
Production Designer—Cory Loftis
Art Director, Environments—Matthias Lechner
Art Director, Characters—Ami Thompson
Associate Production Designer—Mingjue Helen Chen
Visual Effects Supervisor—Scott Kersavage
Technical Supervisor—Ernest Petti
Visual Development Artist—Mehrdad Isvandi
Visual Development Artist—Jim Martin
Visual Development Artist—Kevin Nelson
Visual Development Artist—Nick Orsi
Visual Development Artist—Mike Yamada
Director of Cinematography, Layout—Nathan Warner
Head of Visual Effects—Cesar Velazquez
Head of Animation—Kira Lehtomaki
Head of Animation—Renato dos Anjos
Director of Story—Jim Reardon
Head of Story—Josie Trinidad

<Mingjue Helen Chen / digital>

 [−] Jessica Julius Author

What inspired you to make a sequel to *Wreck-It Ralph*?

permalink embed

 [−] Rich Moore Director

I love the characters we created and wanted to do more with them. One of my favorite things is when you can keep building on characters and their relationships.

permalink embed parent

 [−] Phil Johnston Director

The first movie is about two outsiders who find a genuine friendship with each other. We wanted to put pressure on Ralph and Vanellope's relationship, to push them somewhere new. And that meant expanding their world, which also presented an exciting artistic challenge.

permalink embed parent

 [−] Rich Moore Director

The first film was a love letter to 1980s video games. But a sequel had to be bigger, which allowed us to go beyond the arcade. The Internet seemed like the perfect place for us to go.

permalink embed parent

 [−] Phil Johnston Director

Once we landed on sending Ralph and Vanellope into the Internet, it opened up everything from an art and story perspective. Almost everyone alive today has some kind of relationship with the Internet, but it has never really been conceived of in this way, as a physical place one can go, with people who live there.

permalink embed parent

 [−] Jessica Julius Author

What were the biggest challenges in creating this film?

permalink embed

 [−] Scott Kersavage Visual Effects Supervisor

Just trying to define the Internet was the first challenge. We wanted to represent the perceptions of everyone who uses it, from those who remember when it was just a tiny network of universities to today's audiences who have grown up on it.

permalink embed parent

 [−] Matthias Lechner Art Director, Environments

Translating the abstractness of the Internet into a real environment. We had to take something familiar and depict it in a way that would give the audience a whole new experience.

permalink embed parent

 [−] Cory Loftis Production Designer

Designing a *Wreck-It Ralph* movie is like designing ten movies at once. Every game, every website, every new location has a different look and style, and new characters to go with it. When you add in the random-ness and chaos of the Internet, the biggest challenge is keeping everything cohesive. The variety is fun but it has to feel like the same movie when you leave eBay to go to Slaughter Race.

permalink embed parent

OLD FRIENDS

TAFFYTA MUTTONFUDGE

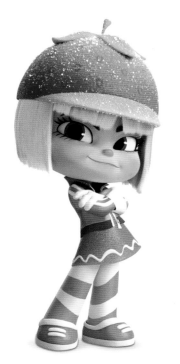

GENE

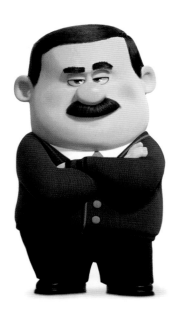

ZOMBIE

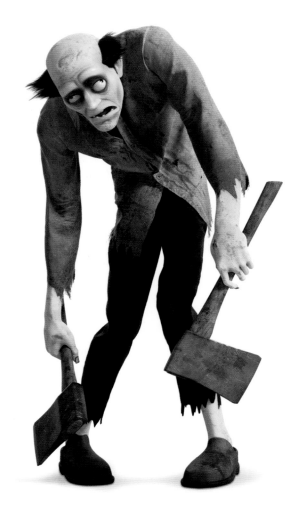

FIX-IT FELIX

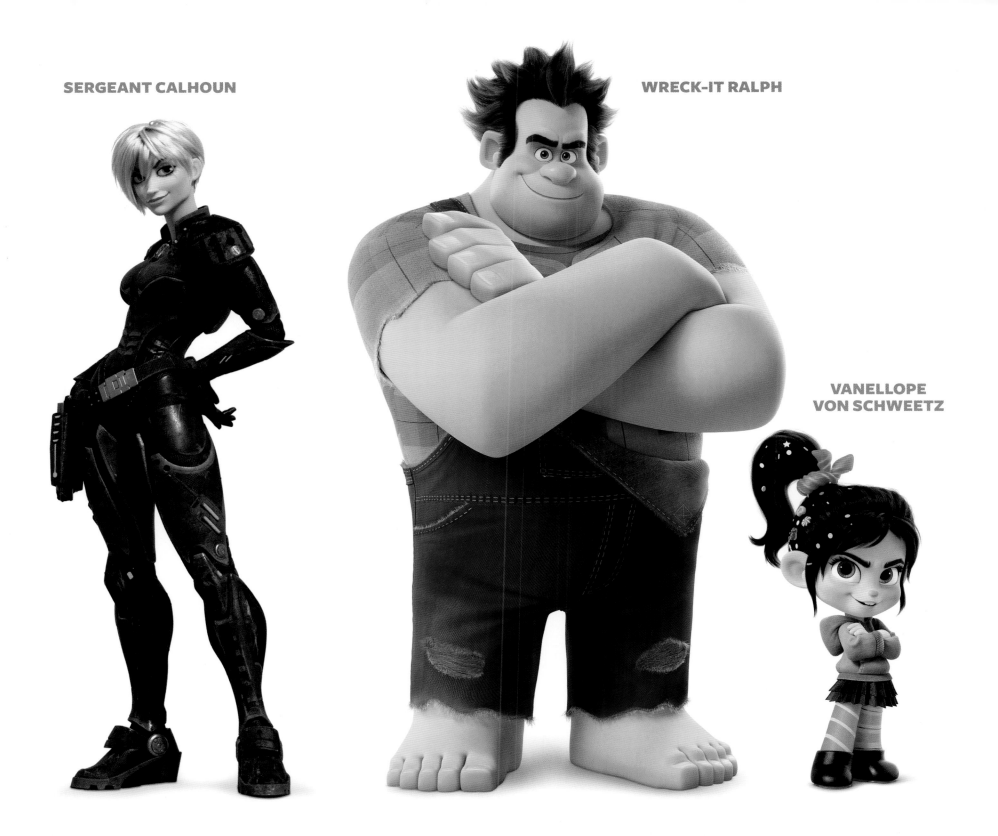

SERGEANT CALHOUN

WRECK-IT RALPH

VANELLOPE
VON SCHWEETZ

 [−] Jessica Julius Author

Wreck-It Ralph was the story of two misfits who find friendship with each other. How did the Internet setting of the new film drive how you developed them and our other friends from the first film?

permalink embed

 [−] Phil Johnston Director

We wanted to test Ralph and Vanellope's friendship, to throw stuff in their way to see if they could stay friends despite the obstacles. The Internet is so big and complicated that they and the other characters have to grow to meet its challenges.

permalink embed parent

 [−] Rich Moore Director

There is a lot of good and a lot of bad in the Internet. It's an environment that can be dangerous for a young person like Vanellope or for a person who is insecure the way Ralph is. Any wedge that could test their friendship exists in this world.

permalink embed parent

 [−] Jessica Julius Author

What design changes did you make to update the original characters for the new film?

permalink embed

 [−] Cory Loftis Production Designer

One advantage of a sequel is that Ralph, Vanellope, Felix, Calhoun, and their games were already designed. But *Wreck-It Ralph* was a long time ago in terms of film-making technology.

permalink embed parent

 [−] Scott Kersavage Visual Effects Supervisor

We had to update all the characters and environments to work with our new Hyperion renderer and rigging tools, yet make sure that the characters still look like themselves.

permalink embed parent

 [−] Cory Loftis Production Designer

With earlier technologies, skin can sometimes look gray, like there's no blood going through it. With Hyperion, the characters' skin feels alive.

permalink embed parent

 [−] Ami Thompson Art Director, Characters

All the characters got updates to their clothing and hair. There were a lot of seemingly small changes that add up to a richer, more believable feeling to the characters.

permalink embed parent

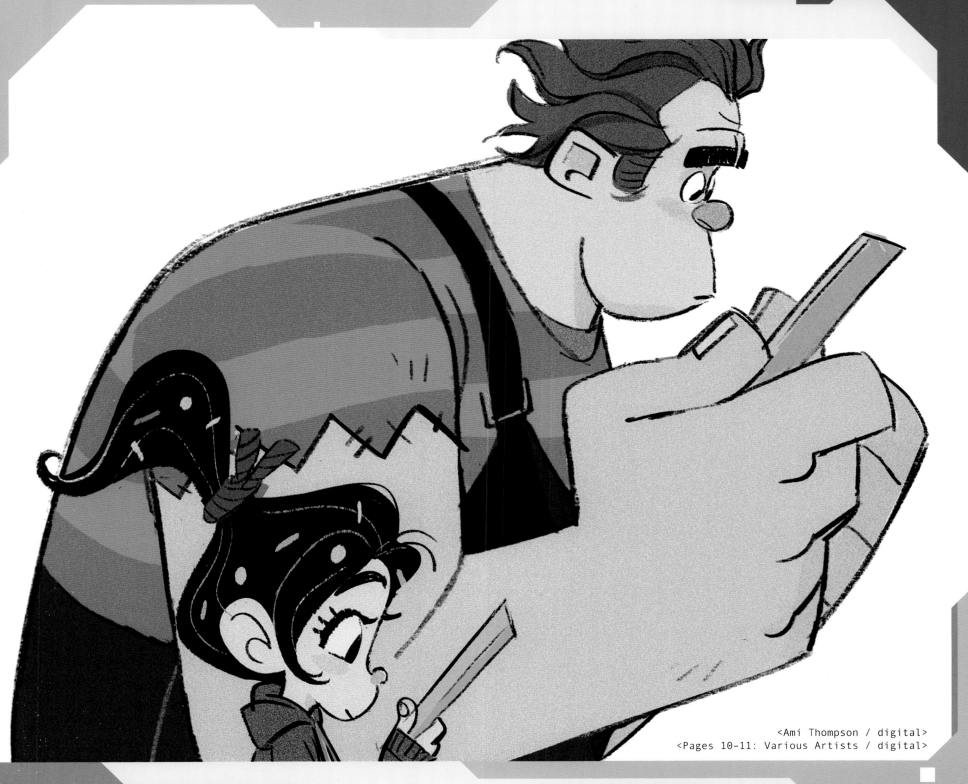

<Ami Thompson / digital>
<Pages 10-11: Various Artists / digital>

>13

RALPH & VANELLOPE

 [−] Jessica Julius Author
What specific obstacles did the Internet allow you to throw in Ralph and Vanellope's way in order to challenge their friendship?

permalink embed

 [−] Rich Moore Director
When they get to the Internet, Ralph and Vanellope realize they want different things. And the people they meet in this new world reinforce their differences. That's something that's very true about the Internet; it's a great connector but it can also be a divider.

permalink embed parent

 [−] Phil Johnston Director
The metaphor we used is two best friends from a small town who go to the big city and suddenly realize there is something else out there. They discover their different needs could potentially drive them apart. But ultimately, they learn that friendships can change and the good ones get better for it.

permalink embed parent

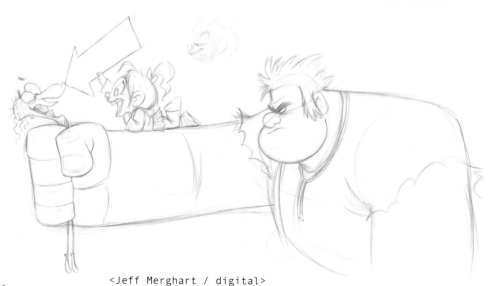

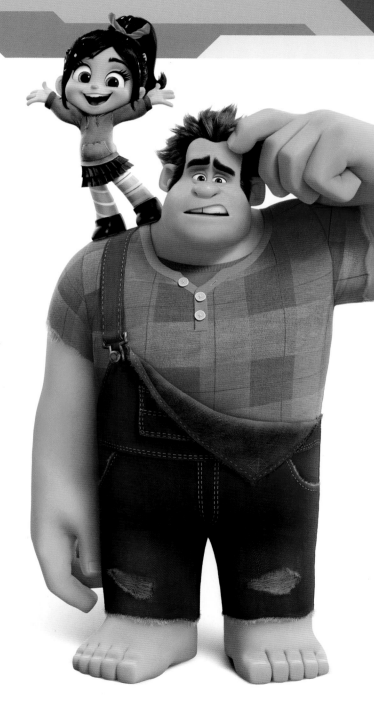

<Jeff Merghart / digital>

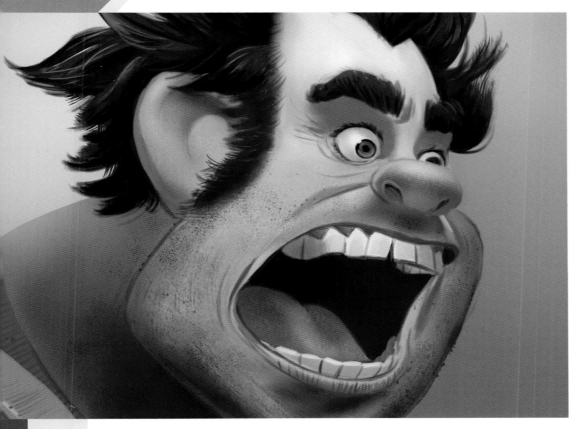

<Paul Felix / digital>

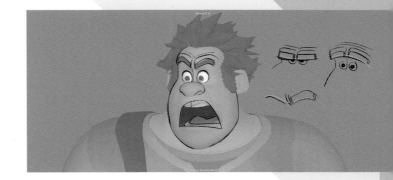

 Renato dos Anjos ✔ @HeadOfAnimation
The computer imposes limitations so we use draw-overs—hand-drawing on top of a computer image—to help animators push poses and get what we really want, so there is no restriction beyond our own imaginations. That hand-drawn sensibility is part of our Disney history but also something we still use every day.

💬 9 🔁 13 ♡ 24

<Ami Thompson / digital>

Cory Loftis ✔ @ProductionDesigner

In the first film, the clothes seem almost plastic-y. For the sequel, we remade outfits to behave and look more like real cloth. Ralph's overalls and shirt wrinkle and slide as he moves, Vanellope's sleeves move up and down.

💬 6 🔁 24 ♡ 31

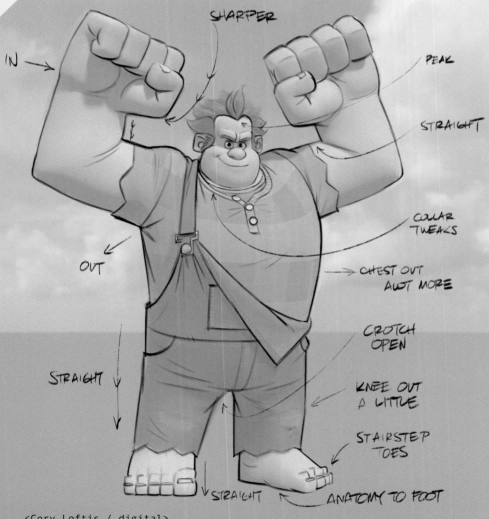

IN

SHARPER

PEAK

STRAIGHT

OUT

COLLAR TWEAKS

CHEST OUT ALOT MORE

CROTCH OPEN

STRAIGHT

KNEE OUT A LITTLE

STAIRSTEP TOES

STRAIGHT ANATOMY TO FOOT

<Cory Loftis / digital>

16<

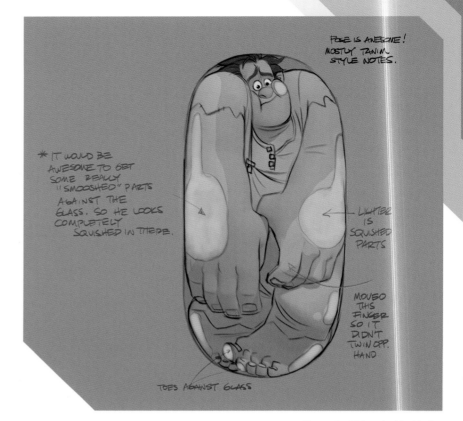

POSE IS AWESOME! MOSTLY TANIM STYLE NOTES.

* IT WOULD BE AWESOME TO GET SOME REALLY "SMOOSHED" PARTS AGAINST THE GLASS, SO HE LOOKS COMPLETELY SQUISHED IN THERE.

LIGHTER IS SQUISHED PARTS

MOVED THIS FINGER SO IT DIDN'T TWIN OPP. HAND

TOES AGAINST GLASS

<Cory Loftis / digital>

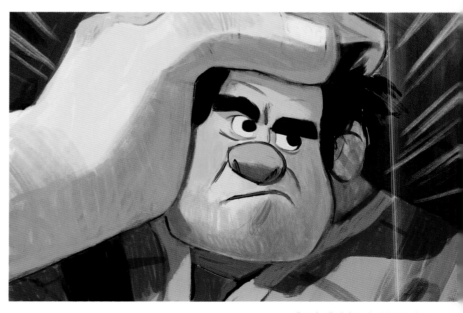

<Paul Felix / digital>

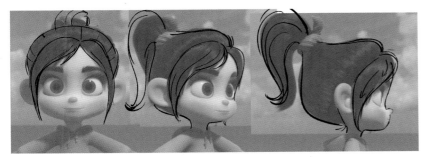

<Ami Thompson / digital>

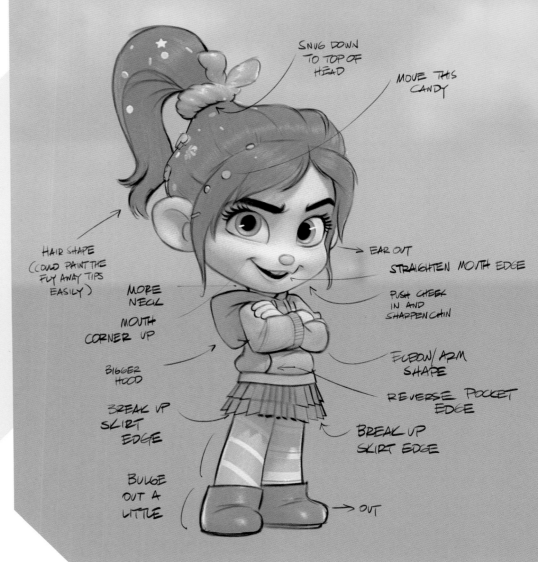

SNUG DOWN TO TOP OF HEAD

MOVE THIS CANDY

HAIR SHAPE (COULD PAINT THE FLY AWAY TIPS EASILY)

EAR OUT

STRAIGHTEN MOUTH EDGE

PUSH CHEEK IN AND SHARPEN CHIN

MORE NECK

MOUTH CORNER UP

BIGGER HOOD

ELBOW / ARM SHAPE

REVERSE POCKET EDGE

BREAK UP SKIRT EDGE

BREAK UP SKIRT EDGE

BULGE OUT A LITTLE

OUT

<Cory Loftis / digital>

Cory Loftis ✔ @ProductionDesigner ⌄

In the first film, Vanellope's hair is in two parts: bangs and ponytail. Now her hair grows from the tip of her head to the end of her ponytail, so if you were to pull on her ponytail, it pulls her head too. It makes her so much more believable. She feels like a real little girl now.

💬 14 🔁 5 ♡ 22

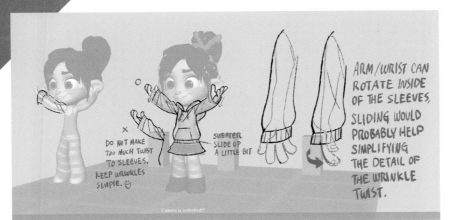

DO NOT MAKE TOO MUCH TWIST TO SLEEVES. KEEP WRINKLES SIMPLE. ☺

SWEATER SLIDE UP A LITTLE BIT

ARM/WRIST CAN ROTATE INSIDE OF THE SLEEVES, SLIDING WOULD PROBABLY HELP SIMPLIFYING THE DETAIL OF THE WRINKLE TWIST.

Camera is unlocked!!!

<Ami Thompson / digital>

Ami Thompson ✔ @ArtDirector_Characters ⌄

We redesigned Vanellope's hands. Her fingers are fatter and smoother, and the tips are rounder, which helps her feel more childlike.

💬 8 🔁 16 ♡ 34

LITWAK'S ARCADE

 [−] Jessica Julius Author

Ralph Breaks the Internet begins with our old friends in Litwak's Arcade. What updates did you make to Mr. Litwak and the arcade?

permalink embed

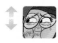 **[−] Ami Thompson** Art Director, Characters

Mr. Litwak is older—he has more white hair, more wrinkles—but he still loves the arcade.

permalink embed parent

 [−] Matthias Lechner Art Director, Environments

Like Litwak himself, the arcade has aged. It's six years older, so it's a little grungier. The main update is that he's installing a Wi-Fi router because he thinks having the Internet will bring in more customers.

permalink embed parent

 [−] Cory Loftis Production Designer

Litwak is a reluctant and late adopter of the Internet. He's the king of archaic forms of technology. He pays in cash, doesn't have a cell phone, still buys a physical newspaper. That's reflected in his office, which we had to design for this story since you don't see it in the first film. He has phone books, a landline, a slide projector. The computer is the one new thing in his office.

permalink embed parent

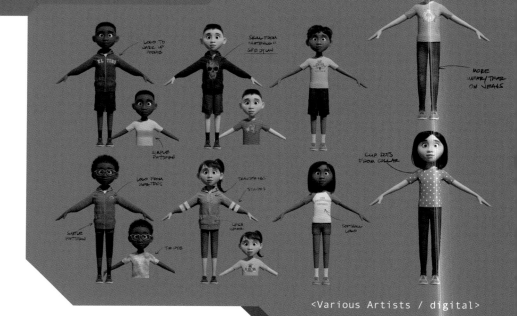

<Various Artists / digital>

<Ryan Lang / digital>

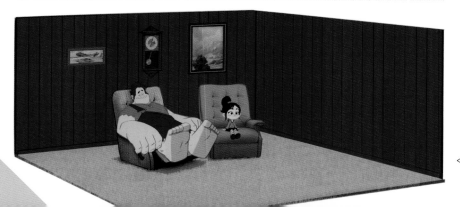

<Ryan Lang / digital>

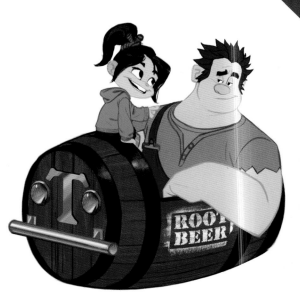

<Ryan Lang / digital>

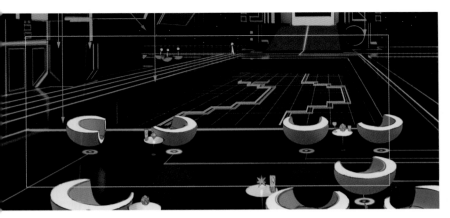

<Mike Yamada / digital>

<Kevin Nelson / digital>

Kevin Nelson, Visual Development Artist

Litwak's office is full of funny, weird stuff: embarrassing old posters, his "CEO" coffee mug, collectible plates. There's a little window with a long-dead plant. He's even got an Emmy®.

<Kevin Nelson / digital>

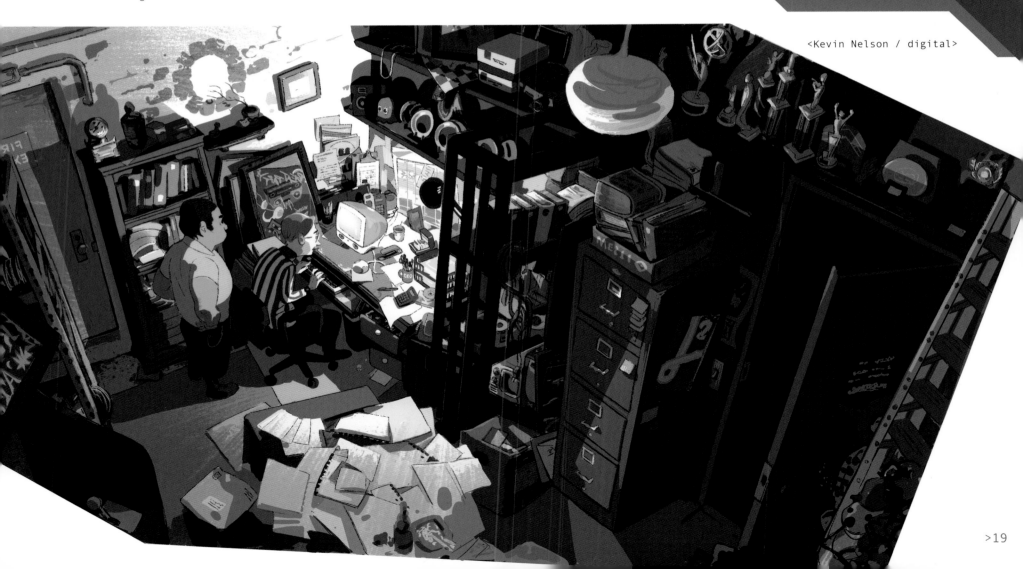

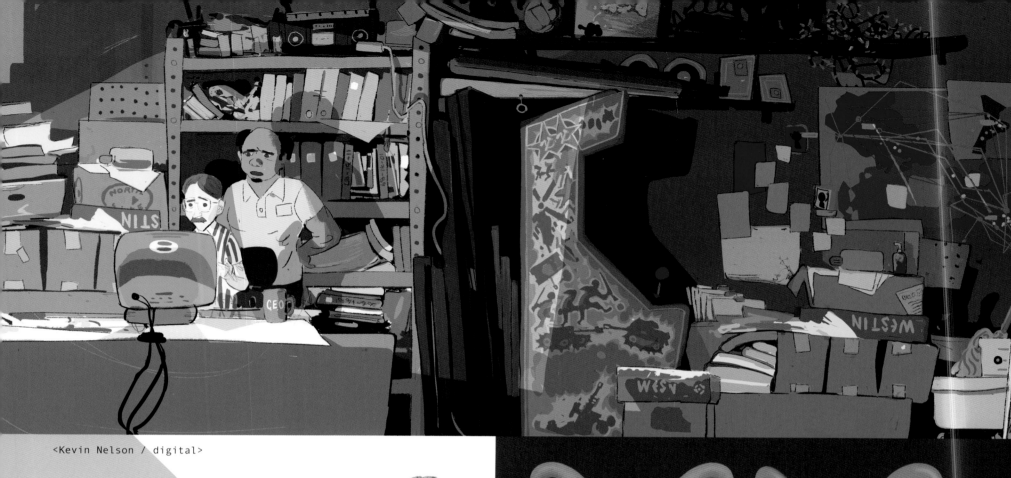

<Kevin Nelson / digital>

LITWAK'S
Family Fun Center

1. RESPECT EACH OTHER
2. RESPECT THE GAMES
3. NO GAMEHOGGING*
4. HAVE FUN!

*LET EVERYBODY HAVE A TURN!

NO FIGHTING

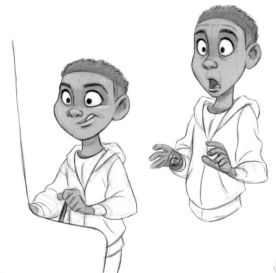

POWER UP

<Matthias Lechner / digital>

<Matthias Lechner / digital>

<Jeff Merghart / digital>

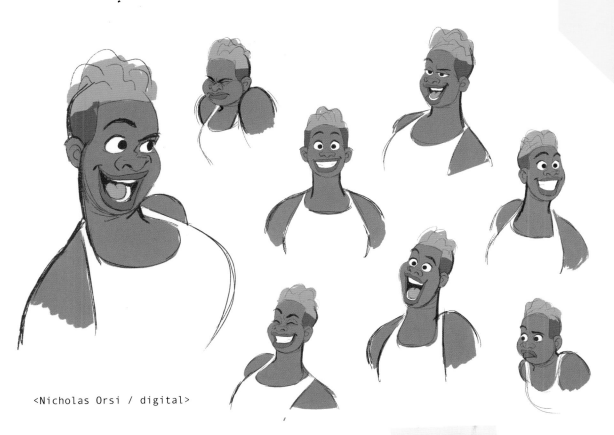

<Nicholas Orsi / digital>

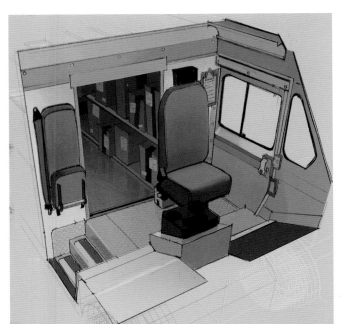

<Mike Yamada / digital>

ABSOLUTELY
NO
FOOD OR
DRINK
ALLOWED
IN THE
ARCADE
☺
THANK YOU

NO
CRYING
IF YOU
LOSE!

<Cory Loftis / digital>

GLOBAL
AIR FREIGHT

EXPRESS
We get it there, yesterday.

<Mike Yamada / digital>

PLAY
AT YOUR
OWN
RISK

We do
BIRTHDAY
PARTIES

contact management for details

<Matthias Lechner / digital>

FELIX & CALHOUN

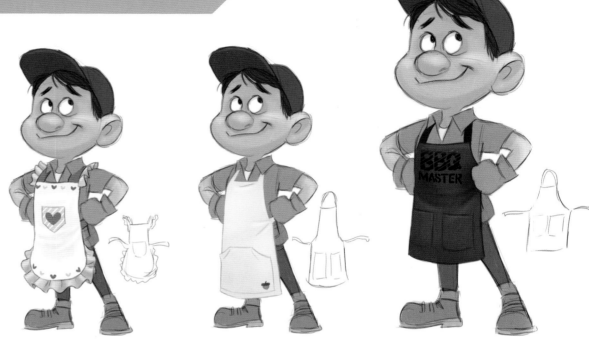

<Jeff Merghart / digital>

<Ryan Lang / digital>

<Cory Loftis / digital>

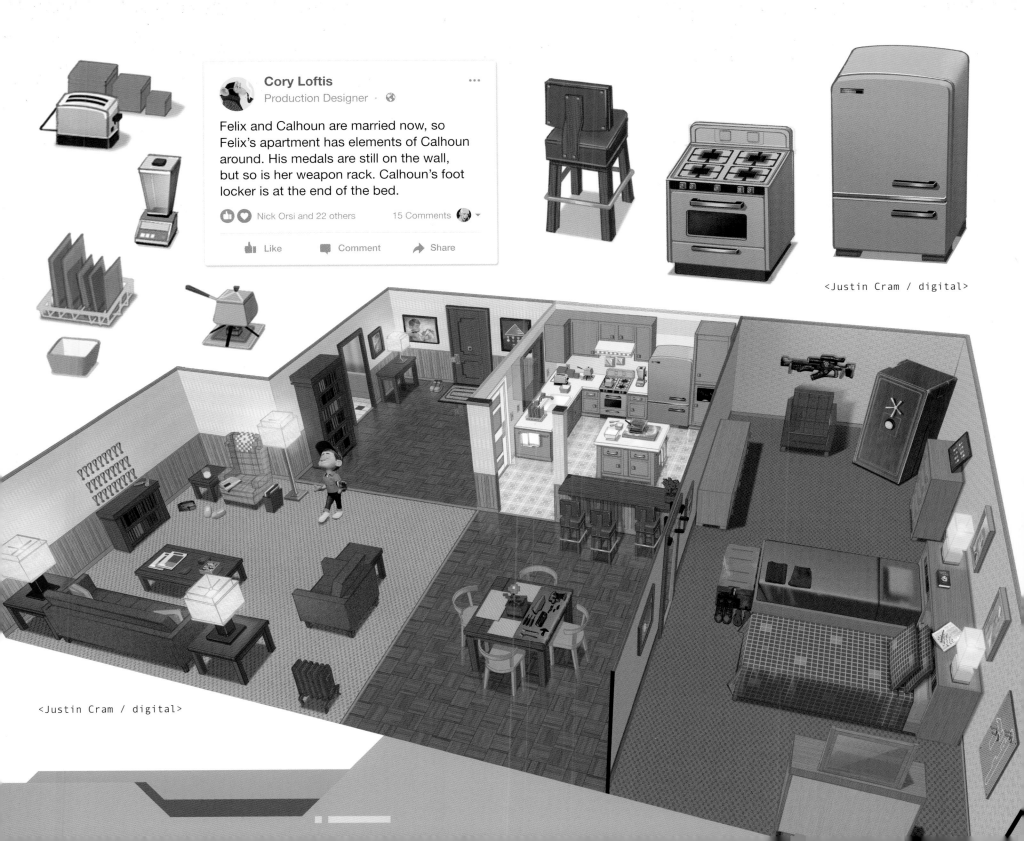

Cory Loftis
Production Designer · 🌐

Felix and Calhoun are married now, so Felix's apartment has elements of Calhoun around. His medals are still on the wall, but so is her weapon rack. Calhoun's foot locker is at the end of the bed.

👍❤️ Nick Orsi and 22 others 15 Comments

👍 Like 💬 Comment ➤ Share

<Justin Cram / digital>

<Justin Cram / digital>

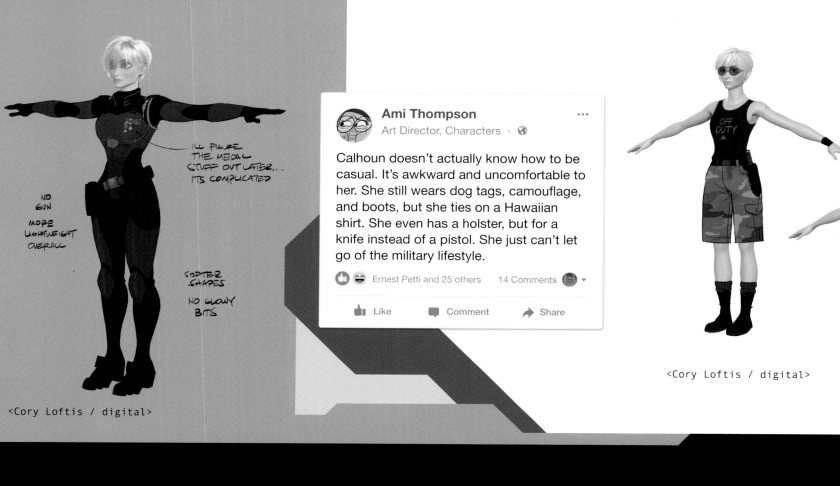

NO GUN

MORE LIGHTWEIGHT OVERALL

SOFTER SHAPES

NO GLOWY BITS

I'LL FIGURE THE MEDAL STUFF OUT LATER,... ITS COMPLICATED

<Cory Loftis / digital>

Ami Thompson
Art Director, Characters · 🌐

Calhoun doesn't actually know how to be casual. It's awkward and uncomfortable to her. She still wears dog tags, camouflage, and boots, but she ties on a Hawaiian shirt. She even has a holster, but for a knife instead of a pistol. She just can't let go of the military lifestyle.

👍😄 Ernest Petti and 25 others 14 Comments ▼

👍 Like 💬 Comment ➤ Share

<Cory Loftis / digital>

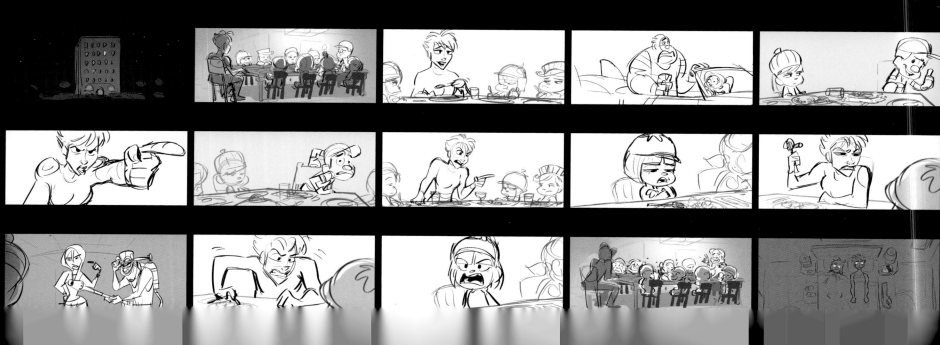

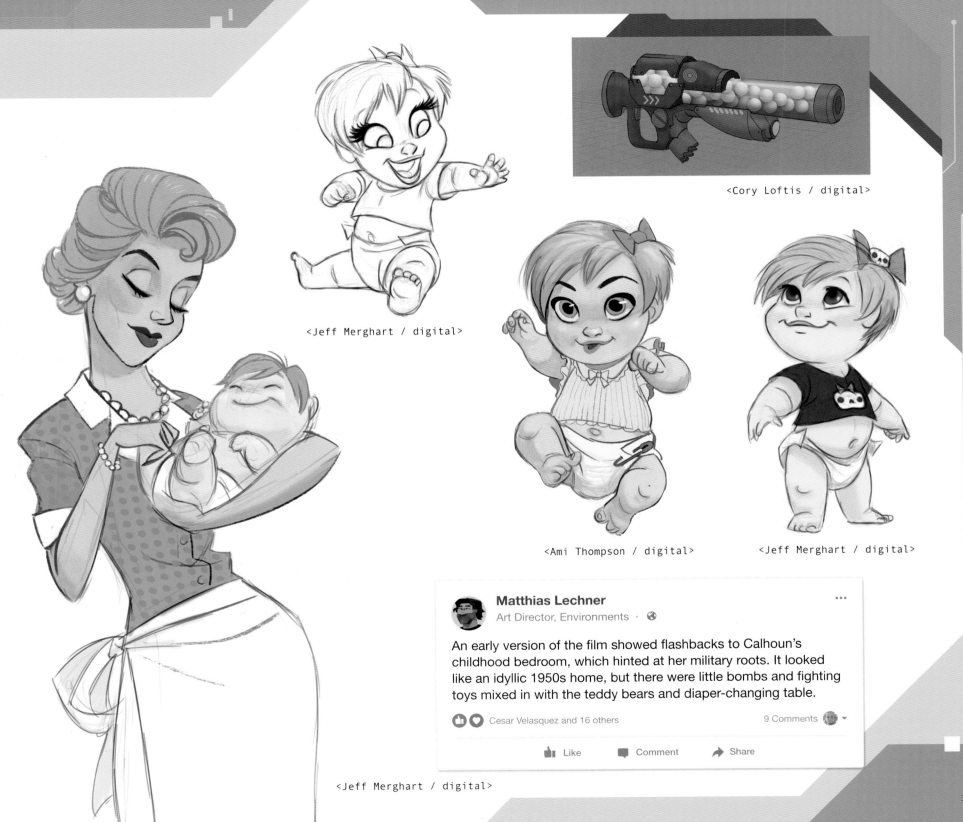

<Cory Loftis / digital>

<Jeff Merghart / digital>

<Ami Thompson / digital>

<Jeff Merghart / digital>

Matthias Lechner
Art Director, Environments · 🌐

An early version of the film showed flashbacks to Calhoun's childhood bedroom, which hinted at her military roots. It looked like an idyllic 1950s home, but there were little bombs and fighting toys mixed in with the teddy bears and diaper-changing table.

👍 ❤️ Cesar Velasquez and 16 others 9 Comments

👍 Like 💬 Comment ➤ Share

<Jeff Merghart / digital>

THE WI-FI ROUTER

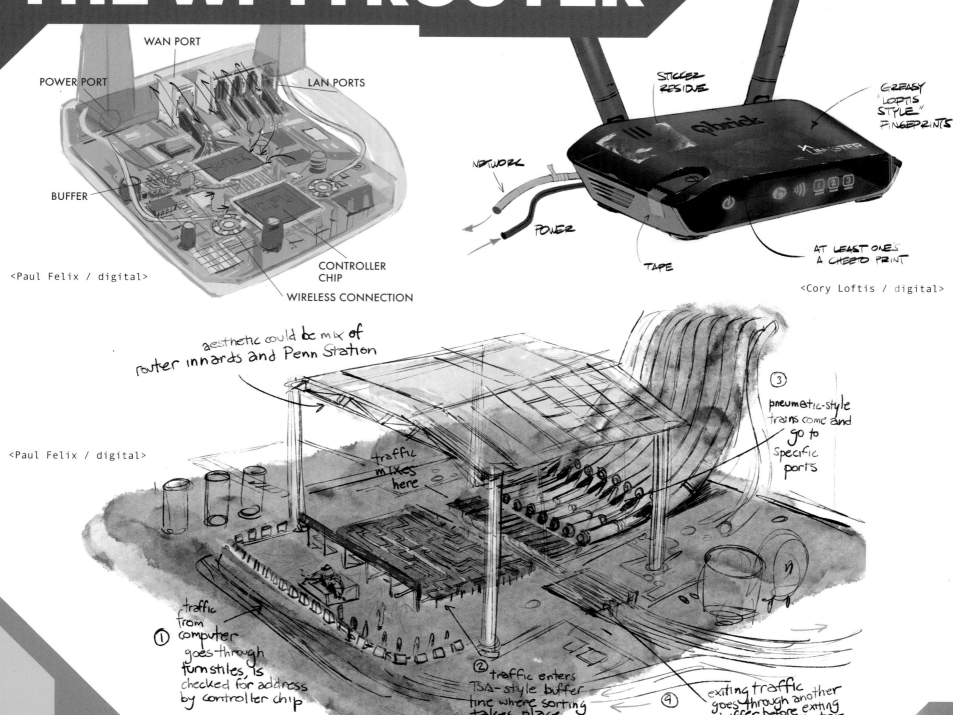

POWER PORT

WAN PORT

LAN PORTS

BUFFER

CONTROLLER CHIP

WIRELESS CONNECTION

<Paul Felix / digital>

STICKER RESIDUE

GREASY "LOFTIS STYLE" FINGERPRINTS

NETWORK

POWER

TAPE

AT LEAST ONE'S A CHEETO PRINT

Qbrick

XINKSTER

<Cory Loftis / digital>

aesthetic could be mix of router innards and Penn Station

traffic mixes here

③ pneumatic-style trains come and go to specific ports

<Paul Felix / digital>

① traffic from computer goes through turnstiles, is checked for address by controller chip

② traffic enters TSA-style buffer line where sorting takes place

④ exiting traffic goes through another buffer before exiting router.

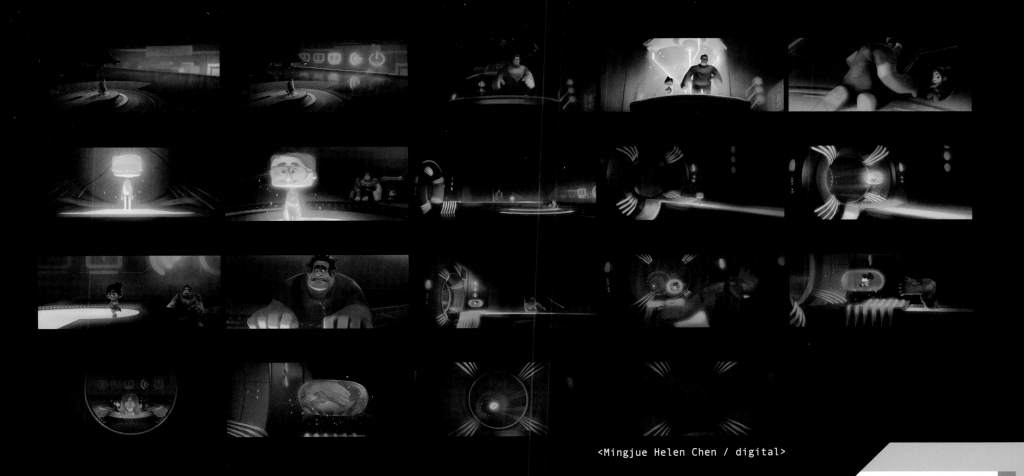

<Mingjue Helen Chen / digital>

 Matthias Lechner ✔ @ArtDirector_Environments ⌄
Our router design is a straightforward harbinger of what our version of the Internet looks like. It has 45-degree angles and the Wi-Fi logo, but it doesn't come to life until Litwak clicks the browser icon. Then the whole room comes to life, lights go on, the portal opens, and Litwak's user appears. Ralph and Vanellope, following Litwak's user, get sucked into the Internet.

💬 5 🔁 16 ♡ 38

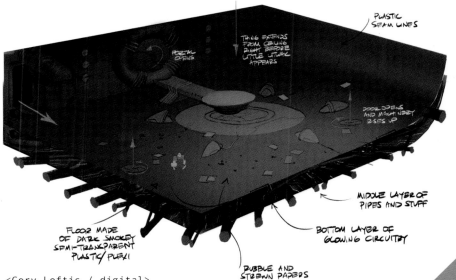

PLASTIC SEAM LINES

THING EXTENDS FROM CEILING RIGHT BEFORE LITTLE LITWAK APPEARS

PORTAL OPENS

DOOR OPENS AND MACHINERY RISES UP

MIDDLE LAYER OF PIPES AND STUFF

FLOOR MADE OF DARK SMOKEY SEMI-TRANSPARENT PLASTIC/PLEXI

RUBBLE AND STREWN PAPERS

BOTTOM LAYER OF GLOWING CIRCUITRY

<Cory Loftis / digital>

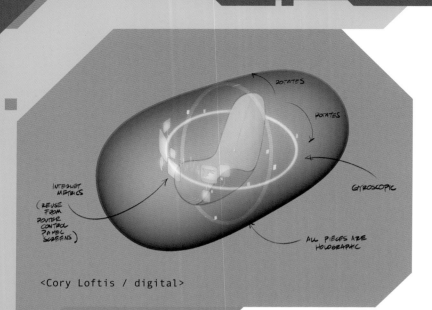

<Cory Loftis / digital>

ROTATES

ROTATES

GYROSCOPIC

INTERNET METRICS
(REUSE FROM ROUTER CONTROL PANEL SCREENS)

ALL PIECES ARE HOLOGRAPHIC

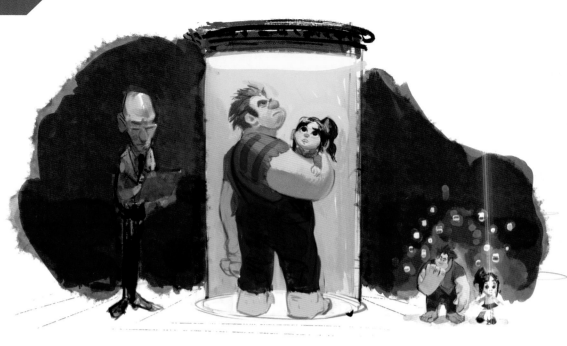

<Paul Felix / digital>

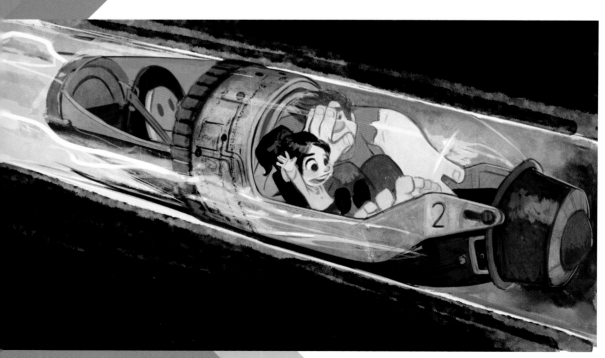

<Paul Felix / digital>

 Nathan Warner ✓
@DirectorOfCinemotography_Layout
We initially tried having them go through a coaxial cable, enter a fiber-optic box, warp and become light, and then enter the Internet. But then it was suggested that it should feel more like they were flying over the Los Angeles basin at nighttime, to really show the vastness of the Internet.

💬 12 🔁 7 ♡ 29

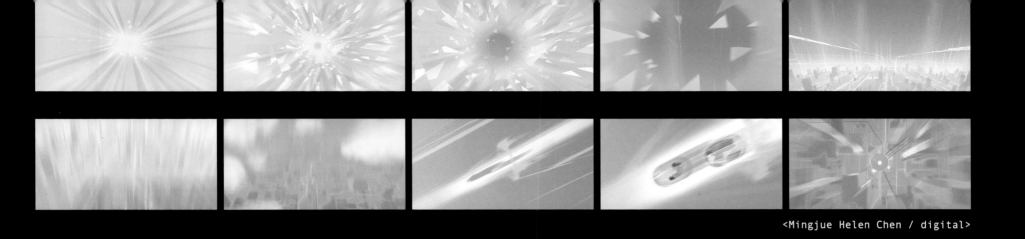

<Mingjue Helen Chen / digital>

<Peter DeMund / digital>

<Various Artists / digital>

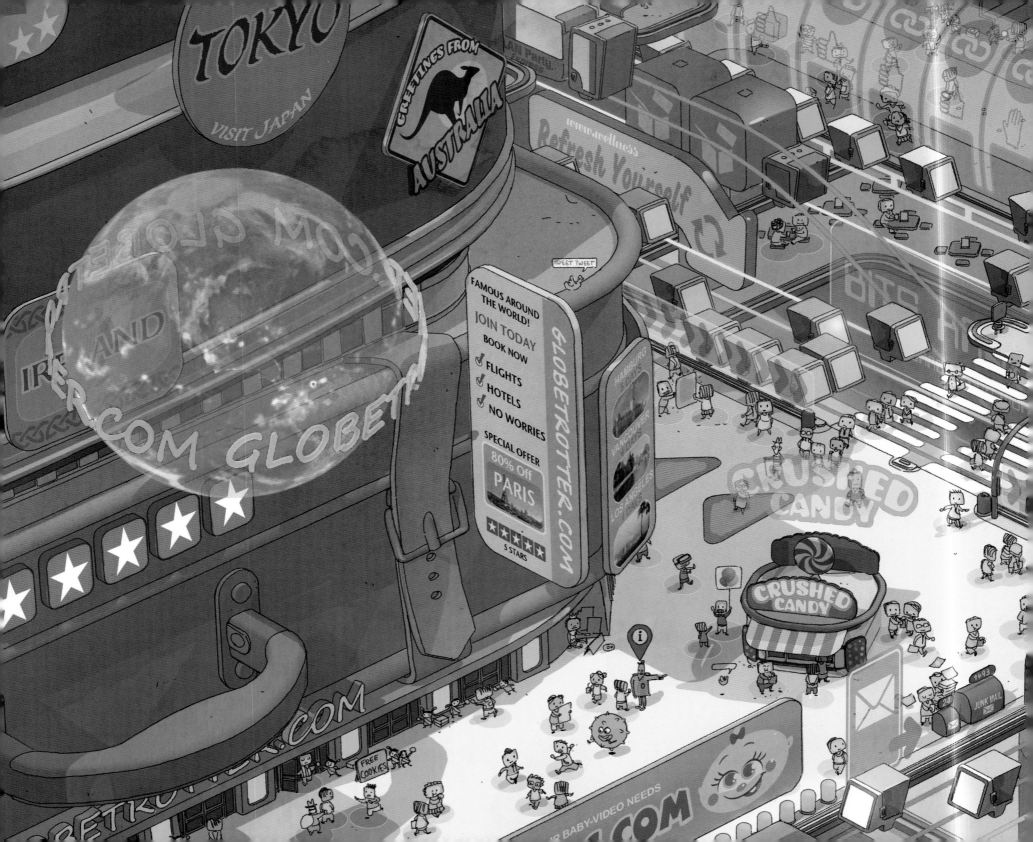

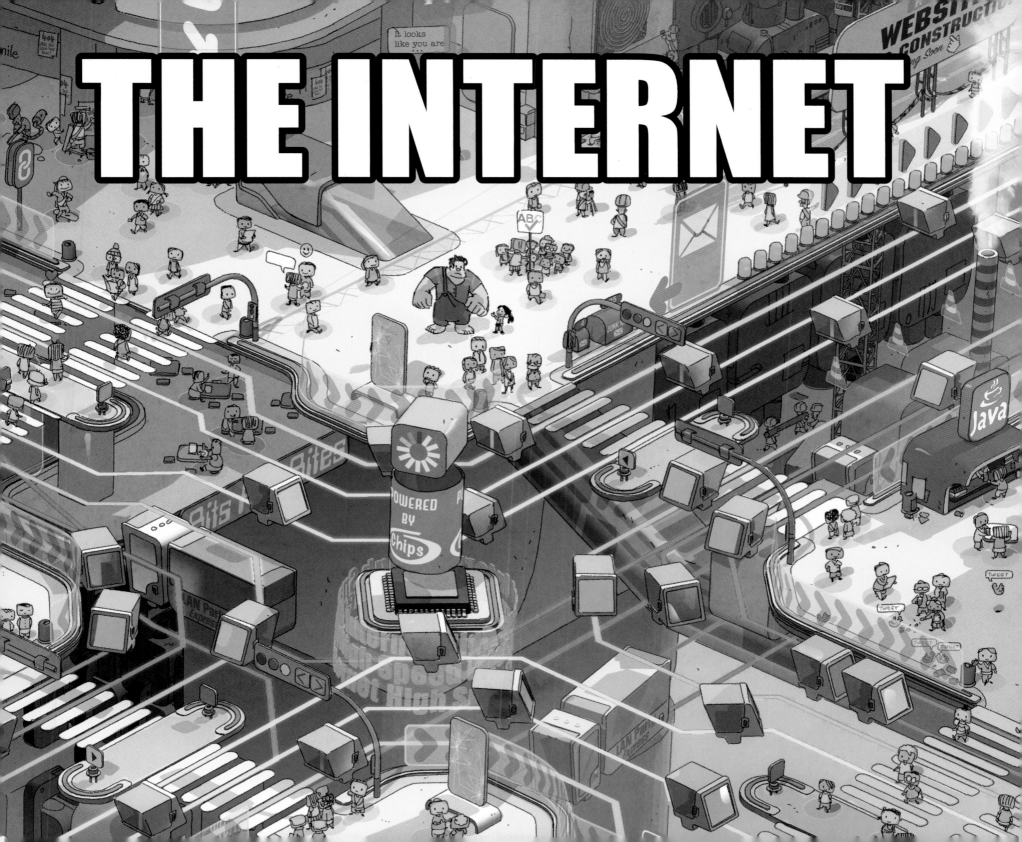

[−] Jessica Julius Author

What research did you do as you prepared to tackle something as enormous and chaotic as the Internet?

permalink embed

[−] Clark Spencer Producer

We met with experts in computer science, Internet gaming, cyber security.

permalink embed parent

[−] Rich Moore Director

Most of us think about the Internet in a very simplistic, almost magical way. But our research showed us that it's all hardware. The Internet really is just series of tubes—wires, boxes, giant cables under the sea. And huge rooms with row upon row of servers.

permalink embed parent

[−] Phil Johnston Director

We wanted to see a physical representation of the Internet, so we went to a data center in downtown Los Angeles. When people on the West Coast log on to the Internet, their requests go through the data center we visited at One Wilshire. There are several big server farms like this around the world, where social media, gaming, news, and commerce companies rent space like an apartment on a city block.

permalink embed parent

[−] Matthias Lechner Art Director, Environments

We were surprised at how chaotic the physical Internet is. You could see how it had grown over time. Some wires were neatly bundled together, others were a deeply tangled mess layered with years of dust.

permalink embed parent

[−] Jessica Julius Author

How did your research inform your design of the Internet?

permalink embed

[−] Rich Moore Director

Before seeing One Wilshire, we had a very naïve idea of what the Internet was. After seeing it, we went from almost magical thinking to being super literal. In the end, we wanted Ralph and Vanellope to enter a new universe that's exciting and entertaining, so we combined the reality of our research with the artists' fun and fantastical ideas.

permalink embed parent

[−] Jim Martin Visual Development Artist

We tried to capture what it would be like if you could really travel to the Internet. We looked at maps of the Internet showing machines linked to different hubs around the world and thought it looked like a planet filled with connected cities alive with color, motion, and light. It depicted how the Internet truly is global, so we decided to design it that way.

permalink embed parent

[−] Matthias Lechner Art Director, Environments

We designed our version of the Internet literally from the top down. As you approach it from above, it resembles patterns you would find on a mother-board, with a grid of rectangular platforms and repetitive shapes connected by paths that turn in 45-degree angles. But as you descend, it becomes a three-dimensional bustling cityscape with tall website-buildings connected by energy-roads on multiple levels. And this is just the surface level floating above the industrial structures of the endless deep web beneath it.

permalink embed parent

[−] Cory Loftis Production Designer

We used a shape language based on modern smartphones and apps—a square with rounded corners, and a clean, crisp atmosphere with bright white light and blue shadows.

permalink embed parent

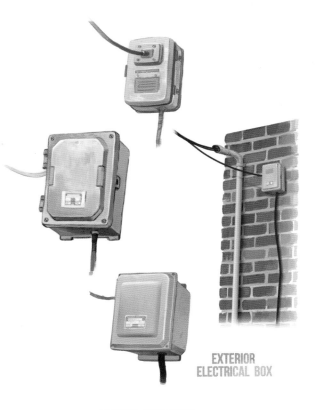

EXTERIOR
ELECTRICAL BOX

OPTICAL TERMINAL

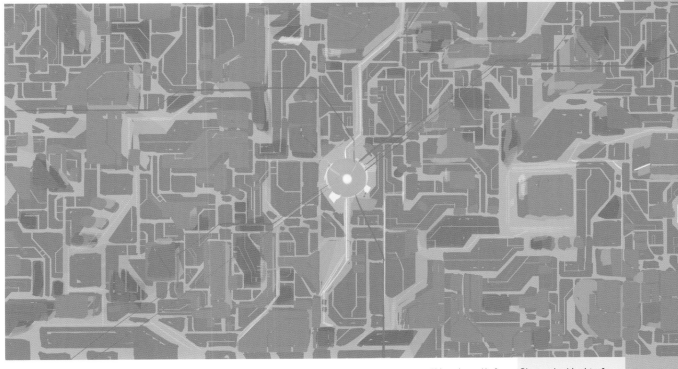

<Mingjue Helen Chen / digital>

OPTICAL TERMINAL

OPTICAL TERMINAL

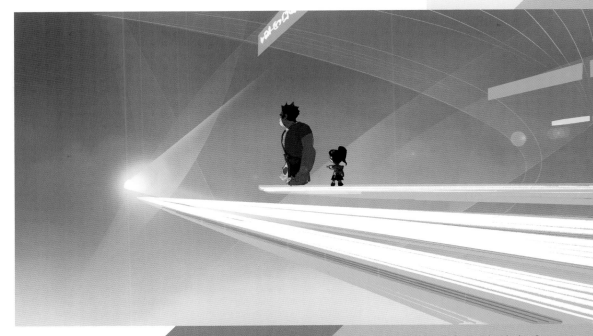

<Jim Martin / digital>
<Pages 30-31 : Matthias Lechner / digital>

<Kevin Nelson / digital>

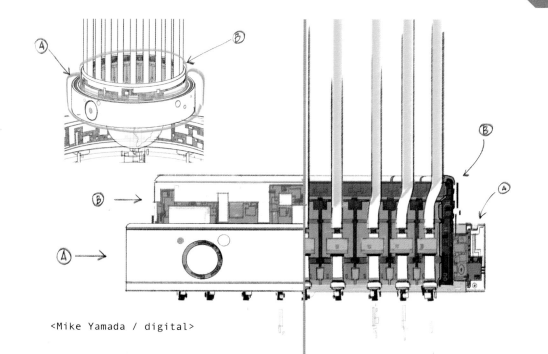

<Mike Yamada / digital>

Matthias Lechner
Art Director, Environments · 🌐

We had so much fun populating this world with Internet-specific gags. The weather app is actually the weather. A travel site is a suitcase. There are Skype and FaceTime phone booths, a java coffee shop, a LAN party bus. There's a little identity thief running around, a Girl Scout handing out cookies at the entrance to a website, a pop-up guy.

Mingjue Helen Chen and 29 others 13 Comments ▼

👍 Like 💬 Comment ➤ Share

<Matthias Lechner / digital>

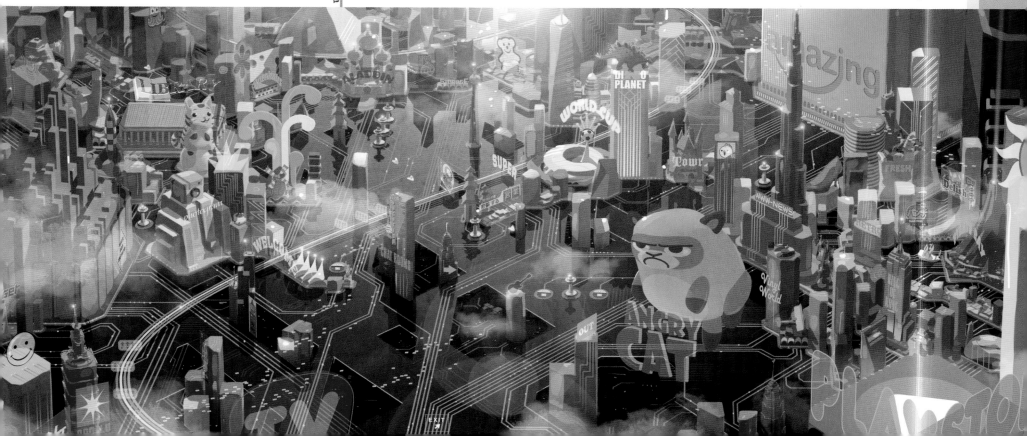

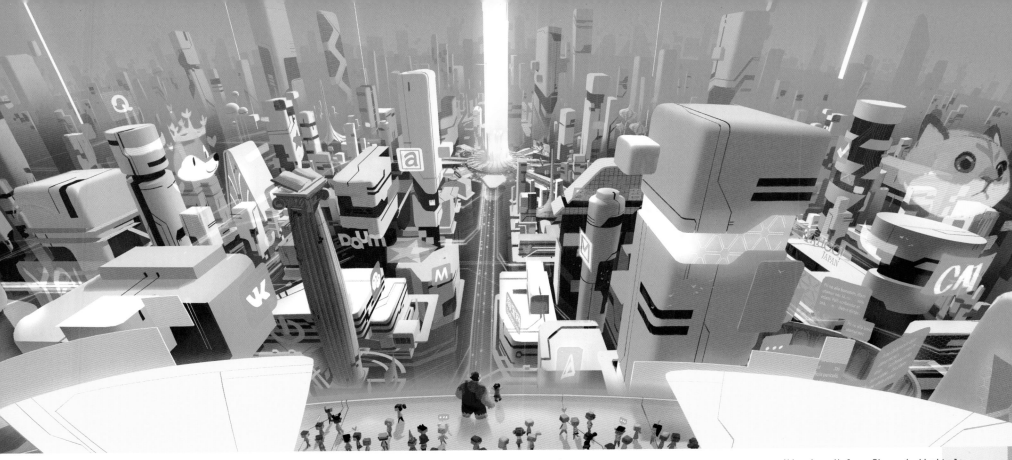

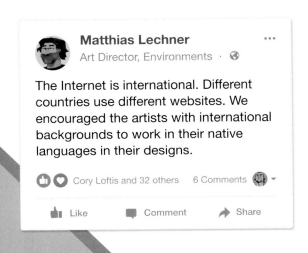

Matthias Lechner ···
Art Director, Environments · 🌐

The Internet is international. Different
countries use different websites. We
encouraged the artists with international
backgrounds to work in their native
languages in their designs.

👍❤️ Cory Loftis and 32 others 6 Comments 🙂 ⌄

👍 Like 💬 Comment ➤ Share

THE HUB

Cory Loftis, Production Designer

The HUB is the portal to the Internet, where users, email, and data arrive and are then transported elsewhere to sites, apps, and games. It's also the central depot for heavy freight like ZIP files and large media files.

<Matthias Lechner / digital>

<Mike Yamada / digital>

Matthias Lechner, Art Director, Environments

Users arrive at the HUB as data packages via fiber-optic cables. They are filtered through a prism that splits the flow of data into different colors, and each of those colors goes to a different site. We were inspired by color-coded guiding systems at airports.

<Matthias Lechner / digital>

STAIR

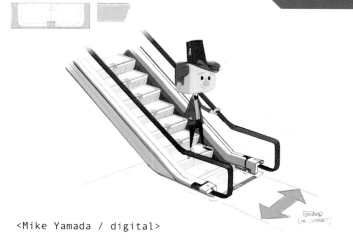

<Mike Yamada / digital>

Cory Loftis, Production Designer

The first place Ralph and Vanellope visit in the Internet is the HUB. They're in the Internet but not yet at a website. It's like arriving at an ultra-modern airport. To go to a website, they have to get down to the ground transportation level, where they can catch a ride to somewhere else.

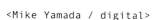

<Mike Yamada / digital>

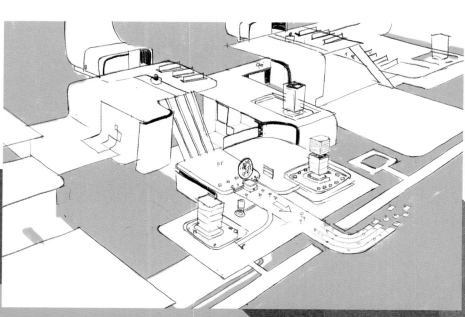

<Mike Yamada / digital>

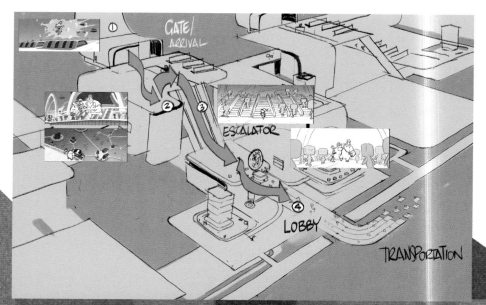

<Mike Yamada / digital>

<Mike Yamada / digital>

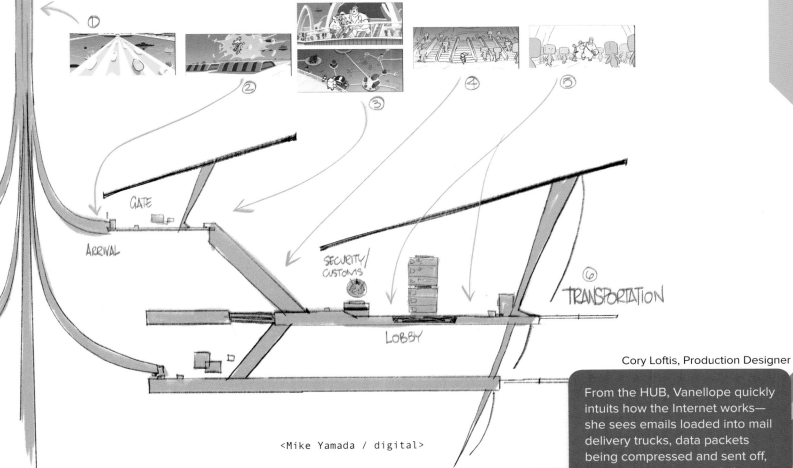

GATE

ARRIVAL

SECURITY/
CUSTOMS

LOBBY

⑥ TRANSPORTATION

<Mike Yamada / digital>

Cory Loftis, Production Designer

From the HUB, Vanellope quickly intuits how the Internet works—she sees emails loaded into mail delivery trucks, data packets being compressed and sent off, and users jumping into linkcars to go to other websites.

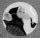

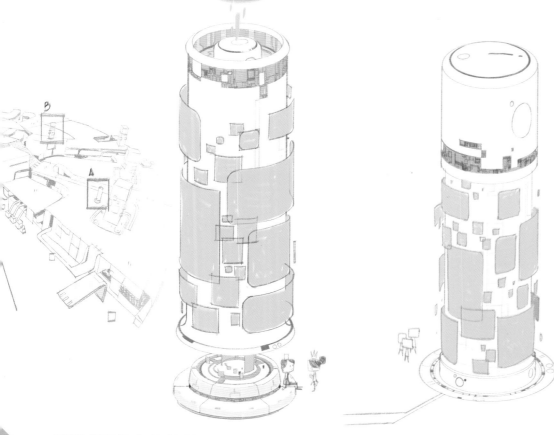

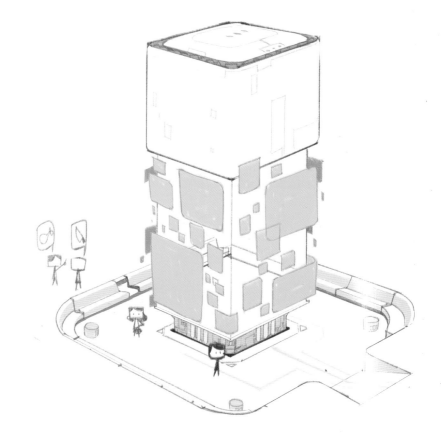

<Mike Yamada / digital>

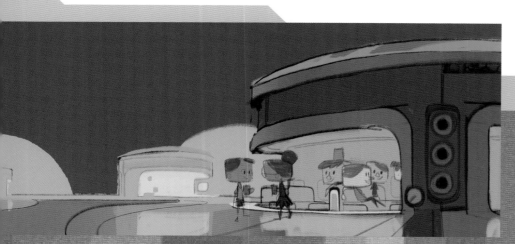

<Mike Yamada / digital>

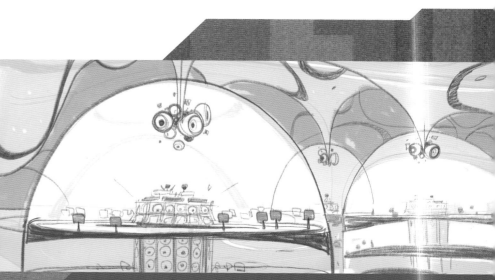

<Mike Yamada / digital>

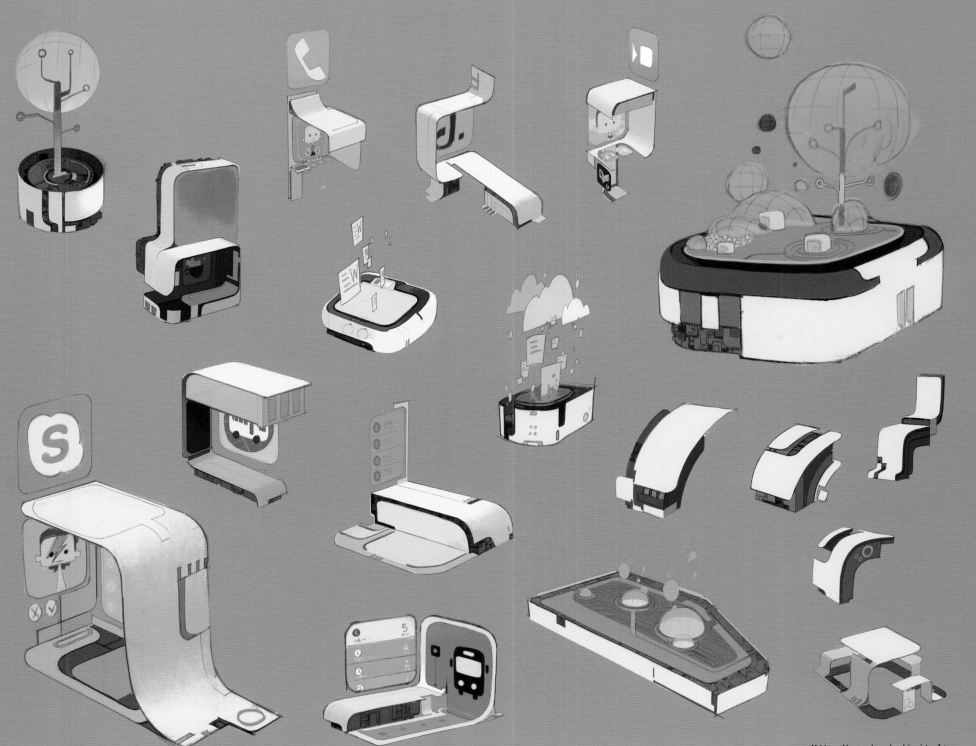

<Mike Yamada / digital>

POPULATING THE INTERNET

 [–] Jessica Julius Author
How did you decide what characters would populate the Internet?

permalink embed

 [–] Ami Thompson Art Director, Characters
We needed to depict the workings of the Internet, so we created two basic types of beings to represent its constant busyness: users and netizens.

permalink embed parent

 [–] Cory Loftis Production Designer
Users are the digital versions of us, our avatars when we're on the Internet. Browsing websites, clicking links, sending emails, doing on the Internet whatever humans tell them to do. Netizens on the other hand are autonomous. We humans don't actually see them but we feel them when we visit a website. They're the ones emptying the recycling bin, delivering email, the HTML workers constructing new websites. They're doing all the things that keep the Internet working.

permalink embed parent

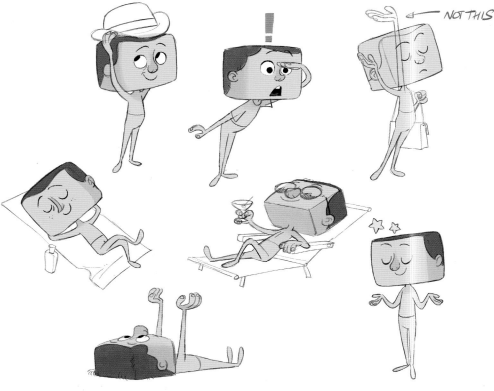

<Borja Montoro / digital>

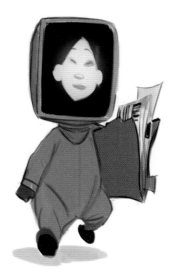

<Paul Felix / digital>

<Nicholas Orsi / digital>

 Ami Thompson ✔ @ArtDirector_Characters ⌄
The users are uniform. They have a basic head and a basic body, but the human can customize features—skin color, eye, mouth and nose shapes, hair, clothing—to make the user feel like a very simplified version of that human on the Internet.

💬 14 🔁 25 ♡ 37

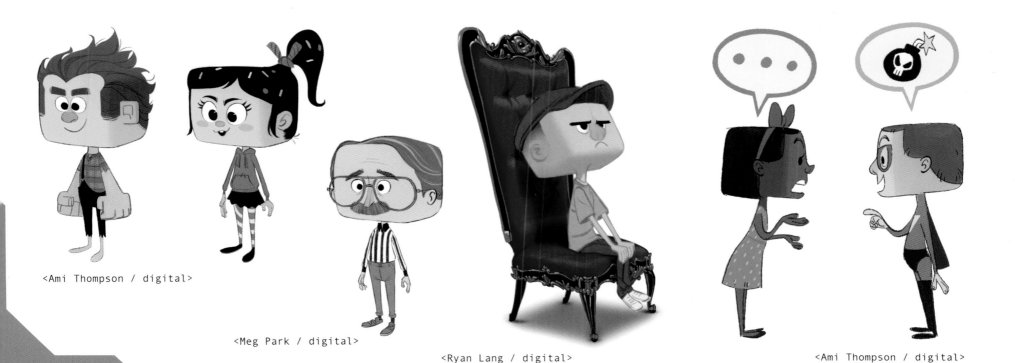

<Ami Thompson / digital>

<Meg Park / digital>

<Ryan Lang / digital>

<Ami Thompson / digital>

Kira Lehtomaki ✓ @HeadOfAnimation
We wanted the users to feel like they are being controlled by a joystick or a mouse, something more mechanical on the other end of the computer. Humans are not physically inside these characters moving them around, but we are controlling them.

💬 9 🔁 18 ♡ 29

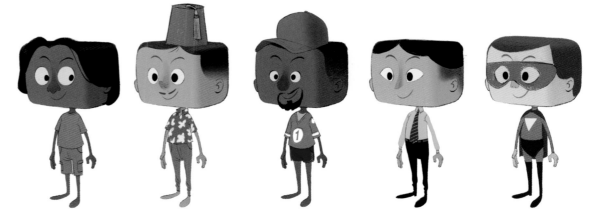

<Cory Loftis / digital>

 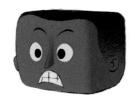

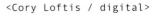
USERS' TEETH STAY IN ONE SPOT AS THOUGH THEY HAD A SKULL. THEIR TEETH AND MOUTHS JUST DON'T SLIDE AROUND THE FACE.

<Cory Loftis / digital>

<Borja Montoro / digital>

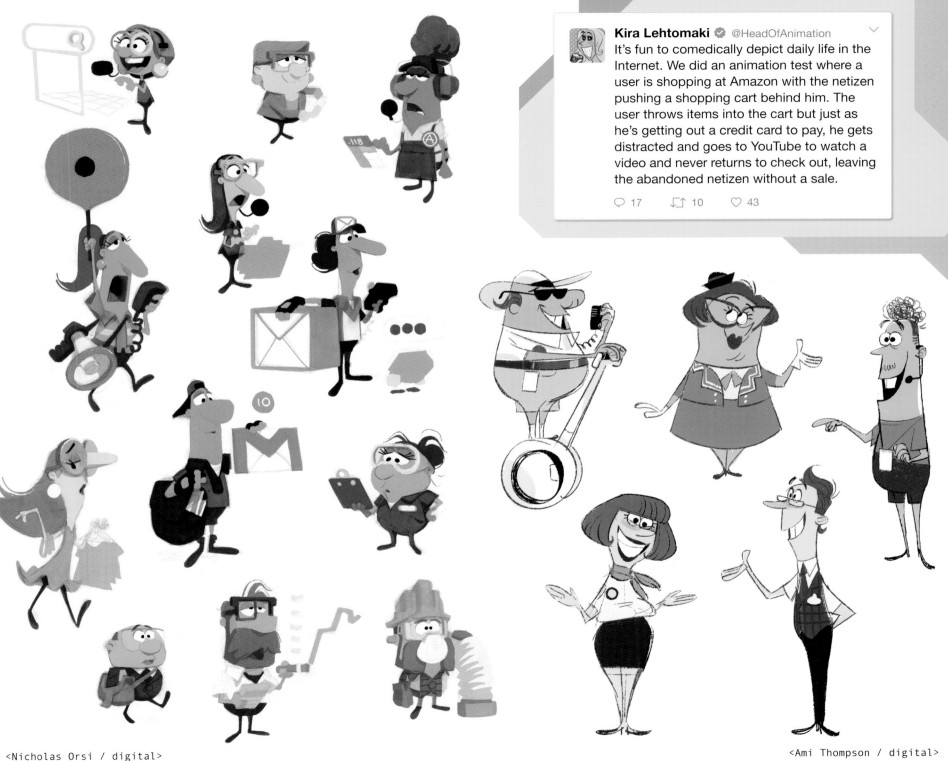

Kira Lehtomaki ✓ @HeadOfAnimation

It's fun to comedically depict daily life in the Internet. We did an animation test where a user is shopping at Amazon with the netizen pushing a shopping cart behind him. The user throws items into the cart but just as he's getting out a credit card to pay, he gets distracted and goes to YouTube to watch a video and never returns to check out, leaving the abandoned netizen without a sale.

💬 17 ↺ 10 ♡ 43

<Nicholas Orsi / digital>

<Ami Thompson / digital>

BUILDING THE WEB

[–] **Jessica Julius** Author

How did you approach the design of the websites themselves?

permalink embed

[–] **Cory Loftis** Production Designer

The challenging part was trying to design the feeling you have when you visit a website, not the reality of it. For example, at Amazon when you select an item to buy, a real person at a physical warehouse somewhere puts that item in a box and ships it to you. But shopping online feels like a private shopping experience, so that's what the website depicted in the film looks like.

permalink embed parent

[–] **Matthias Lechner** Art Director, Environments

We thought of the individual websites as buildings within a city. The interior of each building has a style, shape language, and color palette unique to that website. Scale is based on user traffic, so some buildings are much larger than others. High-traffic sites have many roads connecting to them and they stand out on the horizon. Midsize sites, which comprise most of the Internet, are densely packed, with congested roads. Small sites are isolated, usually with only one small road leading to them.

permalink embed parent

[–] **Mike Yamada** Visual Development Artist

The websites are buildings that can click together and interlock in a Tetris-like way. We had to create buildings that represented generic background websites and apps, as well as well-known sites.

permalink embed parent

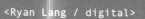

<Ryan Lang / digital>

SCALE REFERENCE

GENERAL INTERNET BUILDINGS - LINEUP GUIDE
SCALE: 50 m per color / thin red lines: 2,50m door hight

(these are NOT designs - just scale guidelines for the actual visdev and modeling)

TOP
FRONT
white: ground level platform
above "ground" level
below ground level
REF

OLDERNET GROUND

1 2 3 4 5 6 7 8 9 10 11 12 13 14 15 16 17 18 19 20 21 22 23 24 25 26 27 28 29 30 31 32 33 34 35 36 37 38 39 40 41 42 43 44 45 46 47

STREET GRID

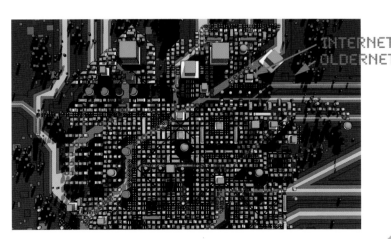

INTERNET
OLDERNET

<Matthias Lechner / digital>

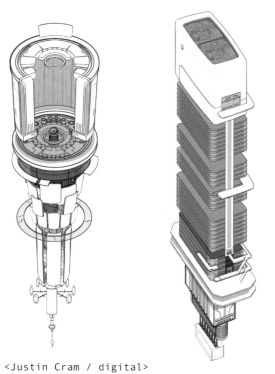
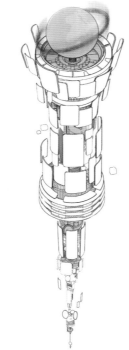
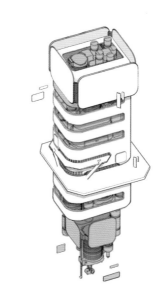
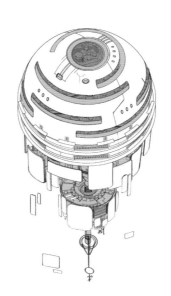
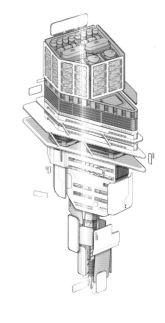

<Justin Cram / digital>

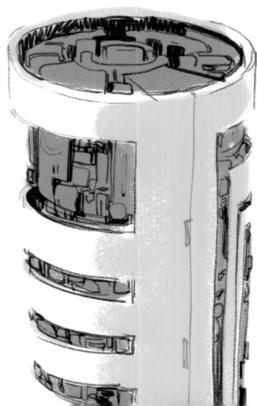
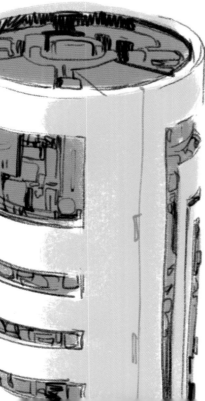

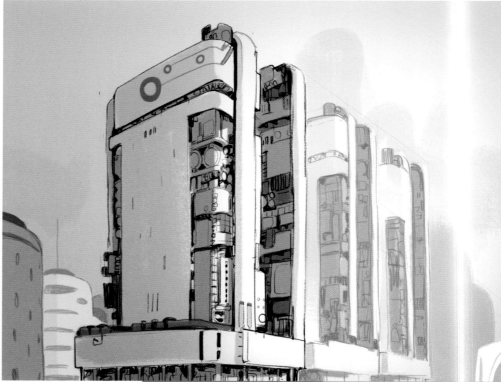

<Mike Yamada / digital>

<Mike Yamada / digital>

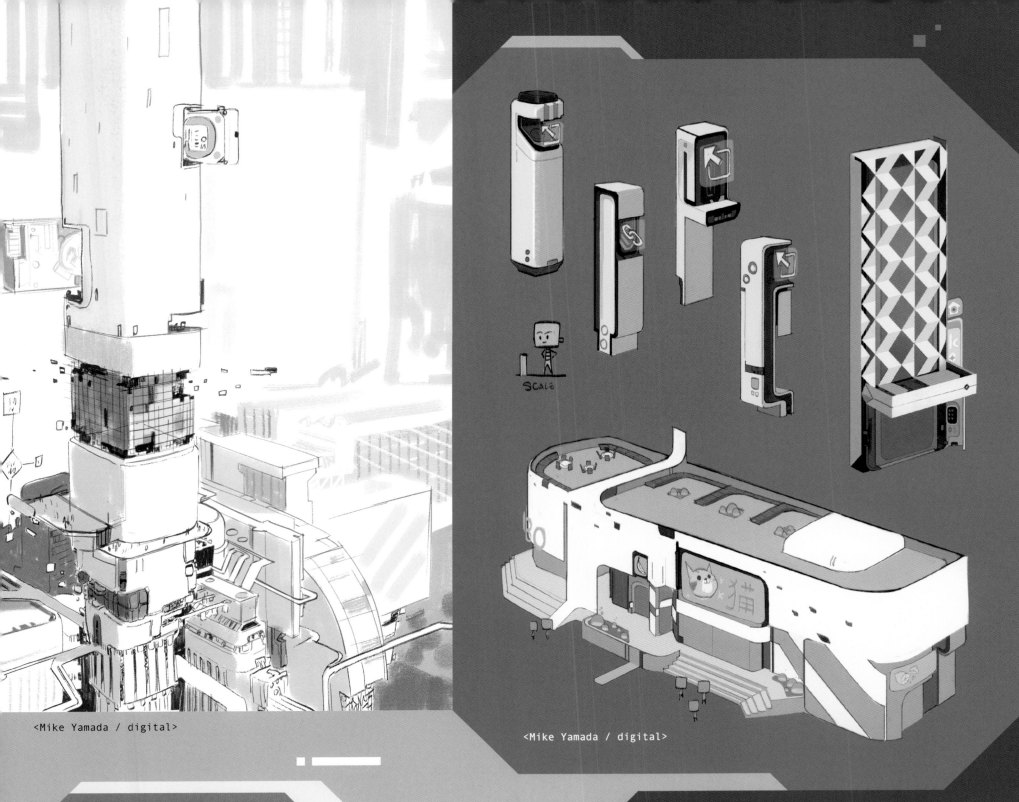

<Mike Yamada / digital>

<Mike Yamada / digital>

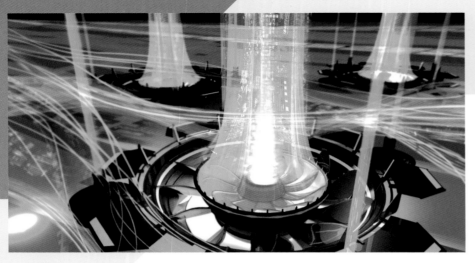

<Jim Martin / digital>

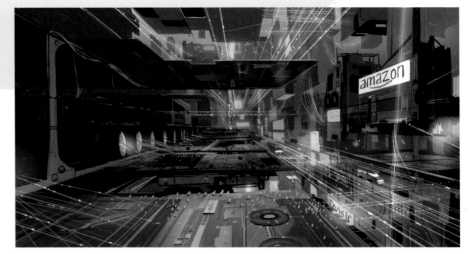

<Paul Felix / digital>

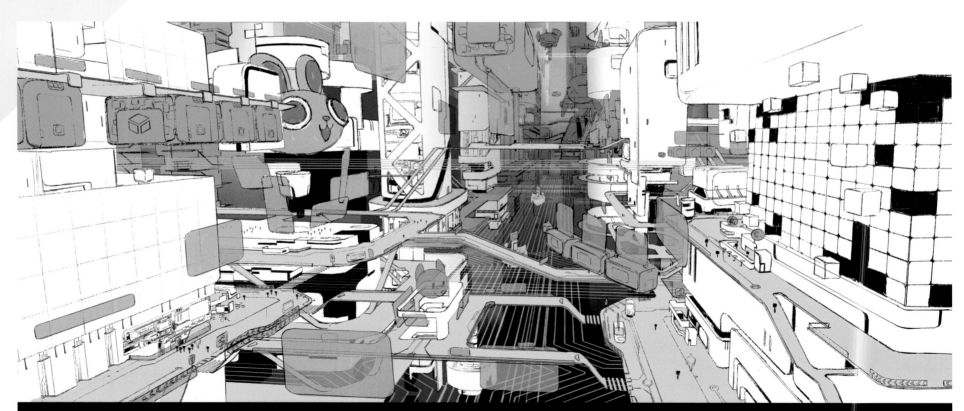

■ PEDESTRIAN WALKWAYS/SIDEWALKS ■ VEHICLES

■ SIGNS/GRAPHICS ■ HOLOGRAMS

<Mingjue Helen Chen / digital>

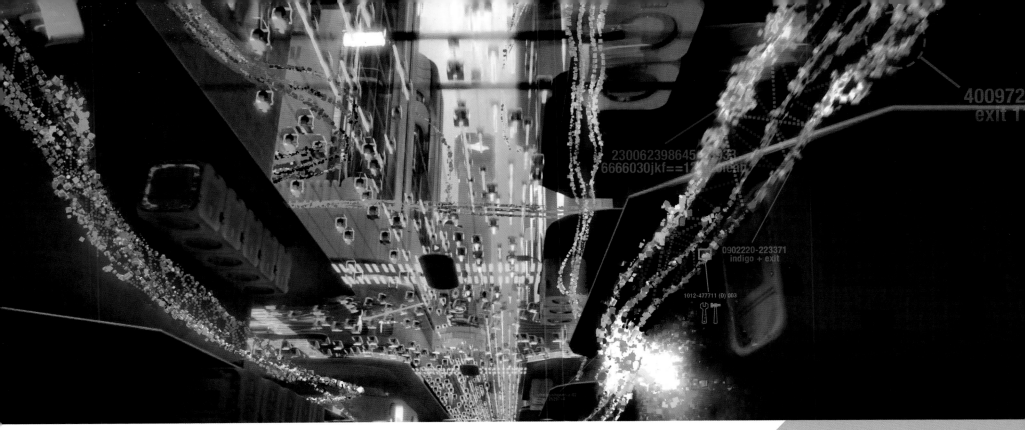

400972
exit 1

2300623986450...933
6666030jkf==12...lean?

0902220-223371
indigo + exit

1012-477711 (D) 003

<Peter DeMund / digital>

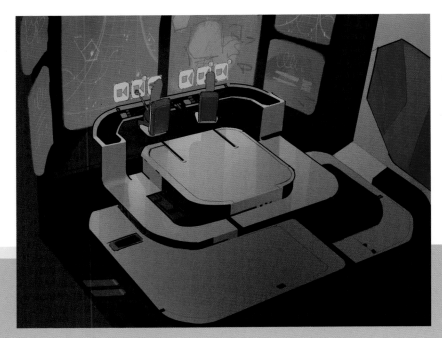

<Mike Yamada / digital>

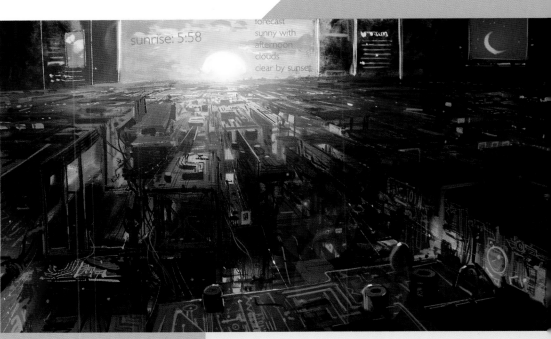

sunrise: 5:58

forecast
sunny with
afternoon
clouds
clear by sunset

<Paul Felix / digital>

Matthias Lechner
Art Director, Environments · 🌐

Our depiction of eBay shows multiple levels of floors filled with colorful auction blocks. Blocks represent general categories—clothes, sports equipment, games—and the boxes themselves have individual items for sale. It's visually straightforward, and combined with the noise from all the bidding, it feels like organized chaos.

👍❤️ Jim Reardon and 14 others 7 Comments 🙂⌄

👍 Like 💬 Comment ➤ Share

<Ryan Lang / digital>

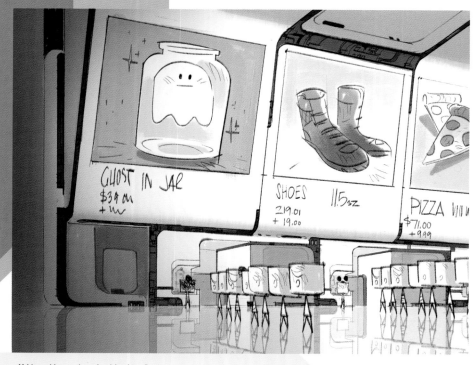

GHOST IN JAR
$34.00
+ m

SHOES 11.5sz
2.19.01
+ 19.00

PIZZA
$71.00
+9.99

<Mike Yamada / digital>

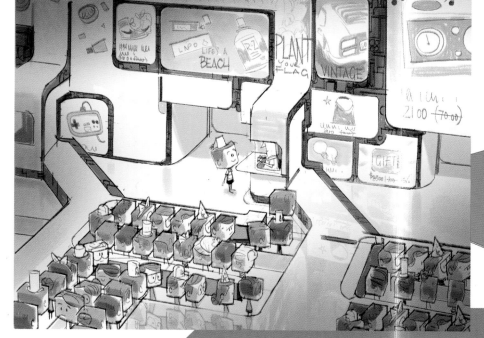

LIFE'S A BEACH

PLANT YOUR FLAG

VINTAGE

GIFT

<Mike Yamada / digital>

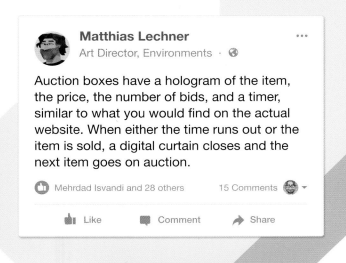

Matthias Lechner
Art Director, Environments · 🌐

Auction boxes have a hologram of the item, the price, the number of bids, and a timer, similar to what you would find on the actual website. When either the time runs out or the item is sold, a digital curtain closes and the next item goes on auction.

👍 Mehrdad Isvandi and 28 others 15 Comments

👍 Like 💬 Comment ➤ Share

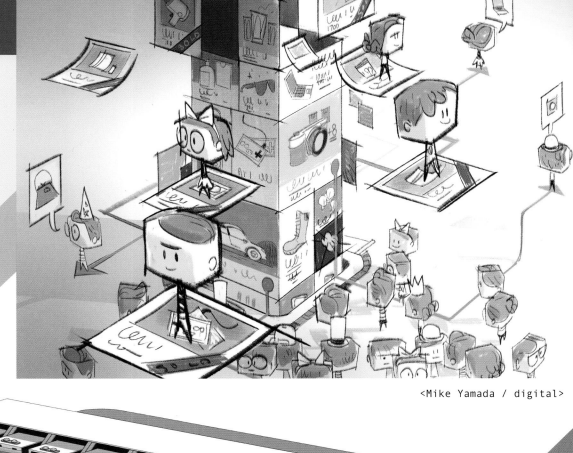

<Mike Yamada / digital>

<Matthias Lechner / digital>

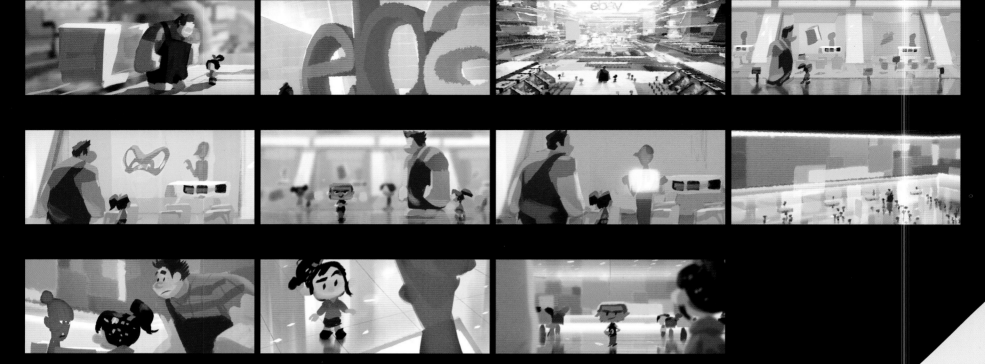

<Mingjue Helen Chen / digital>

<Ryan Lang / digital>

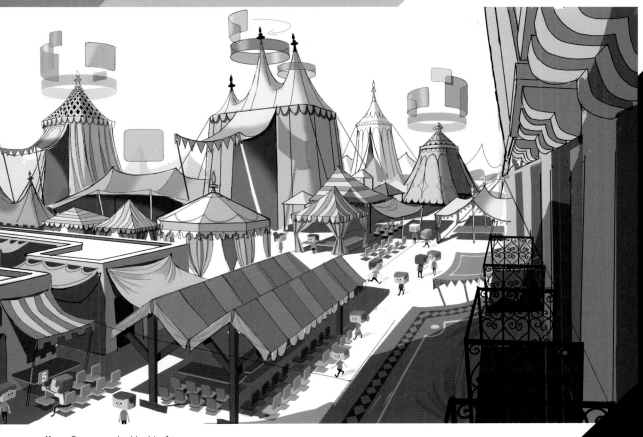

<Mac George / digital>

Cory Loftis ···
Production Designer · 🌐

When we start a design, it can be tough to decide what's important. Our eBay design started as a more curvy, architectural, inventive space but the story was about what was happening at the auction, so the site became more functional to keep the audience focused on the items and the auctioneers.

👍❤️ Ami Thompson and 26 others 4 Comments 🔴 ▾

👍 Like 💬 Comment ➤ Share

<Mac George / digital>

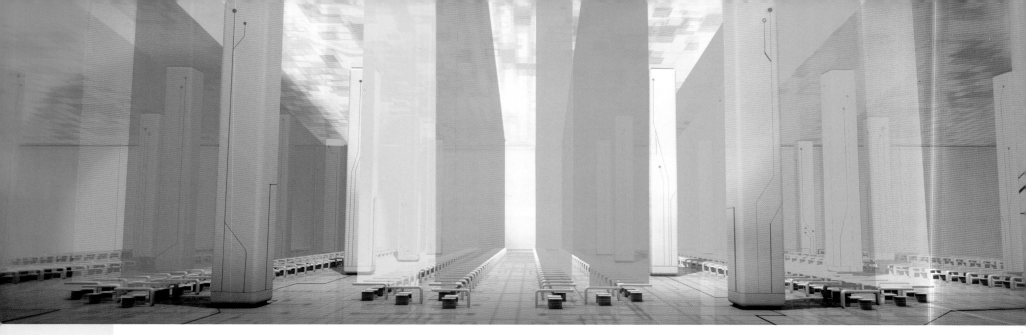

<Justin Cram / digital>

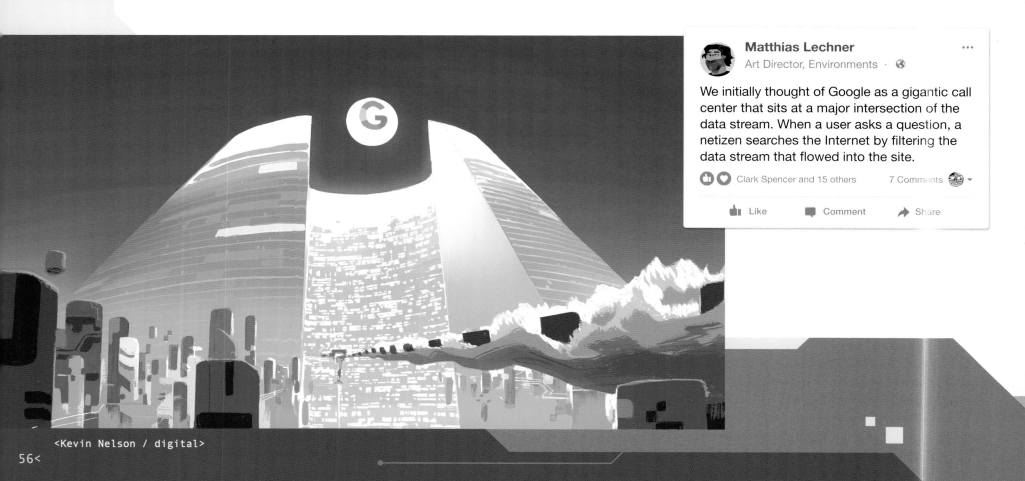

<Kevin Nelson / digital>

Matthias Lechner ···
Art Director, Environments · 🌐

We initially thought of Google as a gigantic call center that sits at a major intersection of the data stream. When a user asks a question, a netizen searches the Internet by filtering the data stream that flowed into the site.

👍❤️ Clark Spencer and 15 others 7 Comments ▾

👍 Like 💬 Comment ➤ Share

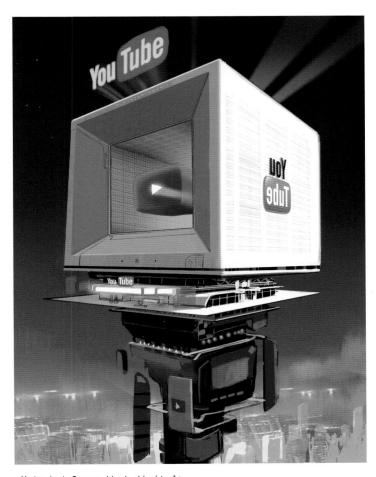

<Mehrdad Isvandi / digital>

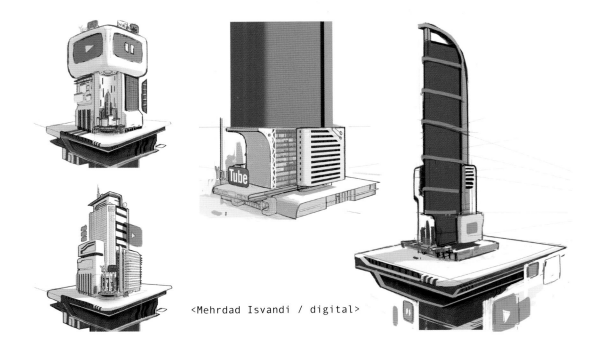

<Mehrdad Isvandi / digital>

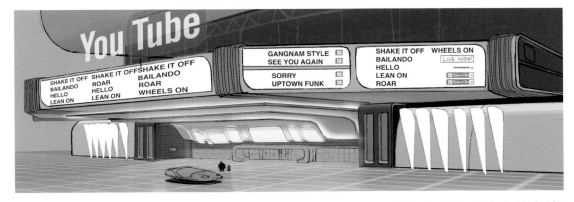

GANGNAM STYLE
SEE YOU AGAIN

SHAKE IT OFF WHEELS ON
BAILANDO
HELLO LIVE NOW
LEAN ON
ROAR

SORRY
UPTOWN FUNK

SHAKE IT OFF SHAKE IT OFF SHAKE IT OFF
BAILANDO ROAR BAILANDO
HELLO HELLO ROAR
LEAN ON LEAN ON WHEELS ON

<Mehrdad Isvandi / digital>

Matthias Lechner
Art Director, Environments · 🌐

YouTube in this movie is a like a multiplex cinema. The exterior resembles a giant cathode ray tube television set. Inside are rows and rows of single-person screening rooms.

👍 Josie Trinidad and 22 others 13 Comments 👥 ▾

👍 Like 💬 Comment ➤ Share

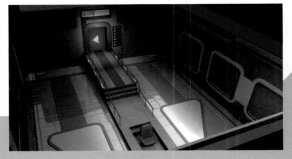

<Jim Martin / digital>

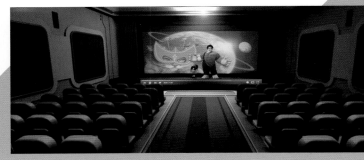

<Jim Martin / digital>

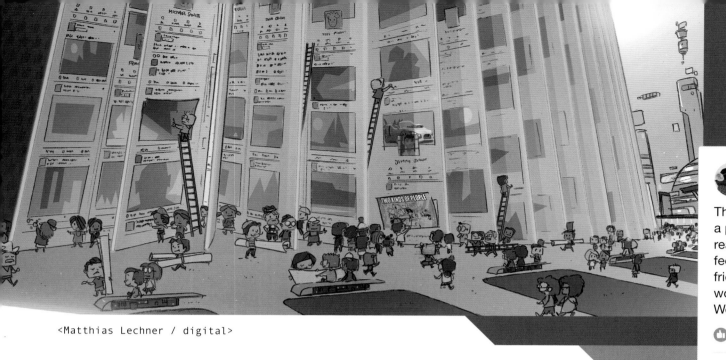

<Matthias Lechner / digital>

Cory Loftis
Production Designer · 🌐

The real-world analogy for Facebook is a person handing you a photograph or reading a newspaper. But what Facebook feels like is having a conversation with your friends or having reporters from all over the world do a custom newscast just for you. We tried to capture what it feels like.

👍 Scott Kersavage and 19 others 5 Comments 😊 ▾

👍 Like 💬 Comment ➤ Share

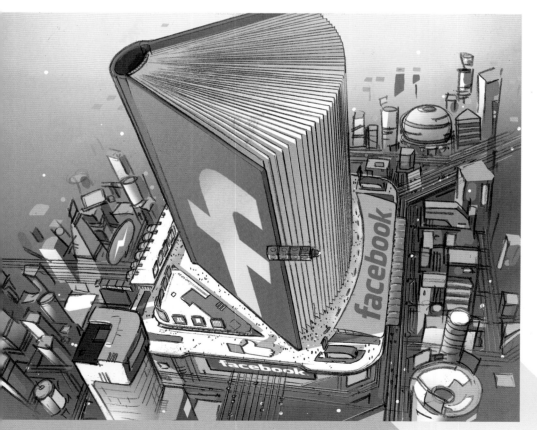

<Matthias Lechner / digital>

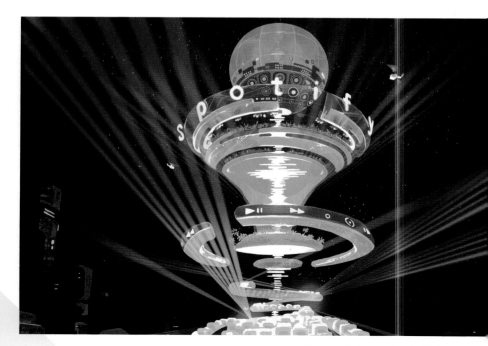

<Kevin Nelson / digital>

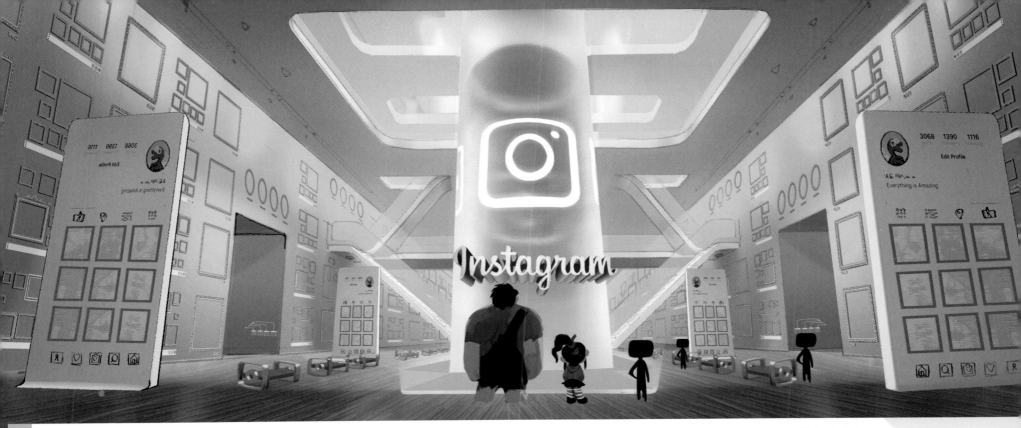

<Mehrdad Isvandi / digital>

Mehrdad Isvandi
Visual Development Artist · 🌐

Our version of Instagram was designed to look like a museum. There are millions of pictures and framed art pieces lining the walls.

Rich Moore and 26 others 8 Comments

👍 Like 💬 Comment ➤ Share

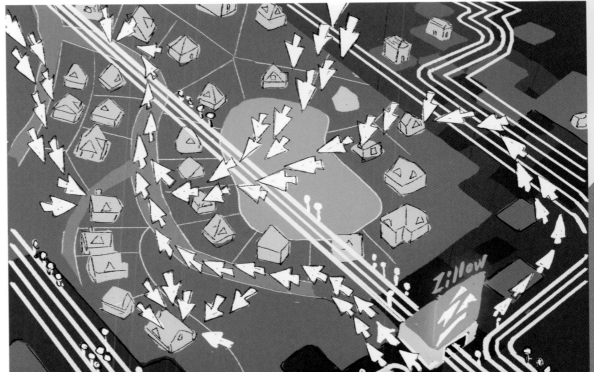

<Kevin Nelson / digital>

Matthias Lechner
Art Director, Environments · 🌐

The film's version of Amazon looks like a monolithic structure made out of cardboard boxes. Swarms of drones travel in and out from all directions, looking for items users are buying.

👍❤️ Renato Dos Anjos and 35 others 17 Comments

👍 Like 💬 Comment ➤ Share

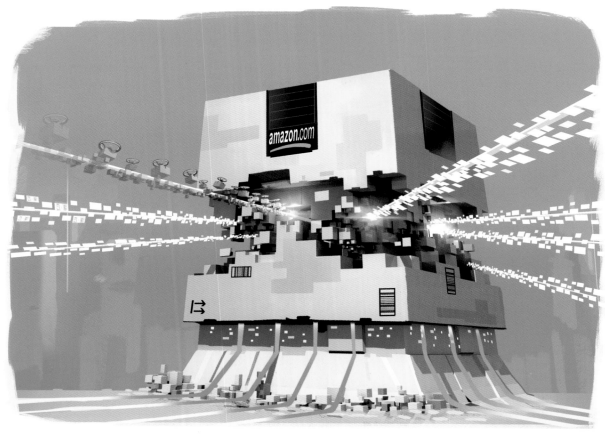

<Jim Martin / digital>

<Mike Yamada / digital>

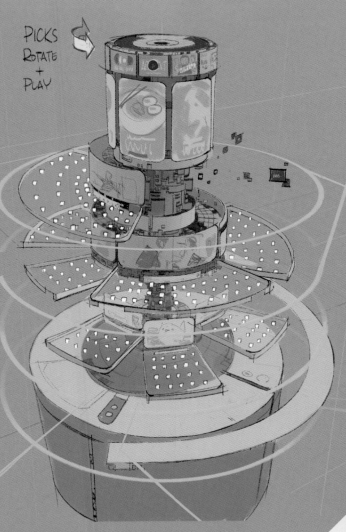

PICKS
ROTATE
+
PLAY

<Mike Yamada / digital>

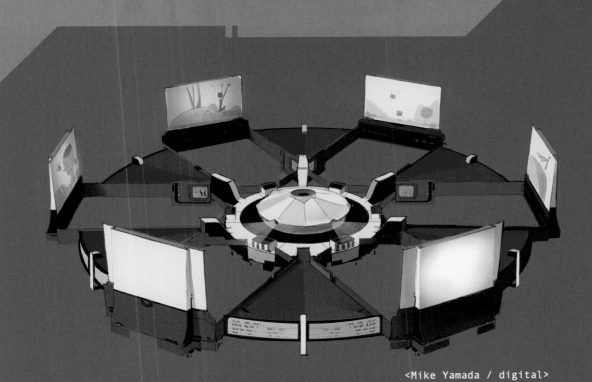

<Mike Yamada / digital>

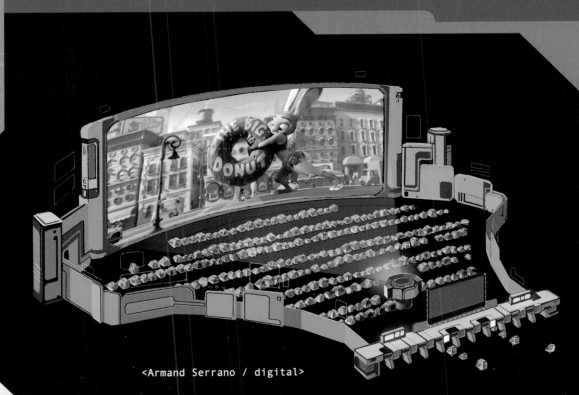

<Armand Serrano / digital>

Matthias Lechner
Art Director, Environments · 🌐

We depicted Netflix as a drive-in movie theater but on a huge scale, with screens on many levels.

👍 Mike Yamada and 22 others 18 Comments ▾

👍 Like 💬 Comment ➤ Share

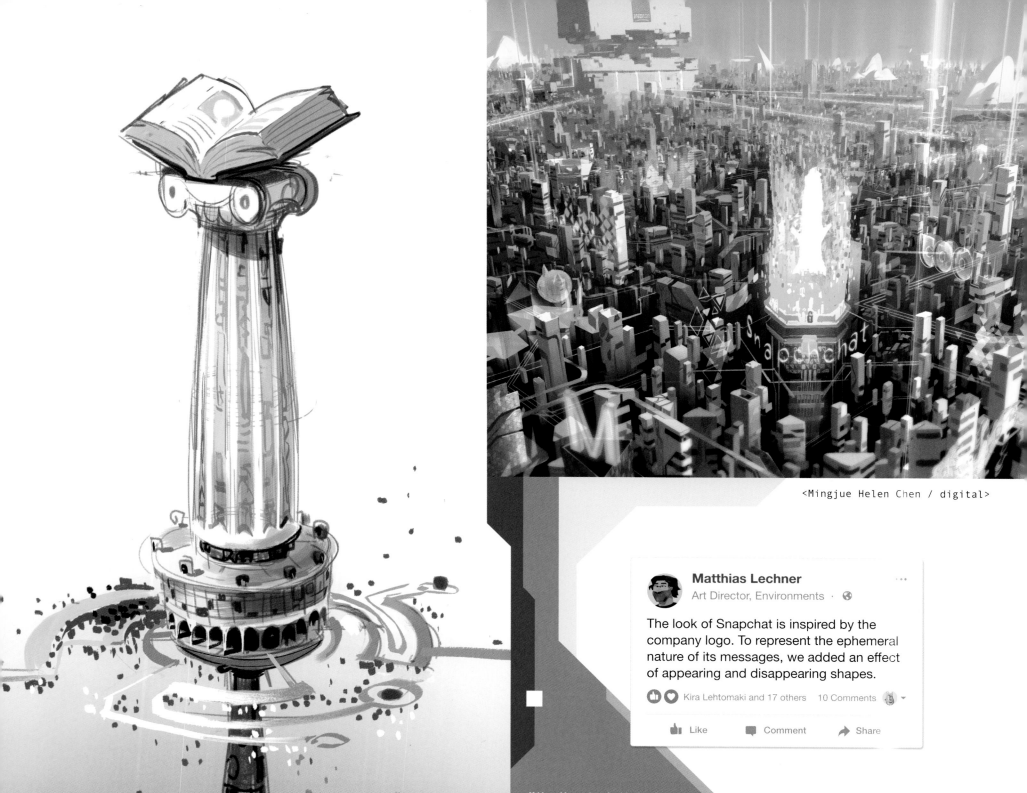

<Mingjue Helen Chen / digital>

Matthias Lechner
Art Director, Environments · 🌐

The look of Snapchat is inspired by the
company logo. To represent the ephemeral
nature of its messages, we added an effect
of appearing and disappearing shapes.

👍❤️ Kira Lehtomaki and 17 others 10 Comments

👍 Like 💬 Comment ➤ Share

<Mike Yamada / digital>

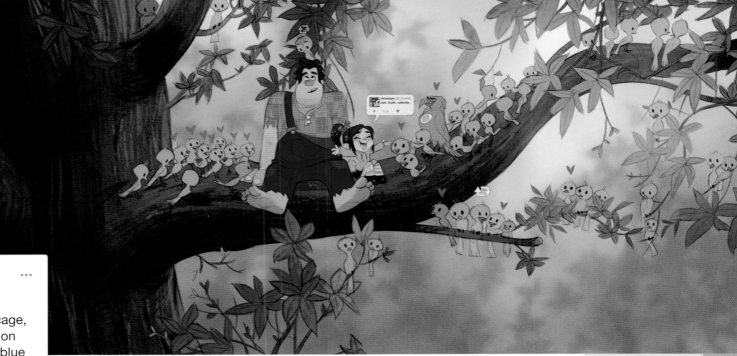

<Cory Loftis / digital>

Matthias Lechner
Art Director, Environments · 🌐

We tried many ideas for Twitter: a birdcage, an aviary, a giant tree with birds sitting on little hashtags like they're swings. And blue messenger birds are present throughout our Internet, like pigeons in a city.

 Nathan Warner and 22 others 6 Comments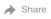

👍 Like 💬 Comment ➤ Share

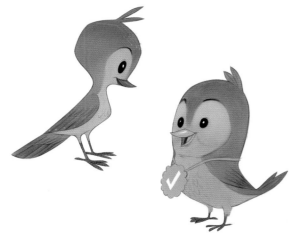

TWITTER FOREST

<Cory Loftis / digital>

<Matthias Lechner / digital>

VISUAL NOISE

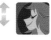 **Jessica Julius** Author

[−] **Jessica Julius** Author
One of the biggest creative and technical challenges of this film is how many screens there are. How did you tackle that?

permalink embed

 [−] **Ami Thompson** Art Director, Characters
The environment had to look like a big city filled with all kinds of signs, videos, advertisements, and graphics.

permalink embed parent

 [−] **Ernest Petti** Technical Supervisor
We've depicted screens in films before but never this many. And they're all different sizes and shapes, all showing different video or images.

permalink embed parent

 [−] **Scott Kersavage** Visual Effects Supervisor
Everything you see on those screens is an insert shot. In most films we have maybe a couple hundred insert shots, but here we had to represent tens of thousands of screens in a single frame. Every department collaborated to do it.

permalink embed parent

 [−] **Cory Loftis** Production Designer
Artists from different departments created every meme, gif, video, and image. Since we're trying to recreate the Internet, we didn't put too many rules on what they could do. It was whatever came out of the artists' heads.

permalink embed parent

 [−] **Nick Orsi** Visual Development Artist
There's a little bit of everything in there: clips from Disney movies, caricatures of each other, graffitied puns in computer code. There are so many background jokes and visual gags in there. And, of course, cat videos.

permalink embed parent

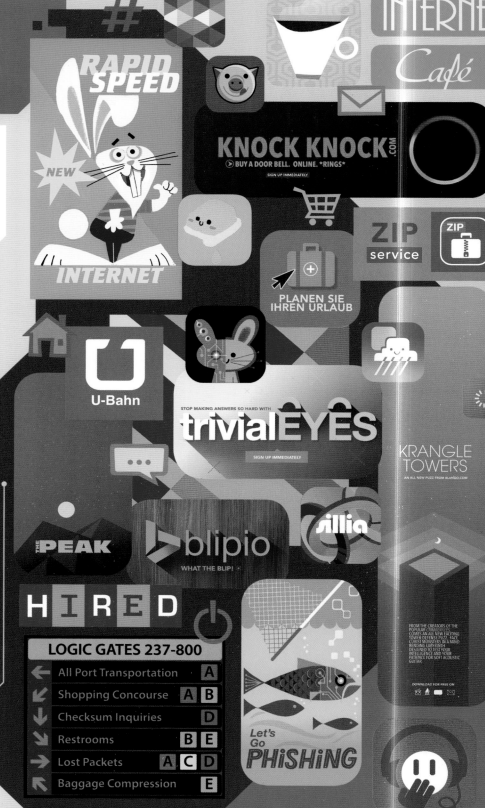

8-Bit Diner

顔文字
Kaomoji

顔文字

redefine graphics with
macgeorge.com

ABSOLUTELY STUNNING

DOWNLOAD FOR FREE ON

COOKBOOK
ratings, reviews, and more....

"I'm really indecisive when it comes to dinner. Cookbook thinks for me, and I'm never disappointed!"
—Belvedere Foodpit

JURASSIC BAJA

SPEED LIMIT
150
Mbps

Smashable
DOWNLOAD TODAY!

Ernest Petti, Technical Supervisor

The Internet holds an overwhelming amount of stuff—it's filled with people, data, traffic—and we had to show that on-screen. The number of crowd characters in other films peaks at around five or six thousand. A single test shot in this film had 50,000 crowd characters.

BuzzFood
COME SEE WHAT ALL THE BUZZ IS ABOUT

울보

FOLLOW US HERE

WAR
DURING VARIOUS
AGES
BUILD YOUR ARMY AND START YOUR EMPIRE TODAY!

THE SUPER SPARKLE CHALLENGE HOUR!

LEVEL THAT MAGIC UP IN
School of Wizarfolks
MULTIPLAYER ONLINE
Join a guild and start slinging spells today! **ENROLL!**

ONLINE BANKING

404
page not found
198.187.190.1

c|note

Refresh Yourself
have a ☕

IS YOUR COMPUTER SICK?
PC PHYSICIAN

window.
location.
reload();

PACKET ANALYSIS		PACKET ANALYSIS	
ARRIVALS		**DEPARTURES**	
A	869.96	A	345.78
B	456.68	B	221.55
C	158.99	C	895.31
D	300.02	D	101.37

PETABYTES PER HOUR

SEQUOIA Speedway

178 EMAIL
6325 JUNK MAIL

SHARK BYTE

Digital Pets

無料でダウンロード
可愛い 寿司
のために作成

App Store

YOUR FRIENDS & FAMILY ARE GONNA HATE OUR
SHOCKING POLITICAL REPOSTS

⊕ THE BEST CHAT APP ON THE INTERWEBS!

blabbIT
DOWNLOAD FOR FREE ON

arthouse
FILM ARCHIVE

oboy

tuj

.com/dts
Now back in our original location! Technically our fourth, but still.

ORDER NOW

"MY SISTER IN-LAW GOT **RICH$$** FROM WORKING AT **HOME!!!**"

YAMADA
creating worlds

GET STARTED TODAY!
JobsterLinx

GET VERY WEALTHY IN JUST ONE CLICK

refresh yourself

wwwellness

STUNT RACER

POWER UP

HECHOS Y CIFRAS

VACAY PEDIA
YOUR DREAM VACAY IS WAITING

болтовня

INTERNET
YOU ARE HERE
Tumblr
Qzone
WhatsApp
Tencent Weibo
Google+
Sina Weibo
YouTube
Facebook
Line
brought to you by: http

FRANCIEL

spiralina

24h PHOTOSHOP
WE HAVE ALL BRANDS

COLORS BY Chen
BROWSE OUR DIGITAL PALLETES TODAY

TRANSLATION
翻译

"When you're just too lazy to read, and I don't know... I just can't be witty on the spot."
—Satisfied Customer

"It's like reading, but with your ears."
—Valeria Sanchez

AUDIO BOOKS

DOWNLOAD A FREE BOOK RIGHT NOW
SIGN UP

Follow Your Circuit Trace

CONSPIRACY THEORIES

SOCIAL MEDIA STALKER

Endless Vault of Quality
SHERLOCK FAN FICTION
* safe search off *

WEBSITE CONSTRUCTION

HTML
countdown timer
maintanance page
easy templates

SKULL

bIvt
PUTTING THE IVY IN BEETEE.

cyber PUNK

OUTLAW DATA STORAGE

electrolyze you life with the power of lithium ions!

KAWAII RIVALS

JAVA J·I·V·E
UPDATE YOUR DRIVERS FOR THE MORNING COMMUTE

COME TAKE A Gand R
AVAILABLE ON THE FOLLOWING PLATFORMS

MAKE SURE YOUR DATA IS PROTECTED ACROSS THE GLOBE. WE OFFER SINGLE POINT ACCESS TO ALL OF YOUR DATA WITH NO BACKUP NEEDED. WE PROVIDE A SMOOTH BRIDGE BETWEEN ALL OF YOUR WEBSITE RESOURCES REGARDLESS OF MEDIA TYPE: HARD DISK, TAPE, CLOUD, FILING CABINET, OR DECORATIVE TEAK BOX. WE GOT YOU COVERED BRUH!
— Kevin Von Fleek, Chief Brogrammer

muttfinder

STOP MALWARE WORMS

Expectya
your greatest adventure is a mouse click away.
SIGN UP IMMEDIATELY

GIF 'n' TAKE TECHNOLOGIES

Broadband
3 G
4 G L T E
5 G

Don't just ship it--

PML
SFW

c|note
download the latest news in the industry

ZIP it!

Compression Services on Concourse D

THE BLAG
GIGGA. BLARGGA.

HOW TO GET RID OF BELLY FAT
using this one weird trick

Leave latency behind. Stops at all popular DNS servers.

100% fiber optic links will pamper your packets from header to footer.

Bits'n'Bites
INTERNET CAFÉ

SHRUNKEN PRICES!

POP
SERVER SOLUTIONS

LECHNER

GO

grizzbies
HTML SOLUTIONS

DOWNLOAD FOR FREE ON

GLOBAL SIKKERHED

NEW EPISODES EVERY WEDNESDAY

インターネットの戦い

Gorillio
GET STARTED TODAY

FOOD TRUCK RALLY RACE

How 'Bout Some ππ?
EXPAND YOUR CRITICAL THINKING WITH 100'S OF PUZZLES
GET STARTED TODAY

earworm

PHISH MARKET

FOLLOW US ON
SEARCH

POOP QUEST
Down Stream

Tap the Screen
Privacy Policy

This is where it's @

LET'S TALK SHERLOCK
PODCAST

timesuck

THE DAILY BOAST

TOMA NUESTRO QUIZ

POOP QUEST
POOP Chute

Tap the Screen
Privacy Police

MAINFRAME CONSTRUCTION

BEACH CITY

HIDING YOUR DELETED HISTORY

LOGIC

Nathan Warner, Director of Cinematography, Layout

Internet videos are often recorded with smartphone cameras, which have a different motion and orientation than a film camera. They feel handheld, twitchy, vertical. Characters often break frame and the person filming overcorrects and has to come back. Everyone knows what a phone camera feels like because we see it every day, but it's difficult to recreate that style deliberately.

findout
THE WORLD AWAITS

>67

kittycorner.cat

THUG LIFE

Congratulations You Won!!
WINNER !!!
CLICK TO CLAIM YOUR PRIZE
NO Yes!

Cat Got Your Tongue?

MAUSKLICK

triggered.

<Various Artists / digital>

Ami Thompson, Art Director, Characters

Cats are such a big thing on the Internet, so to provide a variety of design choices we created a basic cat design we could modify for various needs—long hair, short hair, fat, skinny. Mochi, the cat from *Big Hero 6*, appears.

<Nicholas Orsi / digital>

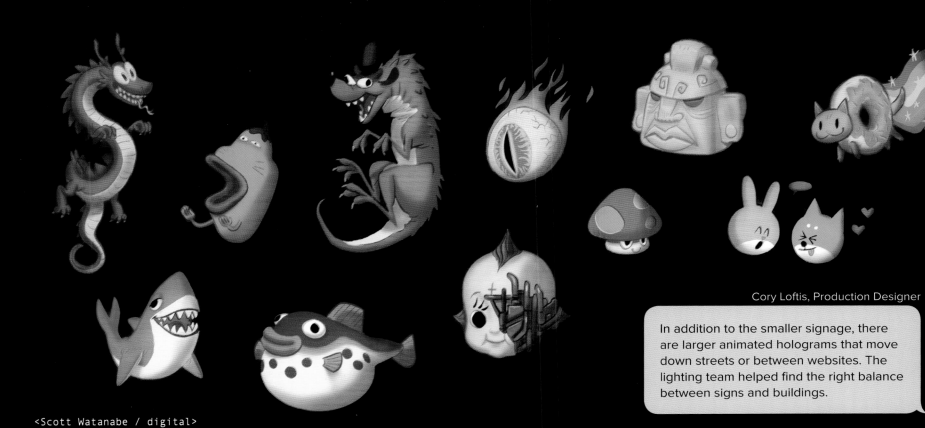

<Scott Watanabe / digital>

Cory Loftis, Production Designer

In addition to the smaller signage, there are larger animated holograms that move down streets or between websites. The lighting team helped find the right balance between signs and buildings.

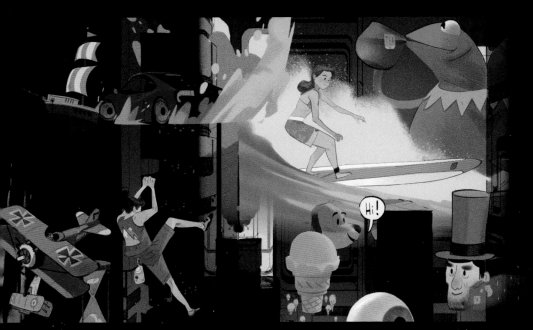

<Mike Yamada / digital>

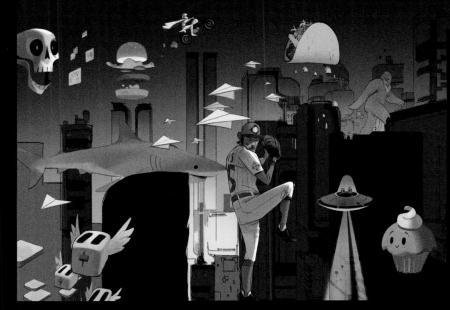

<Mike Yamada / digital>

GETTING AROUND

 [−] Jessica Julius Author
How do users and netizens move around the Internet?

permalink embed

 [−] Matthias Lechner Art Director, Environments
The roads are light bands that turn at 45-degree angles so they're reminiscent of a motherboard. Little cars attach to the light bands like electrons—these are the linkcars.

permalink embed parent

 [−] Cory Loftis Production Designer
A user hops in a linkcar to travel from website to website. Linkcars are self-driving and carry the user straight to wherever she wants to go. They travel at different speeds, so if you're still on DSL your linkcar goes slower than those on fiber-optic lines.

permalink embed parent

 [−] Matthias Lechner Art Director, Environments
Netizens' vehicles represent the sites they're from, the jobs they do. There are postal vans for delivering emails, a garbage truck for junk mail.

permalink embed parent

 [−] Mike Yamada Visual Development Artist
We created Internet versions of easily recognizable vehicles from the real world so that audiences could quickly process them and enjoy the joke.

permalink embed parent

 [−] Cory Loftis Production Designer
The world started to make sense as we designed the transportation.

permalink embed parent

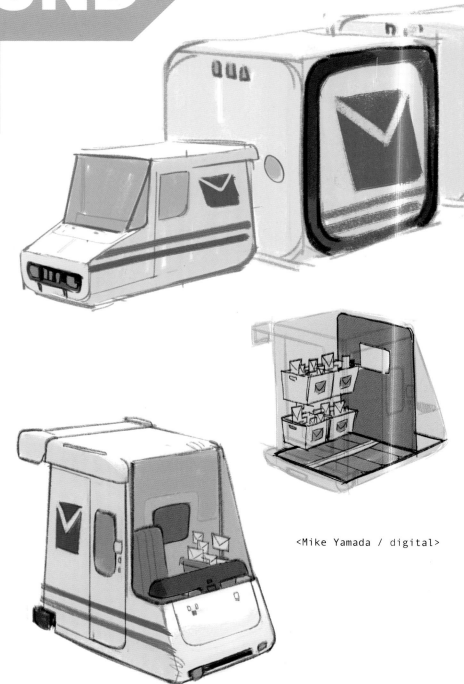

<Mike Yamada / digital>

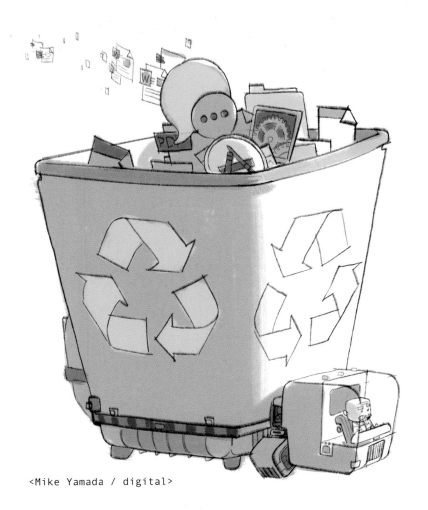

<Mike Yamada / digital>

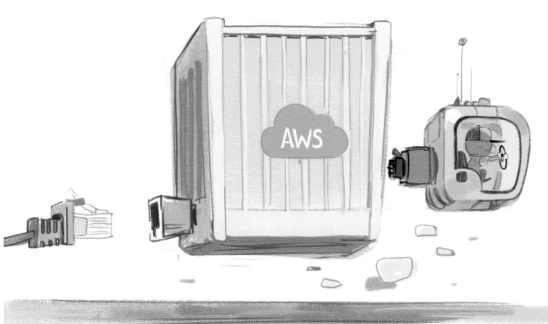

<Mike Yamada / digital>

<Mike Yamada / digital>

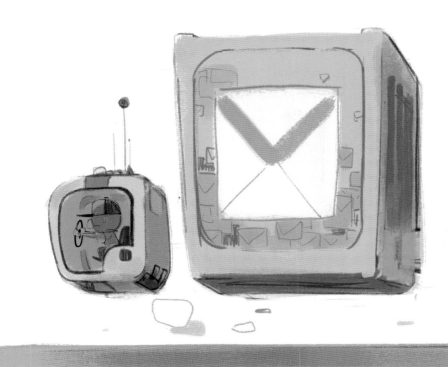

<Mike Yamada / digital>

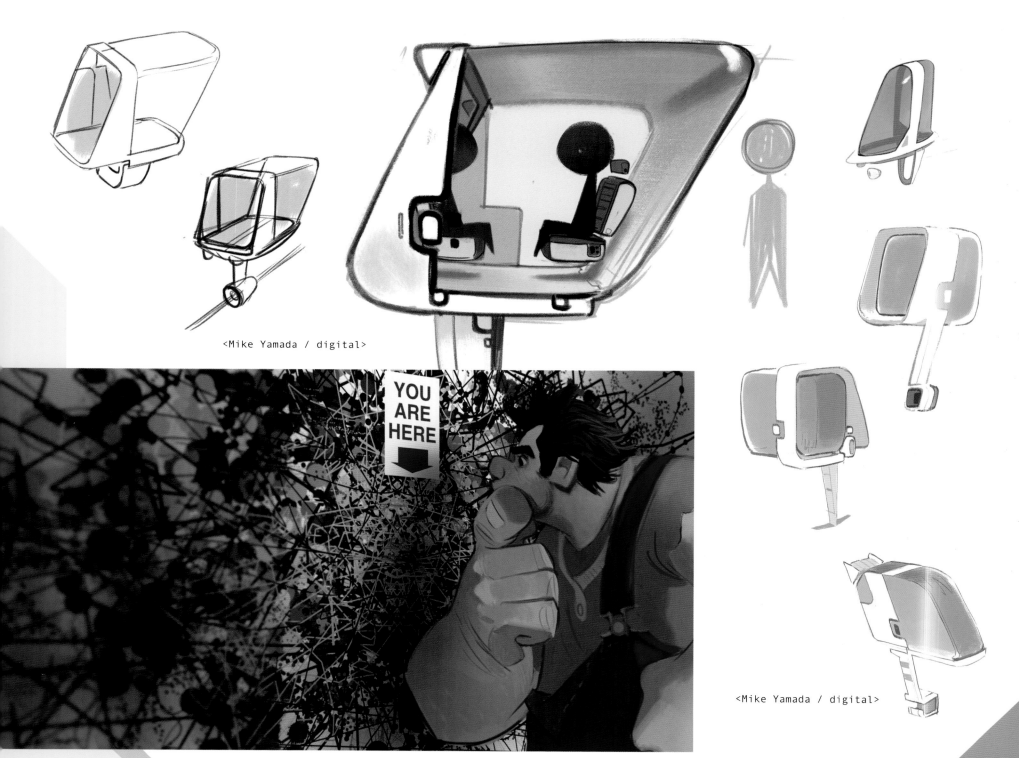

<Mike Yamada / digital>

YOU
ARE
HERE

<Mike Yamada / digital>

<Paul Felix / digital>

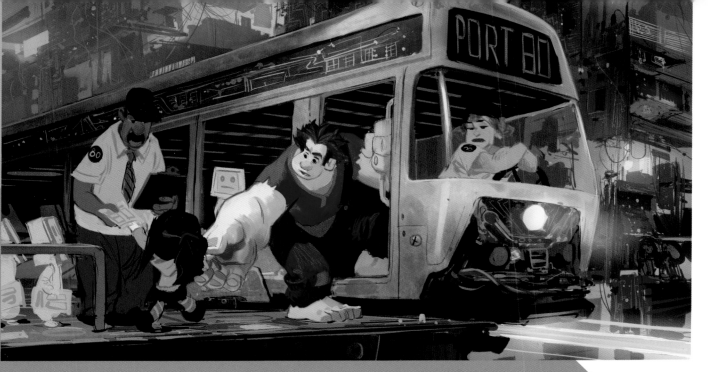

<Paul Felix / digital>

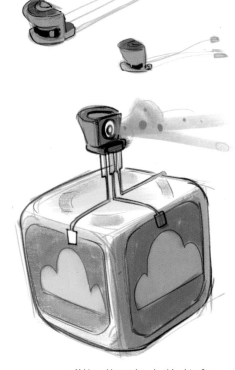

<Mike Yamada / digital>

> **Matthias Lechner** ✔ @ArtDirectorEnvironments
> The traffic lights evoke the maximize, minimize, and close-out buttons at the top left of a window screen.
>
> 💬 9 🔁 13 ♡ 24

<Mike Yamada / digital>

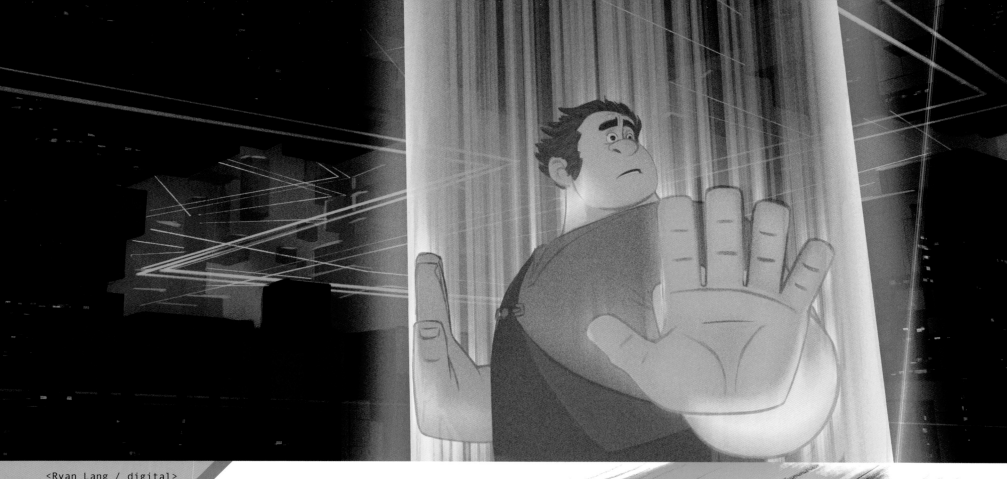

<Ryan Lang / digital>

Cesar Velazquez ✔ @HeadOfVisualEffects

We studied the physics of how data travels
through a power line. Electromagnetic pulses
move electricity like a wave, which we
represented as magnetic rings that propel
data forward along an electromagnetic wave.

💬 14 🔁 22 ♡ 37

<Nicholas Orsi / digital>

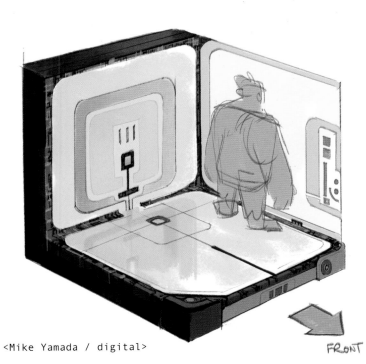

<Mike Yamada / digital>

FRONT

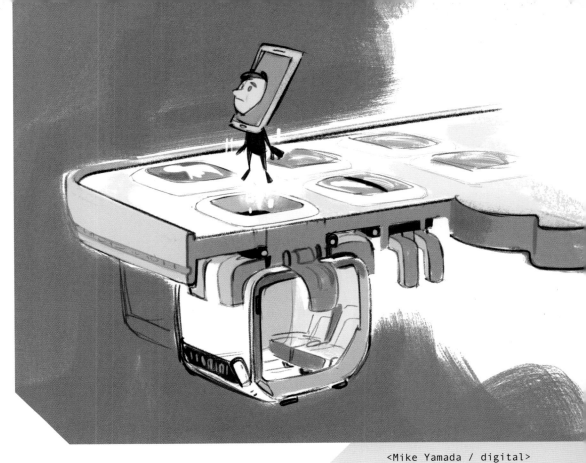

<Mike Yamada / digital>

<Jim Martin / digital>

<Jim Martin / digital>

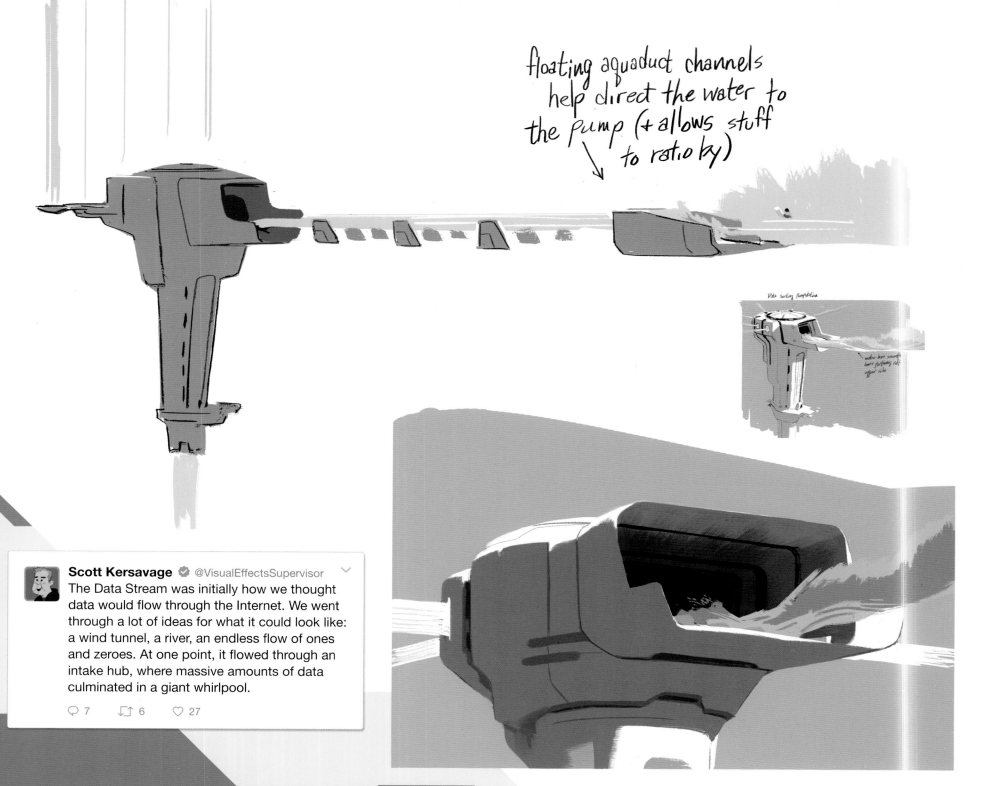

floating aquaduct channels
help direct the water to
the pump (+ allows stuff
to ratio by)

Scott Kersavage ✔ @VisualEffectsSupervisor
The Data Stream was initially how we thought
data would flow through the Internet. We went
through a lot of ideas for what it could look like:
a wind tunnel, a river, an endless flow of ones
and zeroes. At one point, it flowed through an
intake hub, where massive amounts of data
culminated in a giant whirlpool.

💬 7 ↻ 6 ♡ 27

<Kevin Nelson / digital>

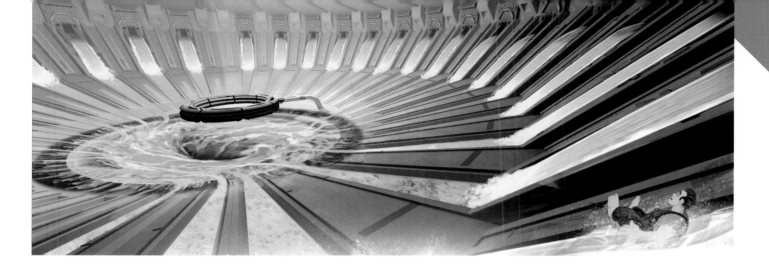

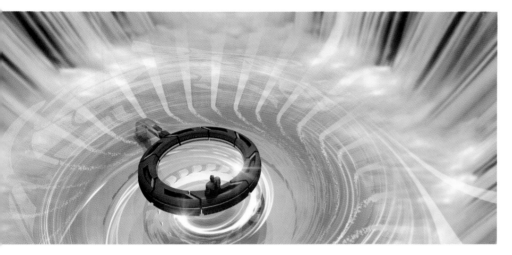

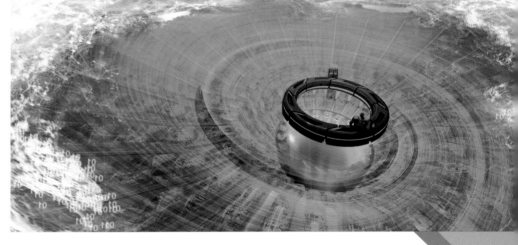

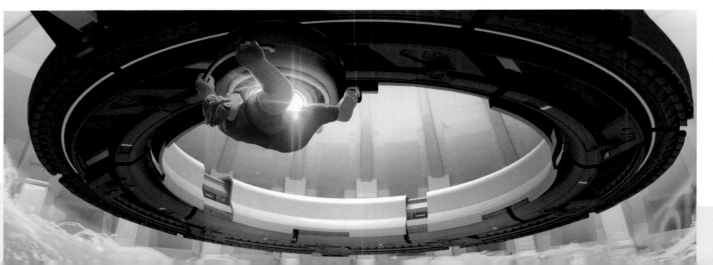

<Jim Martin / digital>

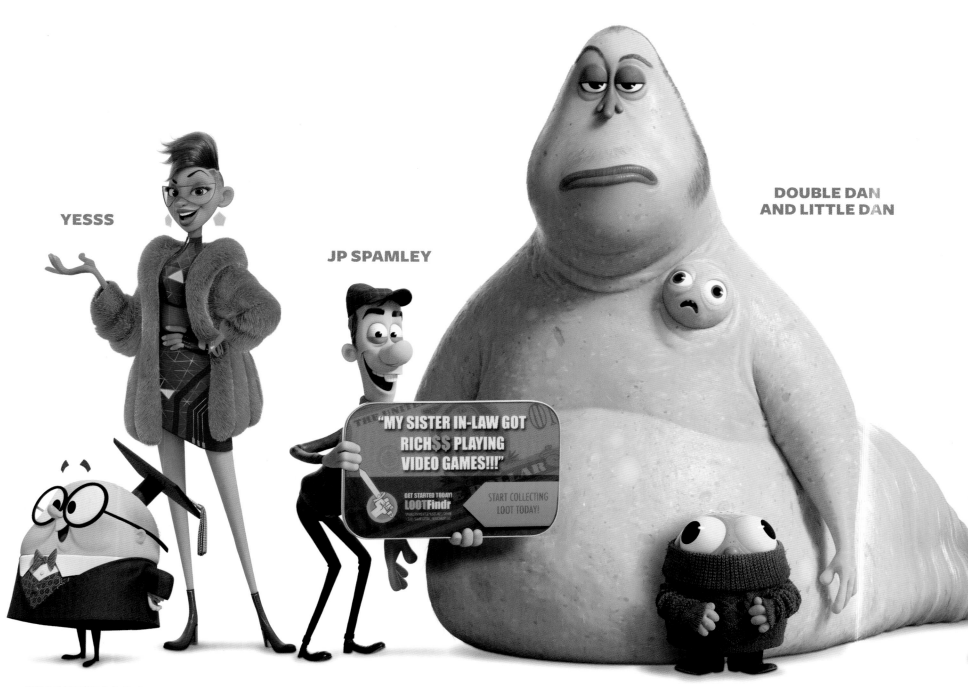

YESSS

JP SPAMLEY

DOUBLE DAN
AND LITTLE DAN

"MY SISTER IN-LAW GOT RICH$$ PLAYING VIDEO GAMES!!!"

GET STARTED TODAY!
LOOTFindr

START COLLECTING
LOOT TODAY!

KNOWSMORE

GORD

NEW FRIENDS

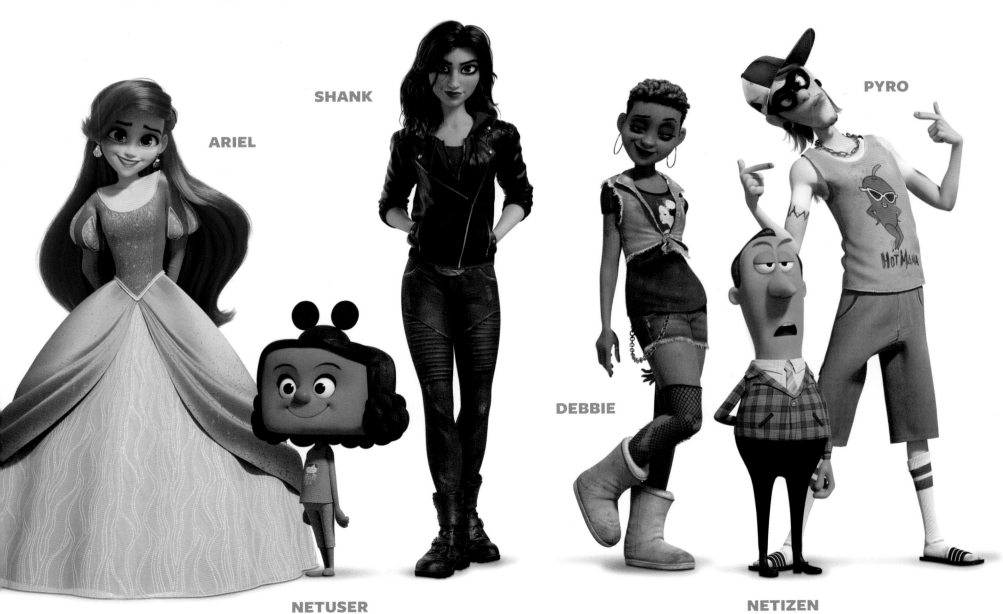

ARIEL

SHANK

NETUSER

DEBBIE

NETIZEN

PYRO

 [−] Jessica Julius Author

Ralph and Vanellope meet a bunch of new characters in the Internet. Tell us about some of the characters you developed.

permalink embed

 [−] Jim Reardon Director of Story

Ralph wants to do the right thing for Vanellope. So he suggests they go to the Internet to find a replacement wheel for her game. But the Internet is overwhelming to Ralph. He's frustrated by the Knowsmore search engine, aggravated at figuring out where to go to find the wheel, excited by the bidding at eBay, but then shocked to realize they have to come up with real money. His ego is boosted by the response to his memes, but he's plunged into despair when he discovers everyone actually hates him and even his best friend wants to leave him. Ralph is on an emotional roller coaster. The characters they meet along the way reinforce all those feelings.

permalink embed parent

 [−] Josie Trinidad Head of Story

Meanwhile Vanellope loves everything about the Internet. Her world is expanding: She's thrilled by the new challenges of Slaughter Race, she finds camaraderie from the princesses who encourage her to know what she wants, and she enjoys Shank's mentorship. Ralph and Vanellope are like two kids from a small town who think life is just great until they go to the big city and see there might be more to life. And Ralph responds by wanting to go back home to how things were, while Vanellope is thrilled by all the new experiences.

permalink embed parent

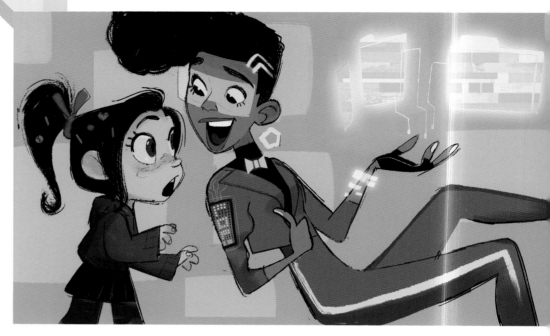

<Ami Thompson / digital>

<Mingjue Helen Chen / digital>
<Pages 78-79: Various Artists / digital>

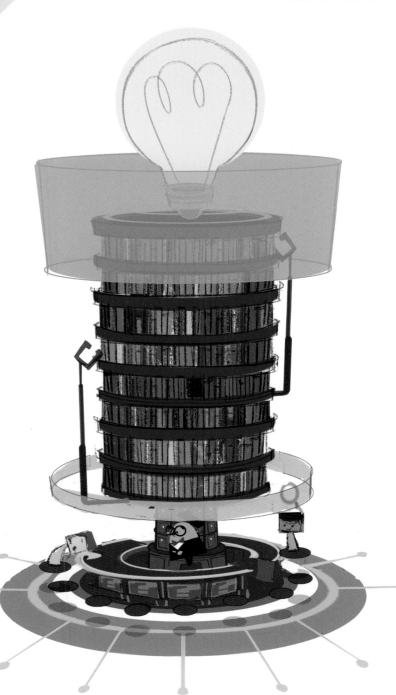

<Justin Cram / digital>

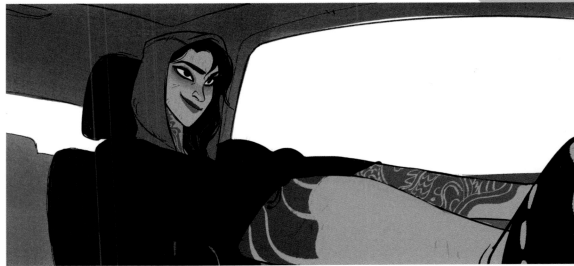

<Ami Thompson / digital>

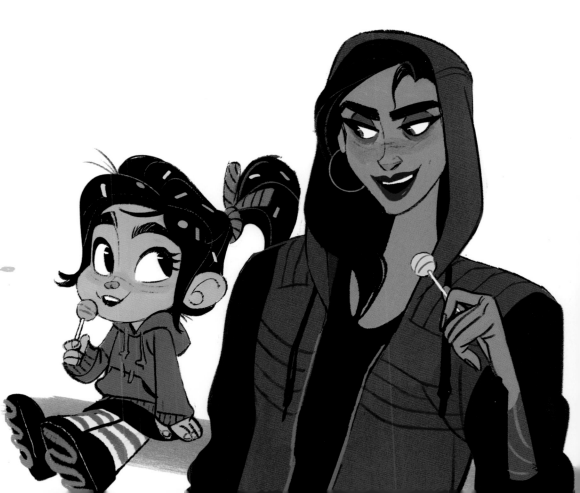

<Ami Thompson / digital>

KNOWSMORE

Ami Thompson, Art Director, Characters

Knowsmore went through many iterations. We drew him as an owl, a lightbulb, a professor. His final form combined those ideas and was inspired by Maurice Noble, M. Sasek, and the flat, graphic UPA style of the 1950s and '60s.

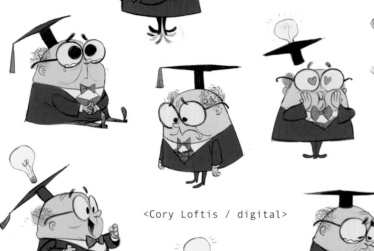

<Cory Loftis / digital>

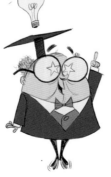

<Ami Thompson / digital>

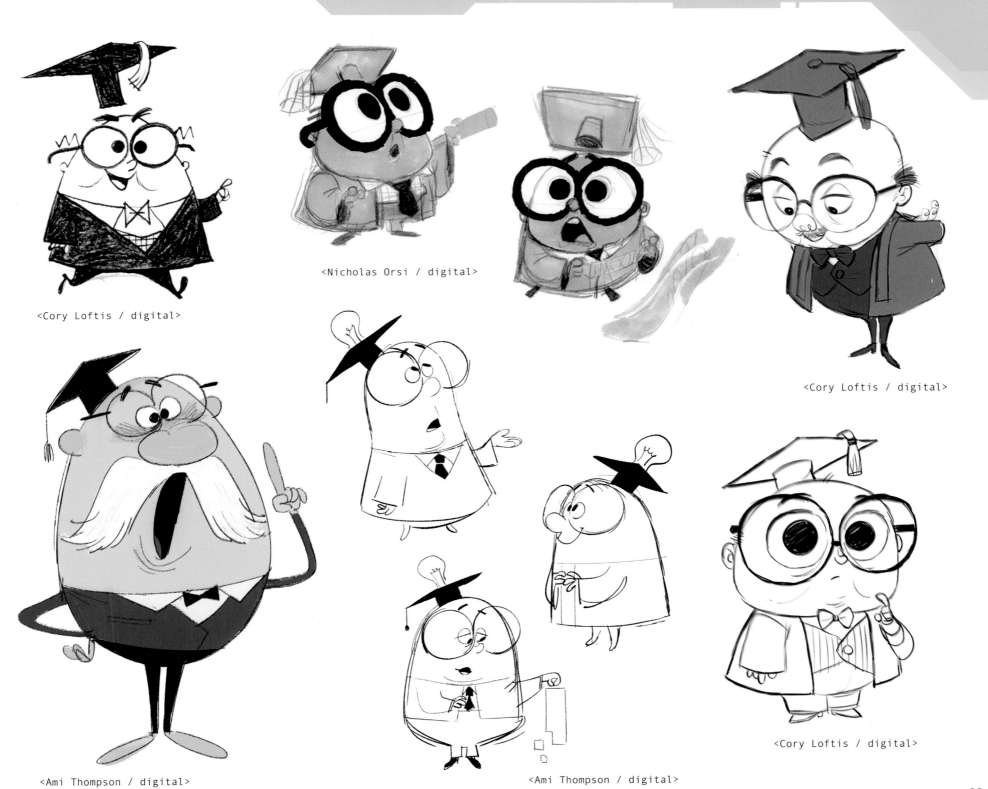

<Cory Loftis / digital>

<Nicholas Orsi / digital>

<Cory Loftis / digital>

<Ami Thompson / digital>

<Ami Thompson / digital>

<Cory Loftis / digital>

>83

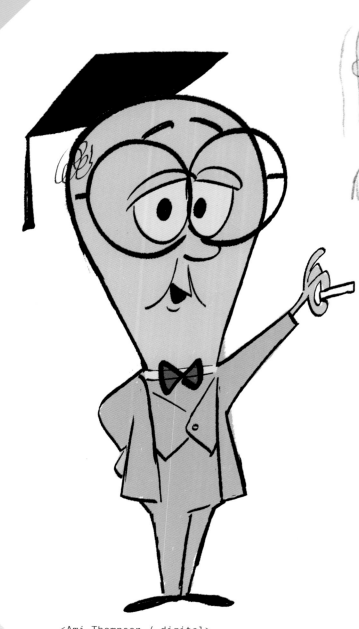

<Ami Thompson / digital>

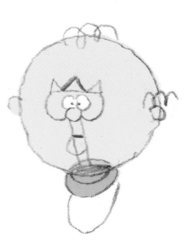

<Nicholas Orsi / digital>

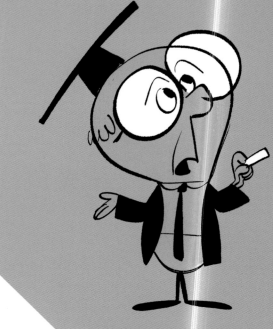

<Ami Thompson / digital>

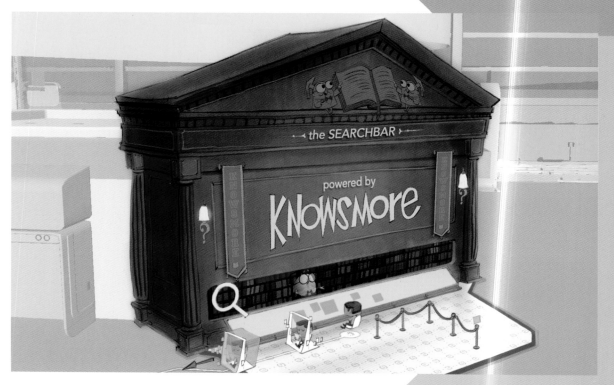

<Cory Loftis / digital>

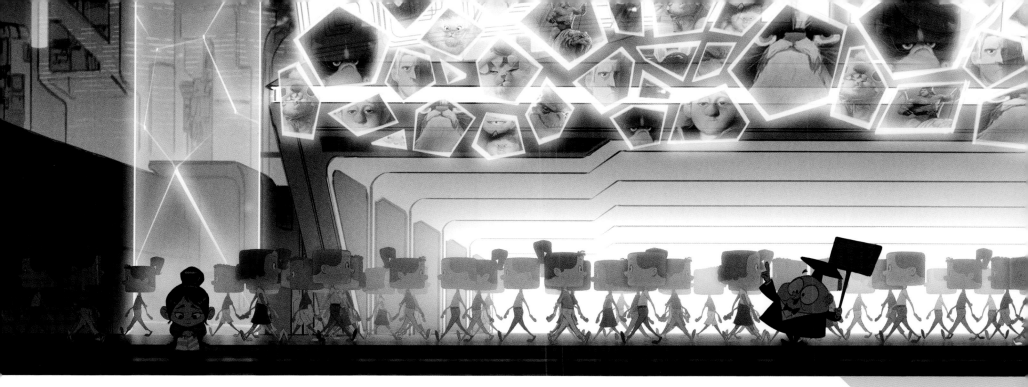

<Ryan Lang / digital>

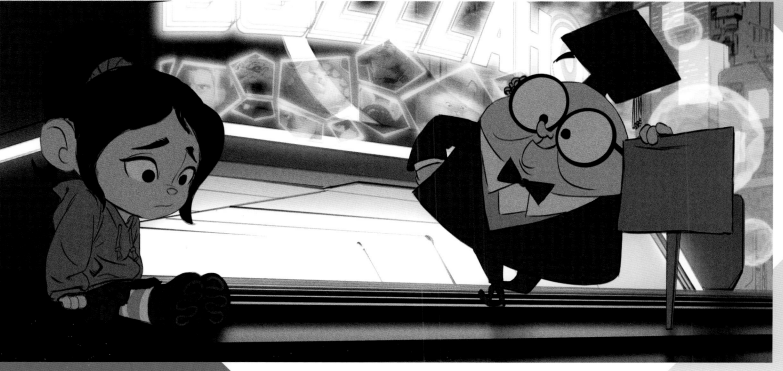

<Ryan Lang / digital>

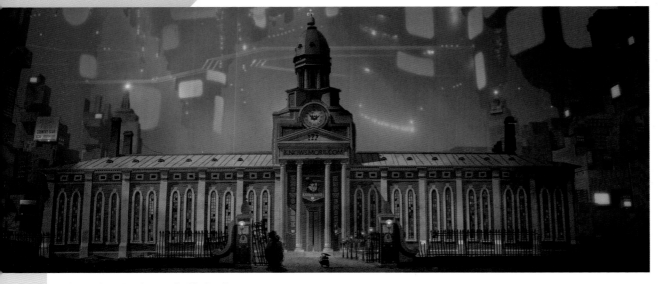

<Matthias Lechner / digital>

<Jim Martin / digital>

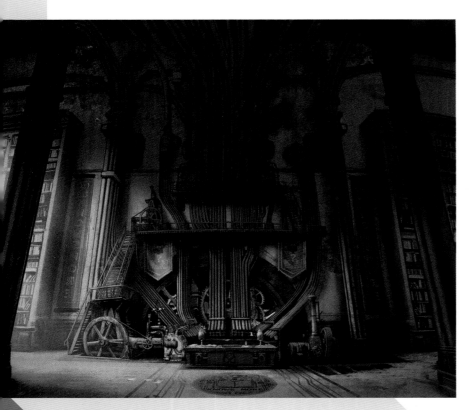

<Mehrdad Isvandi / digital>

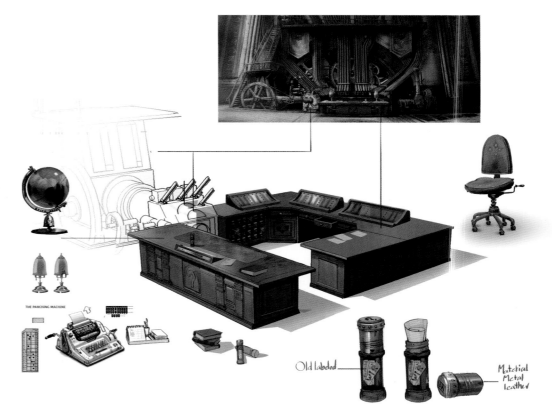

<Mehrdad Isvandi / digital>

<Mehrdad Isvandi / digital>

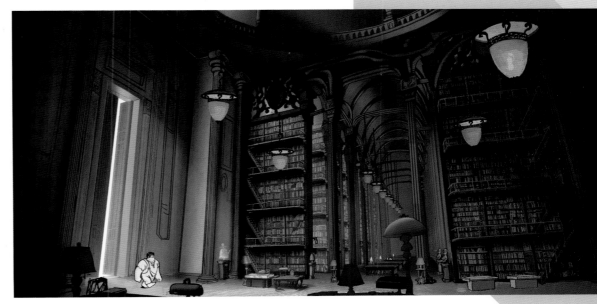

<Mehrdad Isvandi / digital>

Matthias Lechner, Art Director, Environments

Knowsmore.com was initially conceived as an abandoned search engine whose website used to be the biggest on the Internet. It was like a grand college library, with doorways, windows, roof, and interior details that all have a rounded gumdrop shape. Cool, desaturated colors like purple and gold helped emphasize the sad abandoned feeling. In the end it became a booth in the HUB.

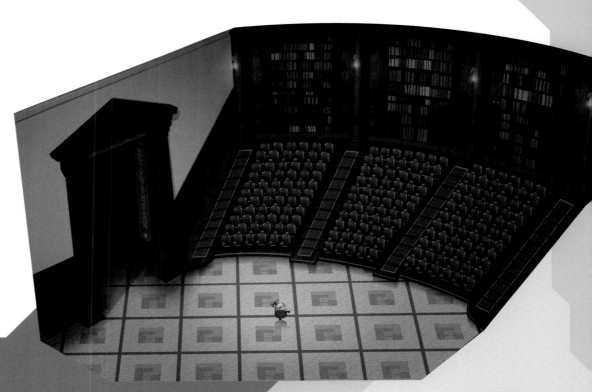

<Justin Cram / digital>

SLAUGHTER RACE

Cory Loftis
Production Designer · 🌐

Slaughter Race is a post-apocalyptic mash-up of inspiration from *Mad Max*, *Grand Theft Auto*, and the *Fast & Furious* movies. It's extreme. It has the most random, wild, dangerous things.

👍 😮 Phil Johnston and 34 others 15 Comments 💀 ▾

👍 Like 💬 Comment ➡ Share

<Scott Watanabe / digital>

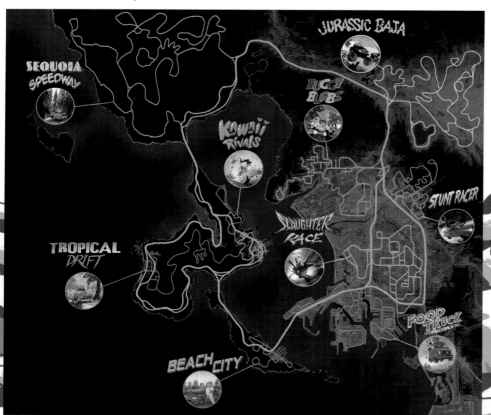

<Ryan Lang / digital>

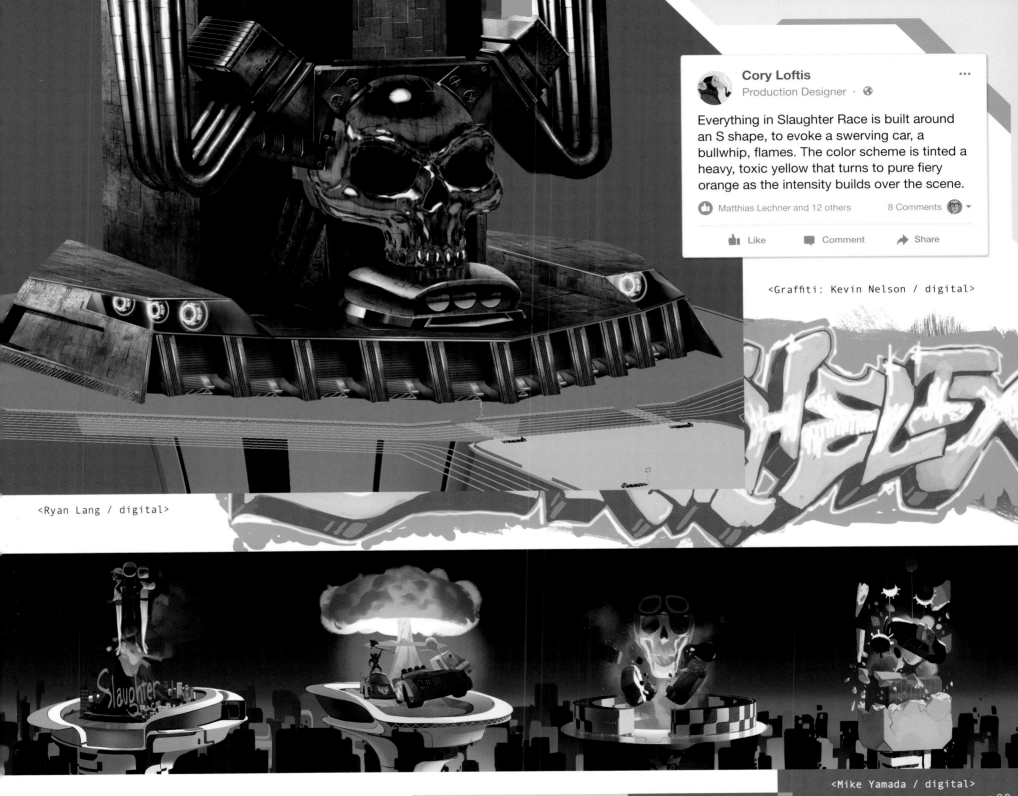

Cory Loftis
Production Designer · 🌐

Everything in Slaughter Race is built around an S shape, to evoke a swerving car, a bullwhip, flames. The color scheme is tinted a heavy, toxic yellow that turns to pure fiery orange as the intensity builds over the scene.

👍 Matthias Lechner and 12 others 8 Comments ▾

👍 Like 💬 Comment ↪ Share

<Graffiti: Kevin Nelson / digital>

<Ryan Lang / digital>

<Mike Yamada / digital>

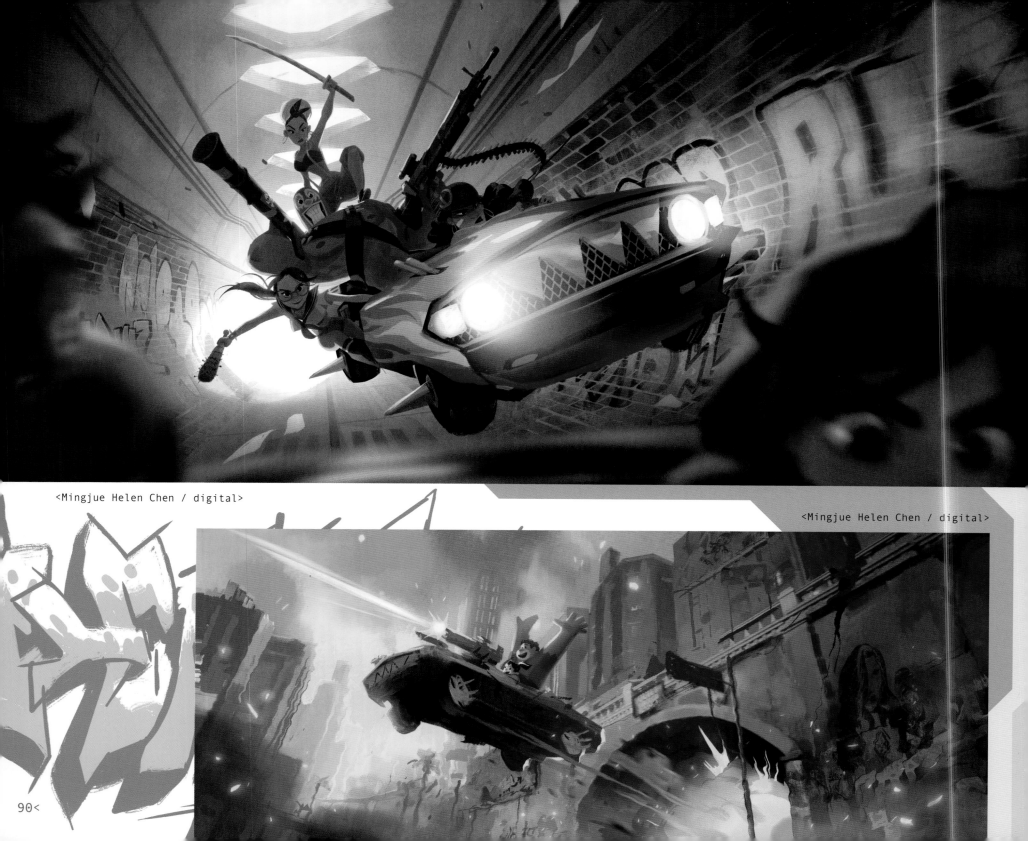

<Mingjue Helen Chen / digital>

<Mingjue Helen Chen / digital>

<Graffiti: Kevin Nelson / digital>

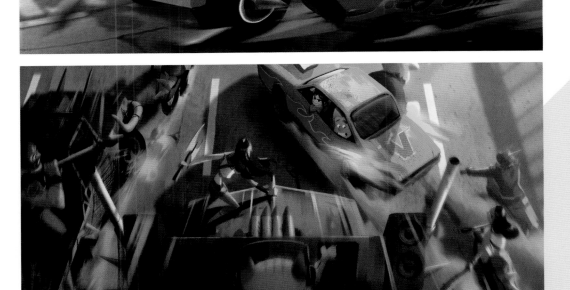

Cesar Velazquez
Head of Visual Effects · 🌐

The effects in Slaughter Race are heavily stylized, graphic and flat with a hand-drawn feeling, almost like a graphic novel. The challenge was to make them look that way even when they were moving.

 Jim Reardon and 17 others 9 Comments

 Like Comment ➤ Share

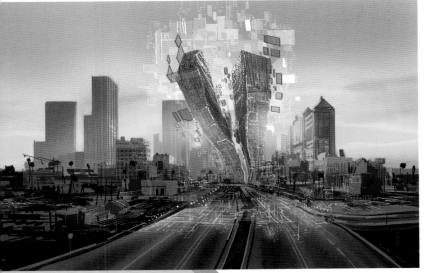

<Paul Felix / digital>

<Mingjue Helen Chen / digital>

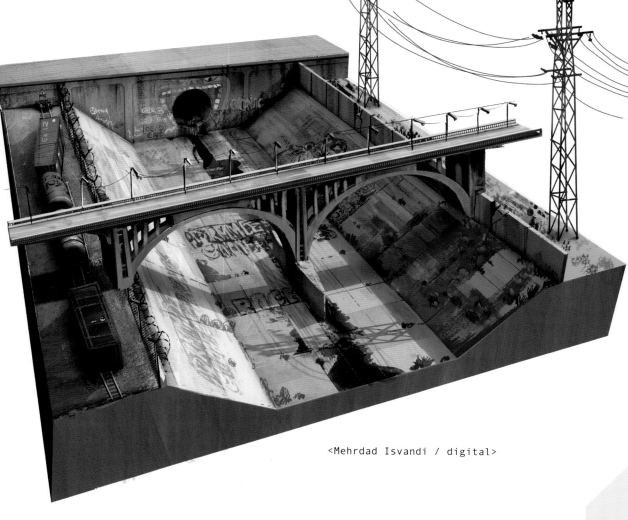

<Mehrdad Isvandi / digital>

<Jim Martin / digital>

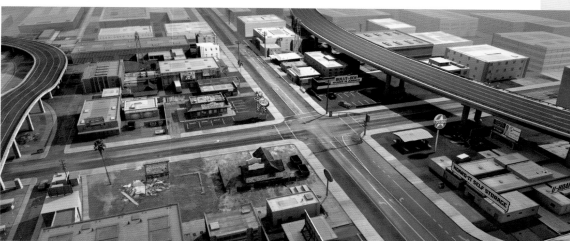

<Jim Martin / digital>

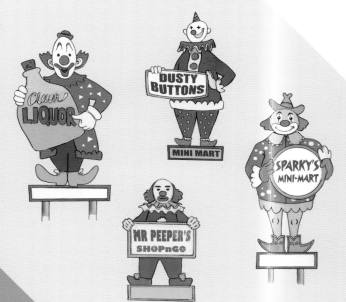

<Jim Martin / digital>

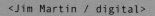

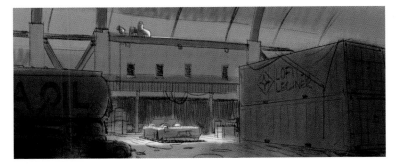

<Mike Yamada / digital>

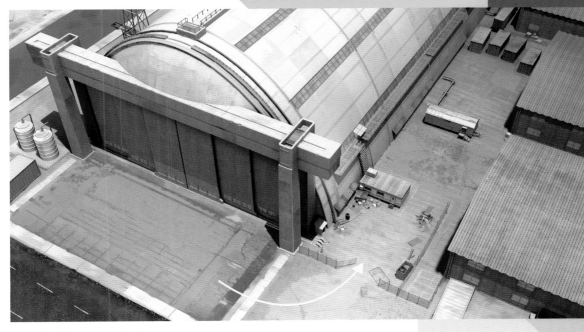

<Jim Martin / digital>

<Jim Martin / digital>

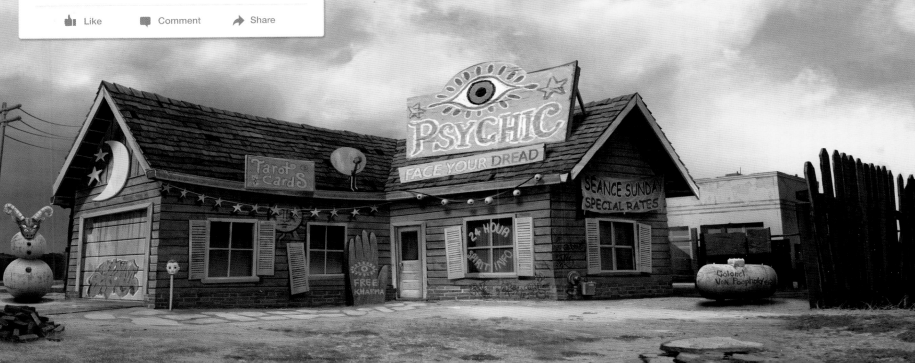

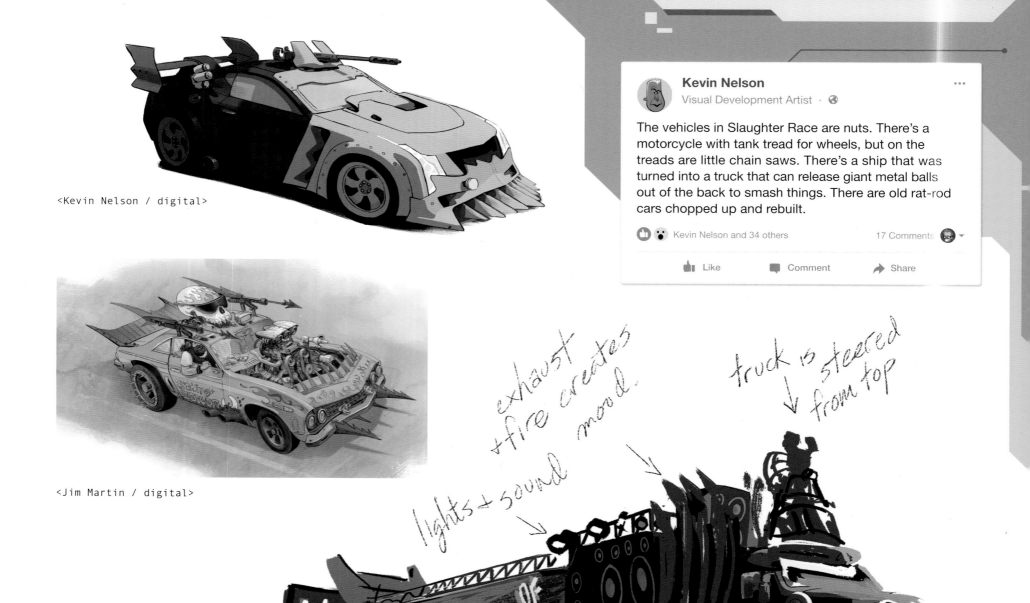

<Kevin Nelson / digital>

<Jim Martin / digital>

exhaust + fire creates mood.

truck is steered from top

lights + sound

<Kevin Nelson / digital>

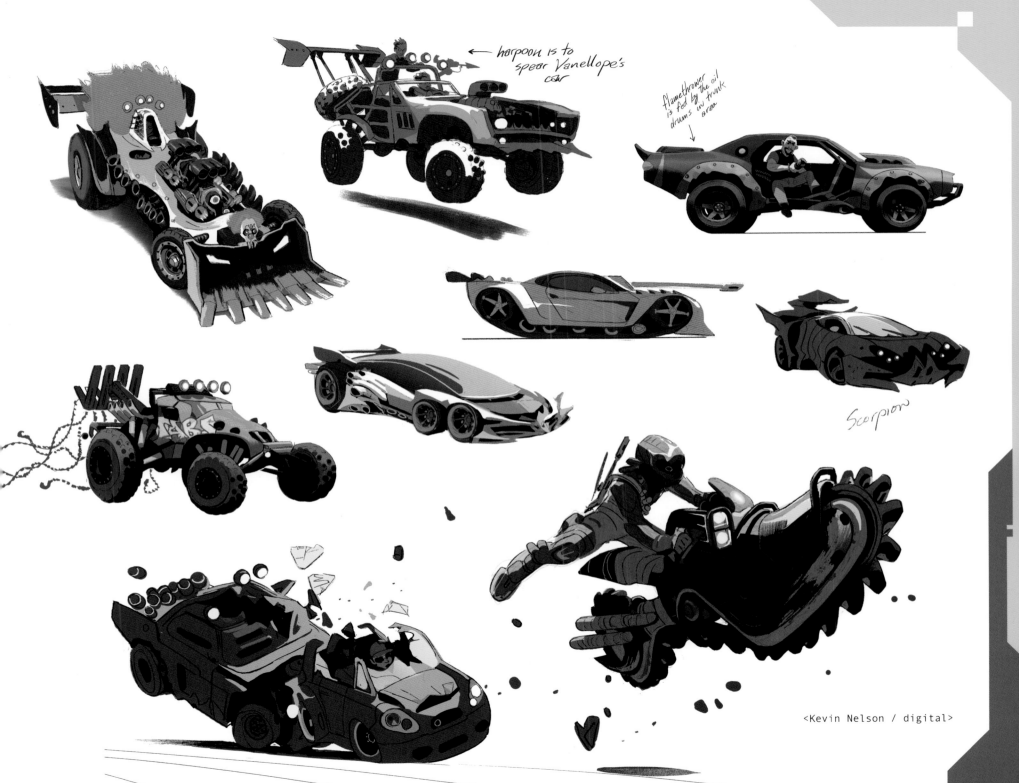

harpoon is to spear Vanellope's car

flamethrower oil is fed by the oil drums in trunk area

Scorpion

<Kevin Nelson / digital>

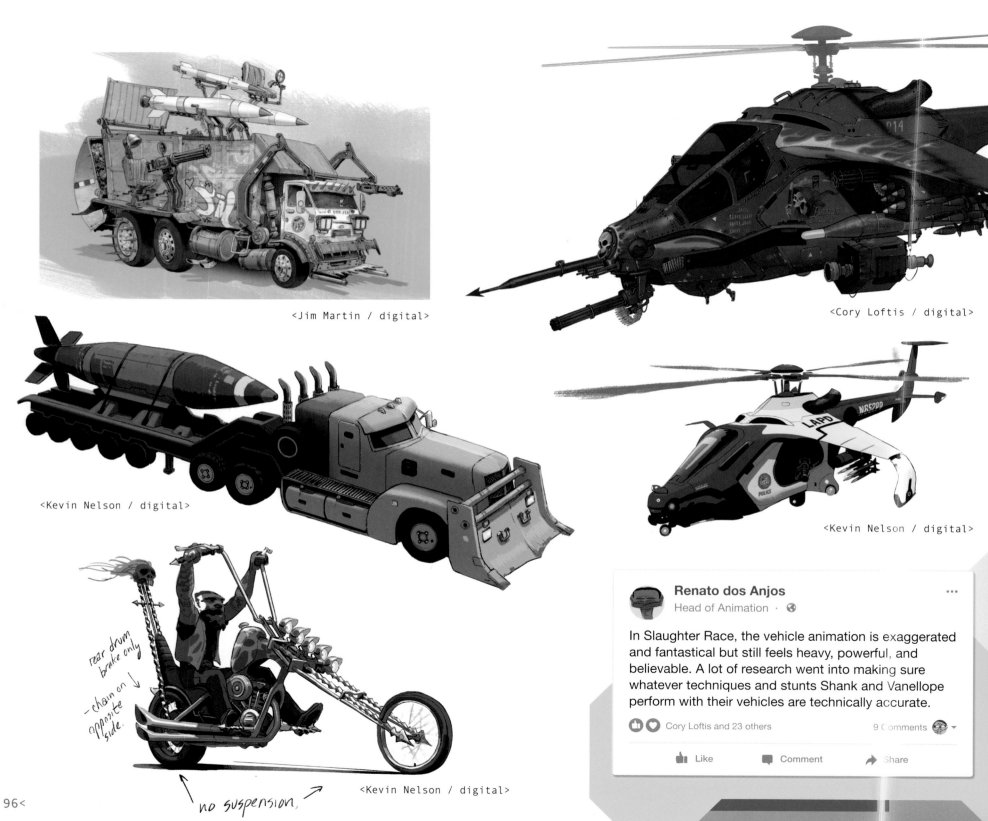

<Jim Martin / digital>

<Cory Loftis / digital>

<Kevin Nelson / digital>

<Kevin Nelson / digital>

rear drum brake only

- chain on opposite side.

no suspension.

<Kevin Nelson / digital>

Renato dos Anjos
Head of Animation · 🌐

In Slaughter Race, the vehicle animation is exaggerated and fantastical but still feels heavy, powerful, and believable. A lot of research went into making sure whatever techniques and stunts Shank and Vanellope perform with their vehicles are technically accurate.

👍❤️ Cory Loftis and 23 others 9 Comments

👍 Like 💬 Comment ➤ Share

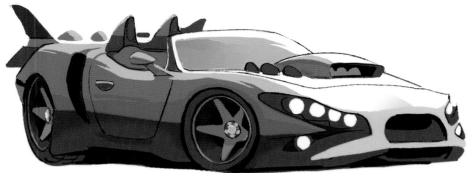

<Kevin Nelson / digital>

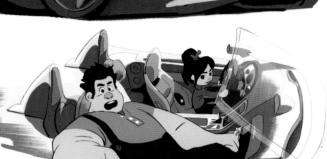

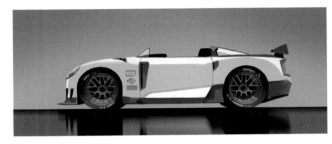

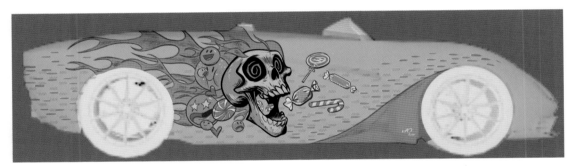

<Cory Loftis / digital>

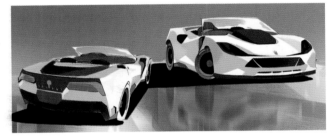

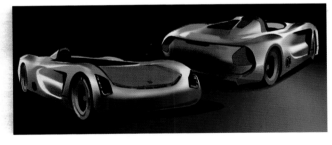

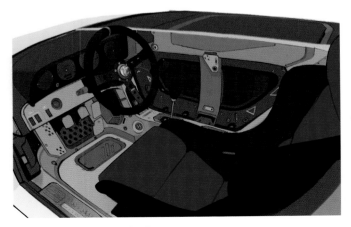

<Mike Yamada / digital>

<Mike Yamada / digital>

SHANK

Jim Reardon, Director of Story

Shank is a tough, take-no-prisoners woman, and she's probably the most evolved character in the film! She tells Vanellope to work things out with Ralph.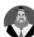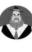

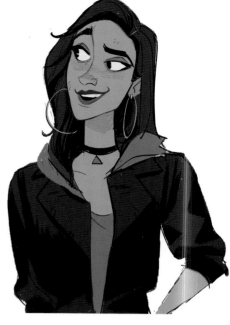

<Ami Thompson / digital>

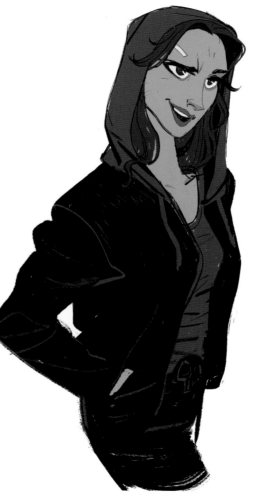

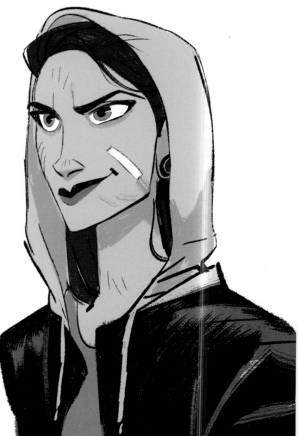

<Ami Thompson / digital>

<Ami Thompson / digital>

<Ami Thompson / digital>

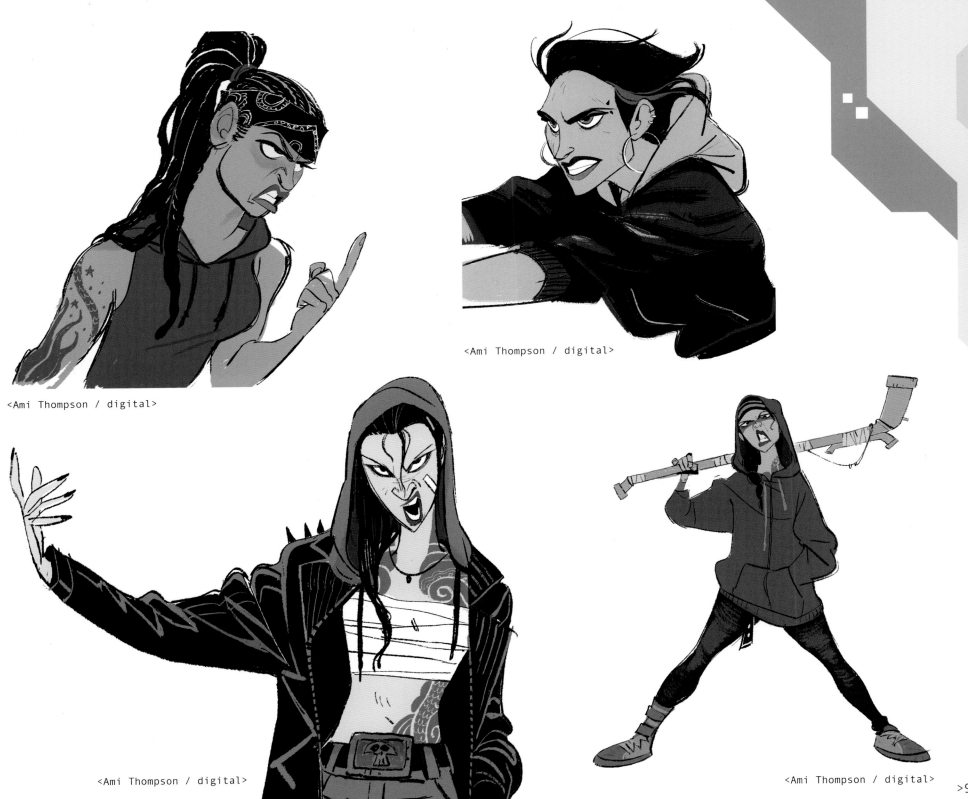

<Ami Thompson / digital>

<Ami Thompson / digital>

<Ami Thompson / digital>

<Ami Thompson / digital>

<Ami Thompson / digital>

Ami Thompson, Art Director, Characters

Shank looks intimidating but Vanellope respects her skills. Shank is all about driving so we designed her to look cool doing that: wind blowing through her hair, her tattoo-covered arm on the wheel.

<Jeff Merghart / digital>

<Ami Thompson / digital>

<Ami Thompson / digital>

<Ami Thompson / digital>

<Jeff Merghart / digital>

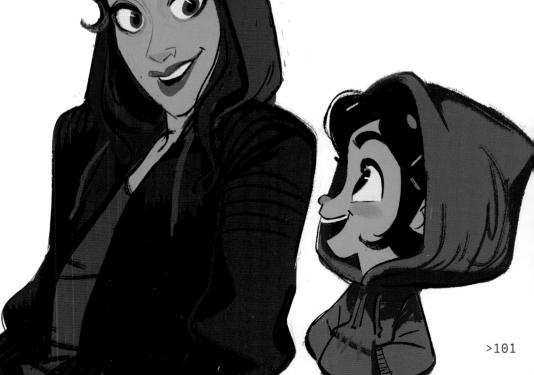

<Ami Thompson / digital>

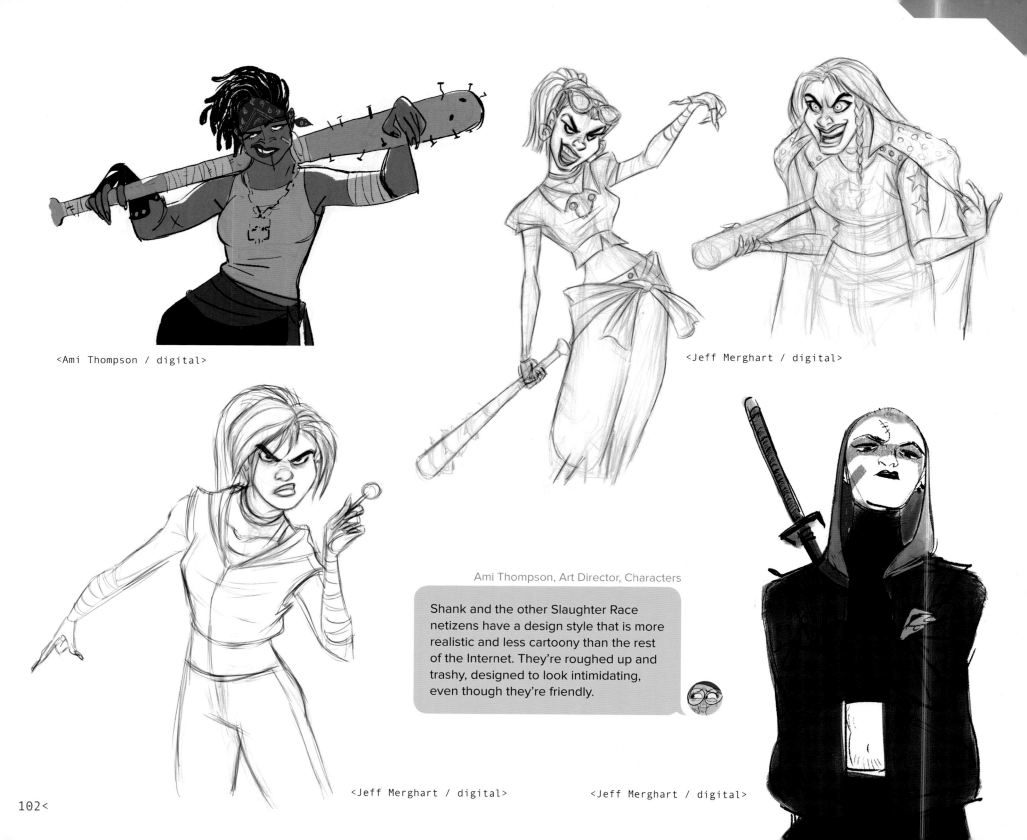

<Ami Thompson / digital>

<Jeff Merghart / digital>

Ami Thompson, Art Director, Characters

Shank and the other Slaughter Race netizens have a design style that is more realistic and less cartoony than the rest of the Internet. They're roughed up and trashy, designed to look intimidating, even though they're friendly.

<Jeff Merghart / digital>

<Jeff Merghart / digital>

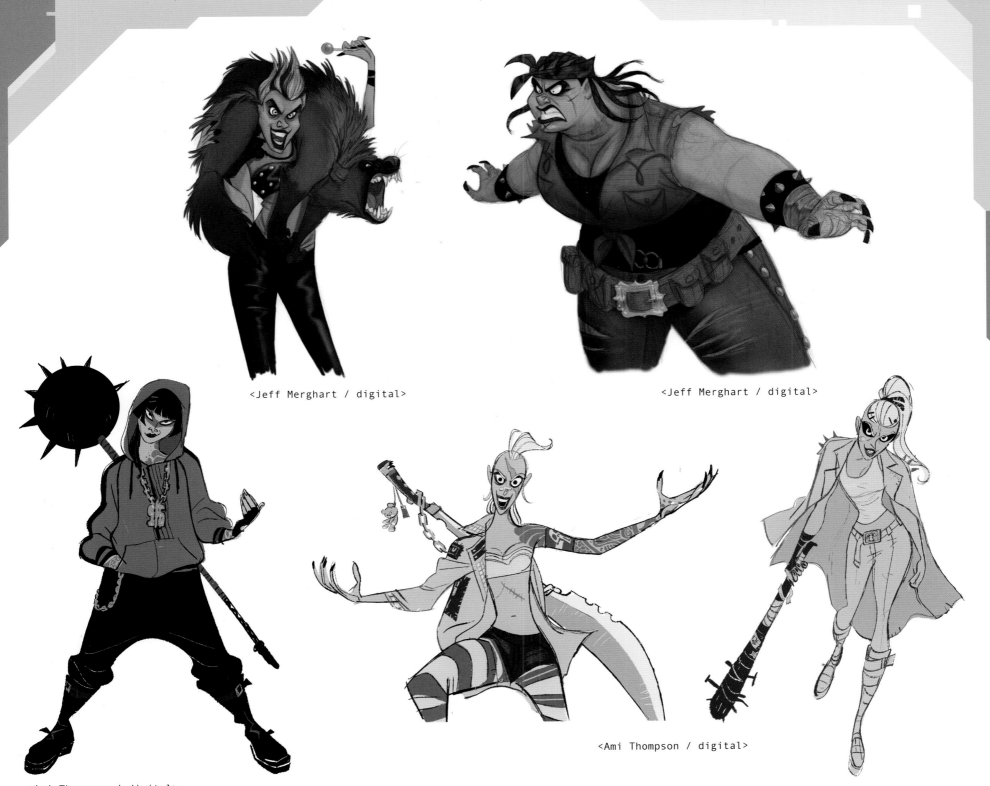

<Jeff Merghart / digital>

<Jeff Merghart / digital>

<Ami Thompson / digital>

<Ami Thompson / digital>

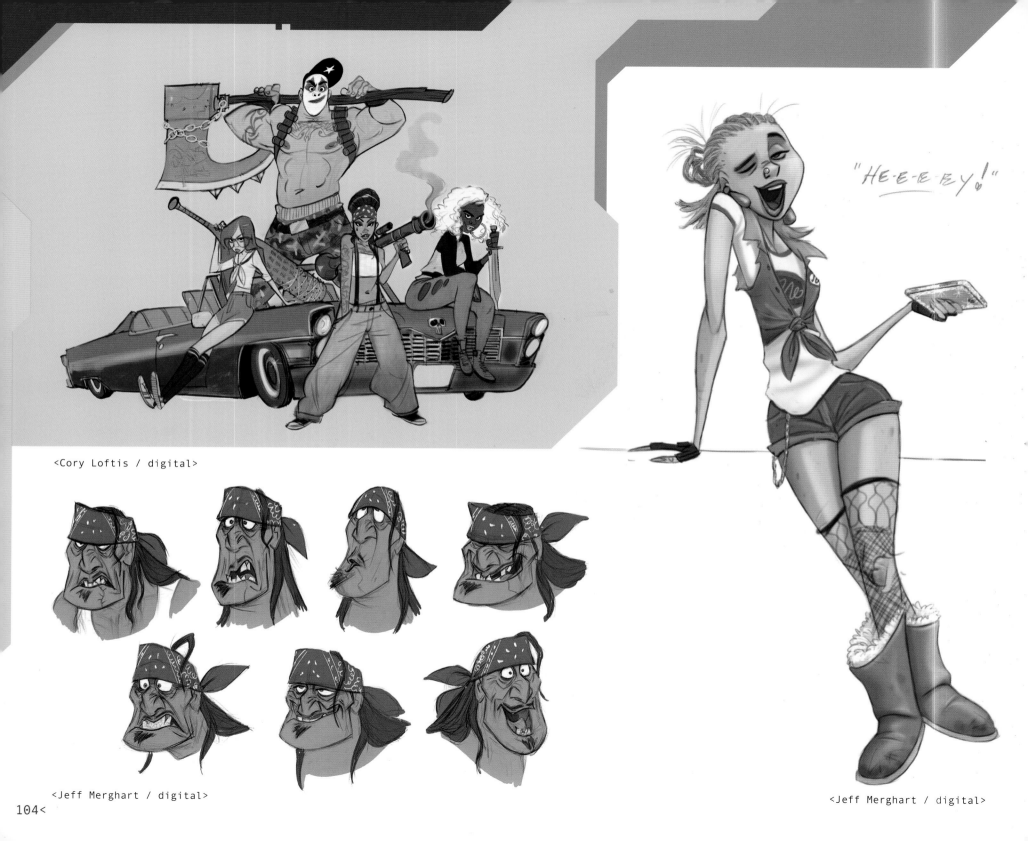

<Cory Loftis / digital>

"HE·E·E·EY♥!"

<Jeff Merghart / digital>

<Jeff Merghart / digital>

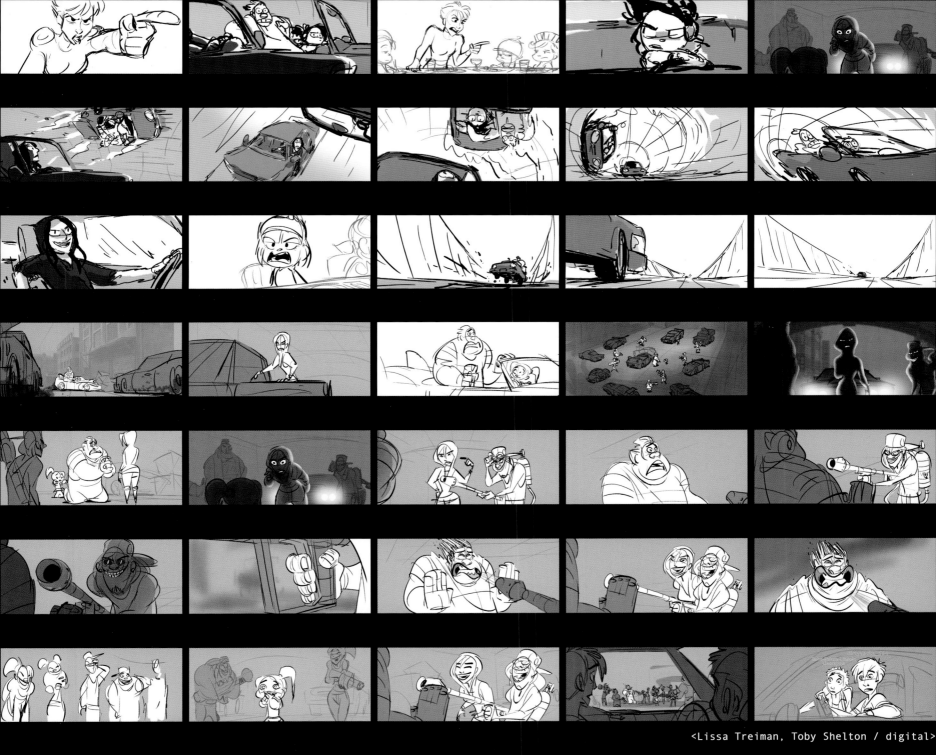

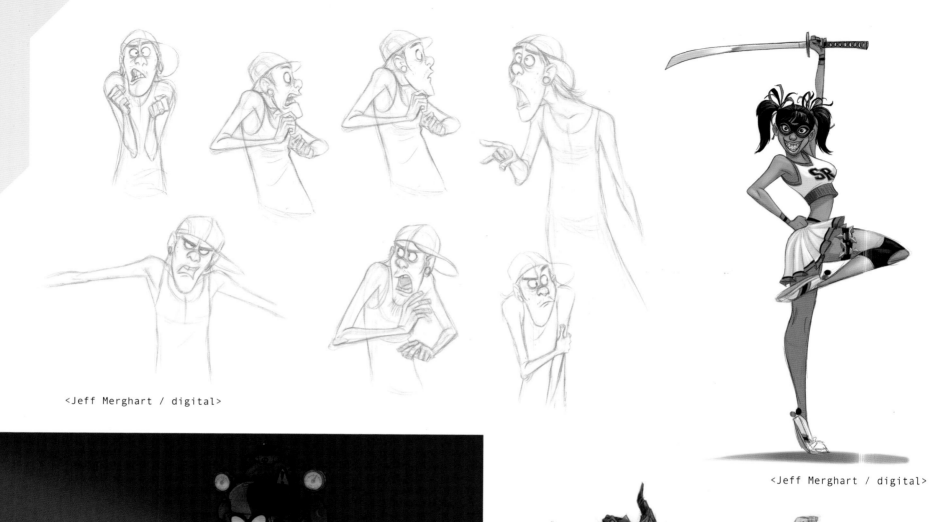

<Jeff Merghart / digital>

<Jeff Merghart / digital>

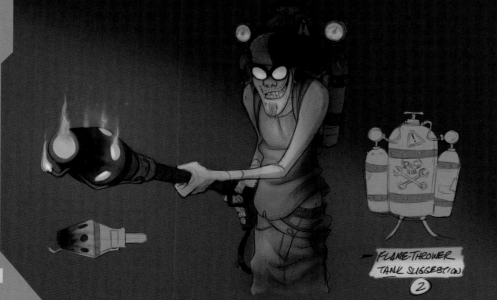

FLAME-THROWER
TANK SUGGESTION
②

<Jeff Merghart / digital>

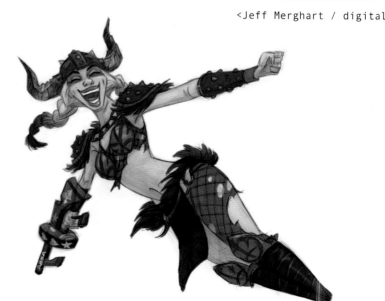

<Jeff Merghart / digital>

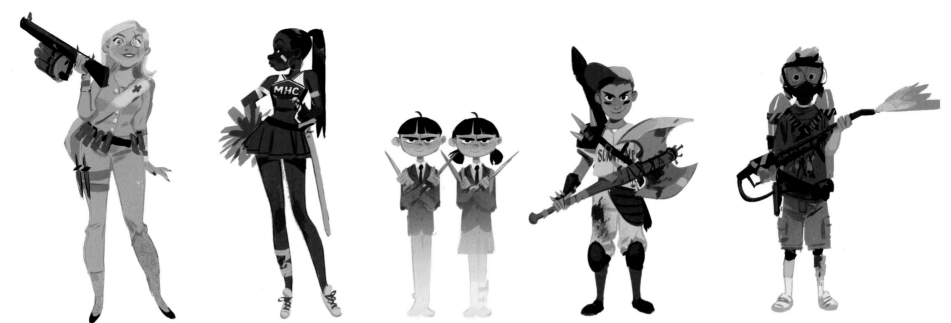

<Mingjue Helen Chen / digital>

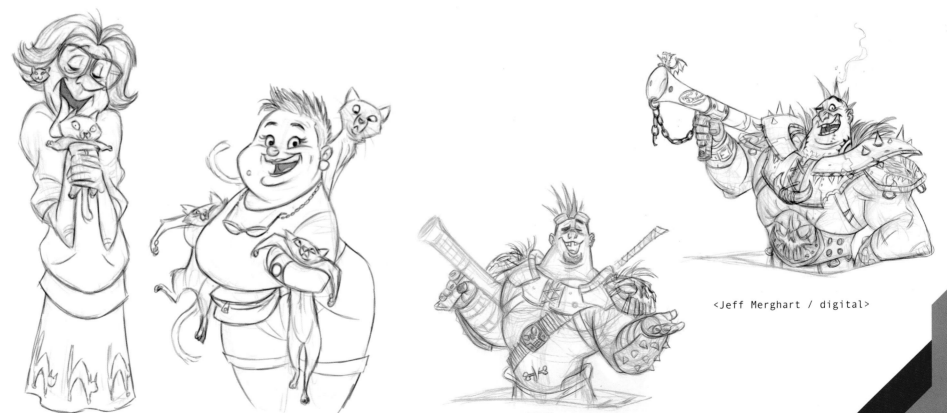

<Jeff Merghart / digital>

<Jeff Merghart / digital>

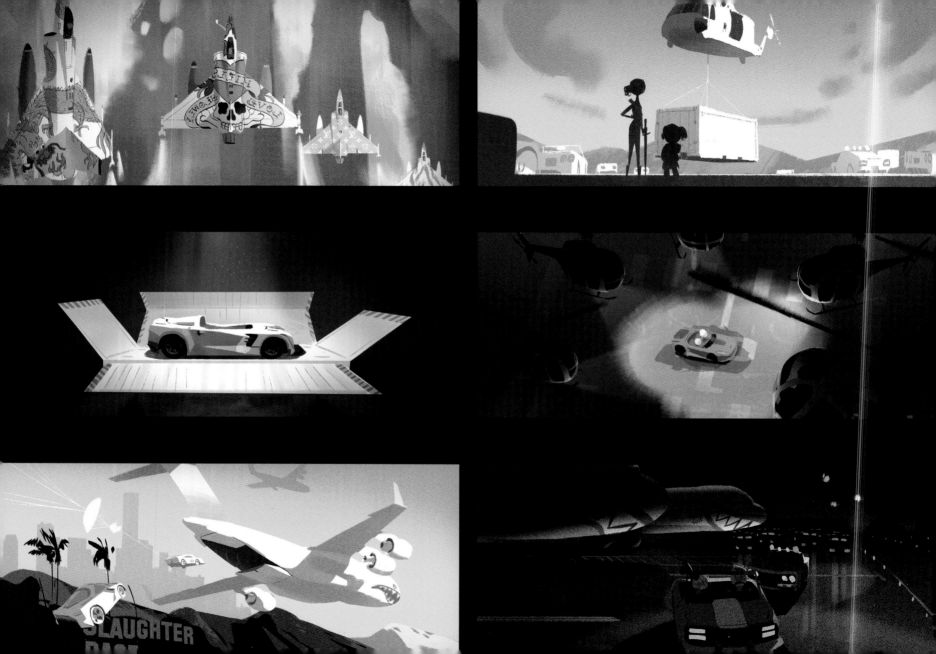

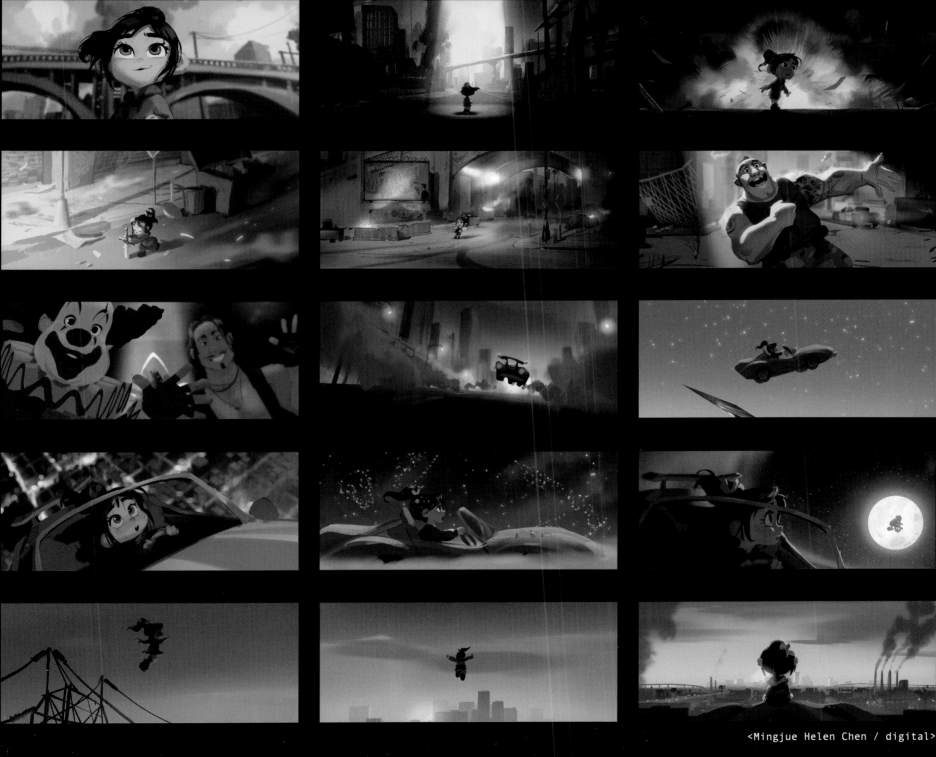

<Mingjue Helen Chen / digital>

BUZZZTUBE

Cory Loftis ✔ @ProductionDesigner

BuzzzTube is the most modern, hip website on the Internet, the ultimate social experiment, a fashion show and nightclub in one. Its aesthetic is all flash and theatrics. The site is connected to the relentless, enormous feed of Internet content and countless screens dominate the space from floor to ceiling, displaying the hottest Internet memes and videos. Users rate the content, voting it up or down, and when something is up-voted it rises to a higher floor of the site. The most popular content is given a place of honor, a VIP room reserved for pieces of media receiving one billion hearts.

💬 15 ↻ 6 ♡ 38

<Mingjue Helen Chen / paintover>

<Mike Yamada / digital>

<Mike Yamada / digital>

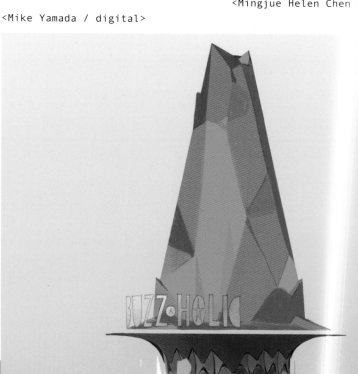

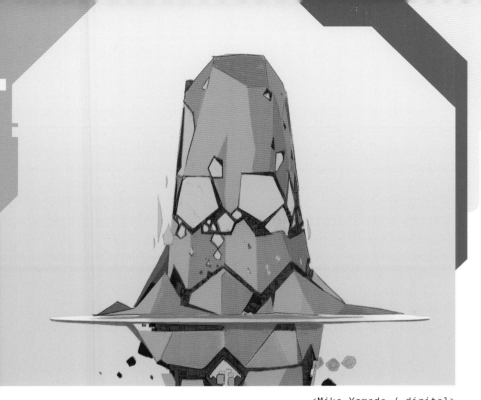

<Mike Yamada / digital>

<Mike Yamada / digital>

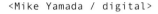

<Mike Yamada / digital>

Mike Yamada ✔ @VisualDevelopmentArtist

BuzzzTube is comprised of long curves mixed with pentagons and hexagons. The exterior is a deconstructed cube language with disconnected yet flowing surfaces. While designing it, I folded and crumpled paper, photographed it, drew over the photos, all while trying to create a structure that physically could not be built in the real world.

💬 8 🔁 14 ♡ 40

BUZZAHOLIC

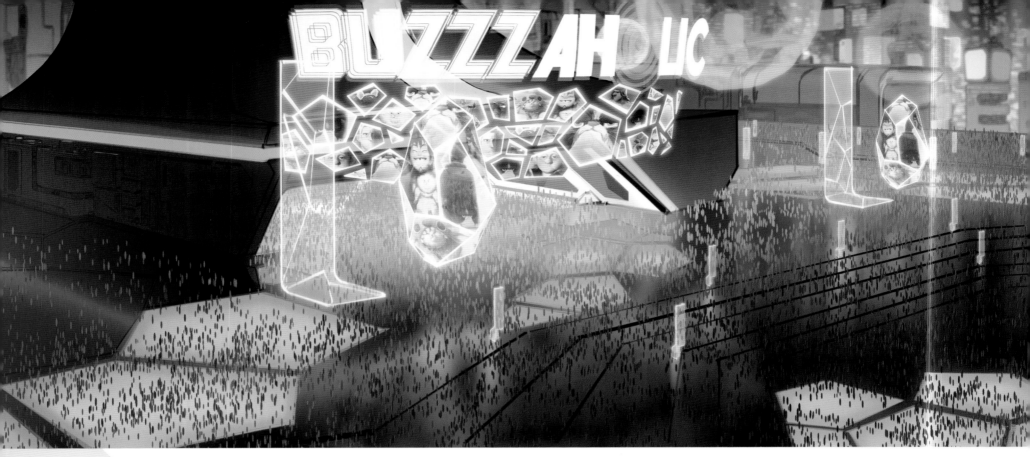

<Ryan Lang / digital>

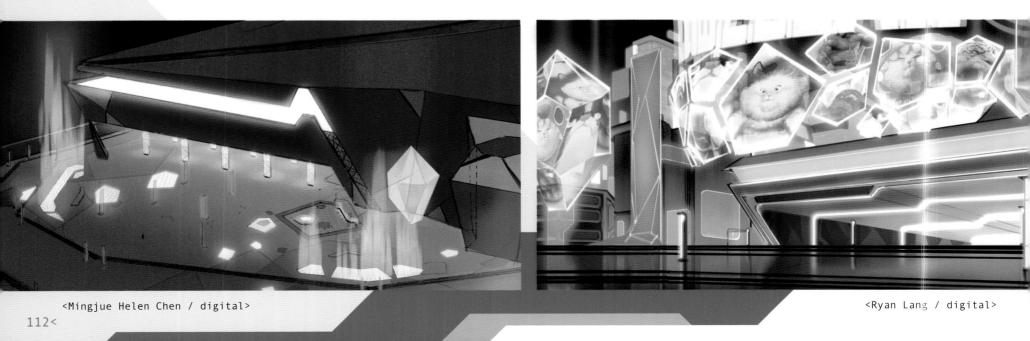

<Mingjue Helen Chen / digital>

<Ryan Lang / digital>

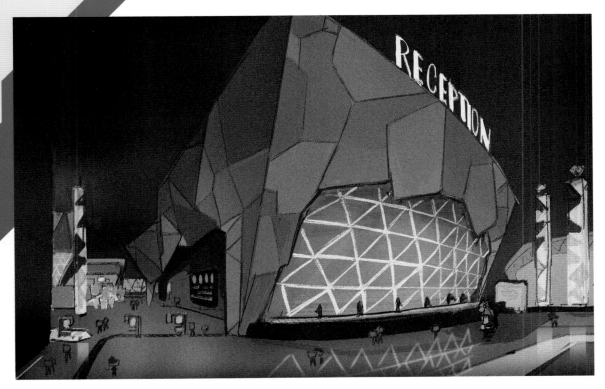

<Scott Watanabe / digital>

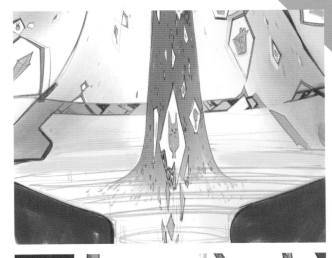

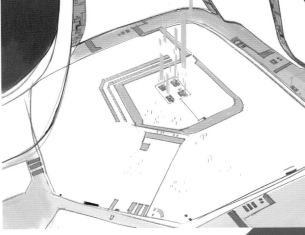

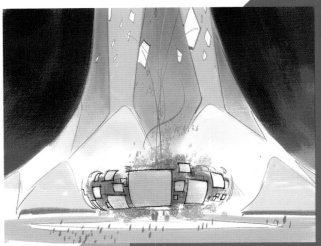

<Scott Watanabe / digital>

<Mike Yamada / digital>

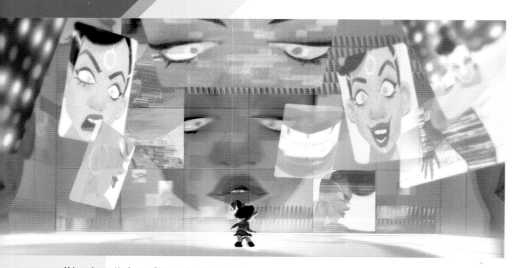

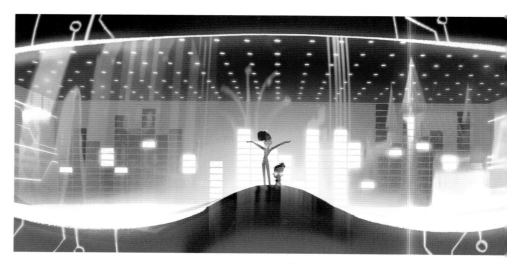

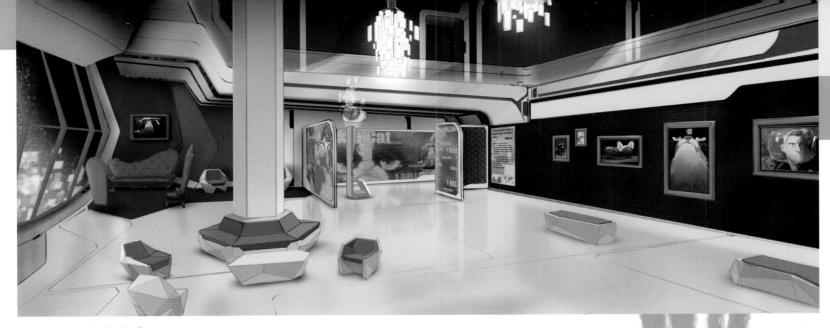

<Ryan Lang / digital>

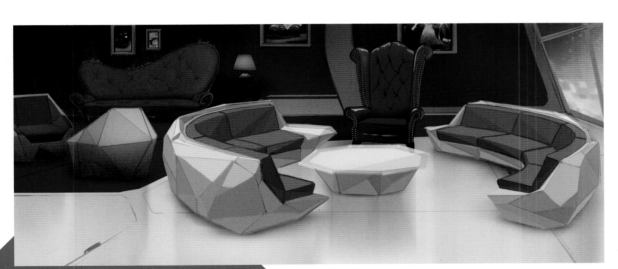

<Ryan Lang / digital>

Ami Thompson ✔ @ArtDirector_Characters
BuzzzTube's color scheme is all magentas, reds, and purples with pops of blue in the characters. It's like the lighting at a concert.

💬 7 🔁 5 ♡ 23

<Mike Yamada / digital>

YESSS

Phil Johnston
Director · 🌐

...

There were many iterations of Yesss as a character. We originally conceived her as a netizen in another game who was like a cool older sister to Vanellope. As the story evolved, we tried her as a trendsetting influencer, which morphed into a version of her as a curator of the coolest stuff on the Internet. That evolved even further into a younger version of her as the most up-to-date responder to what's trending. In the end, we made Yess more like Ralph's manager: she's running a business, focused on BuzzzTube's brand.

👍❤️ Ami Thompson and 36 others 18 Comments ▾

👍 Like 💬 Comment ➤ Share

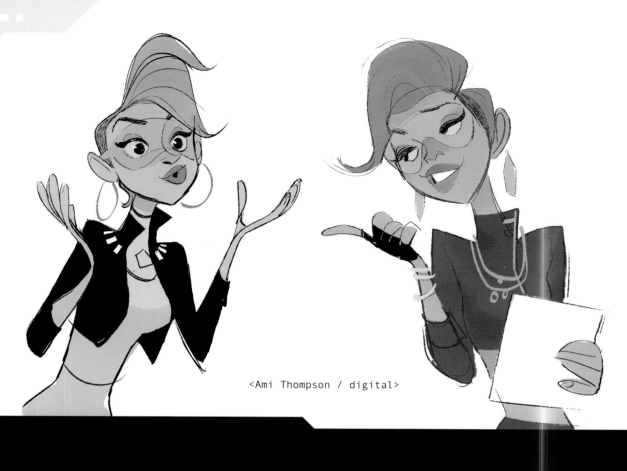

<Ami Thompson / digital>

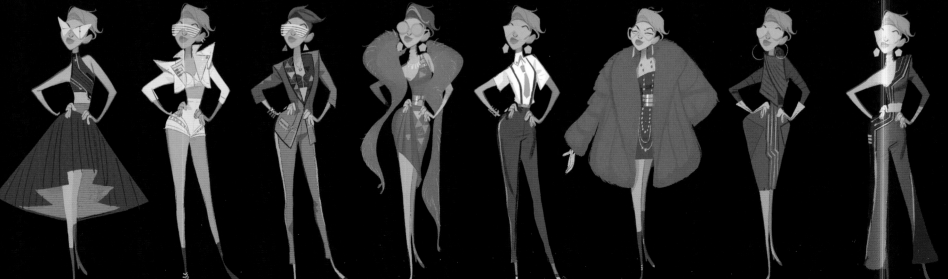

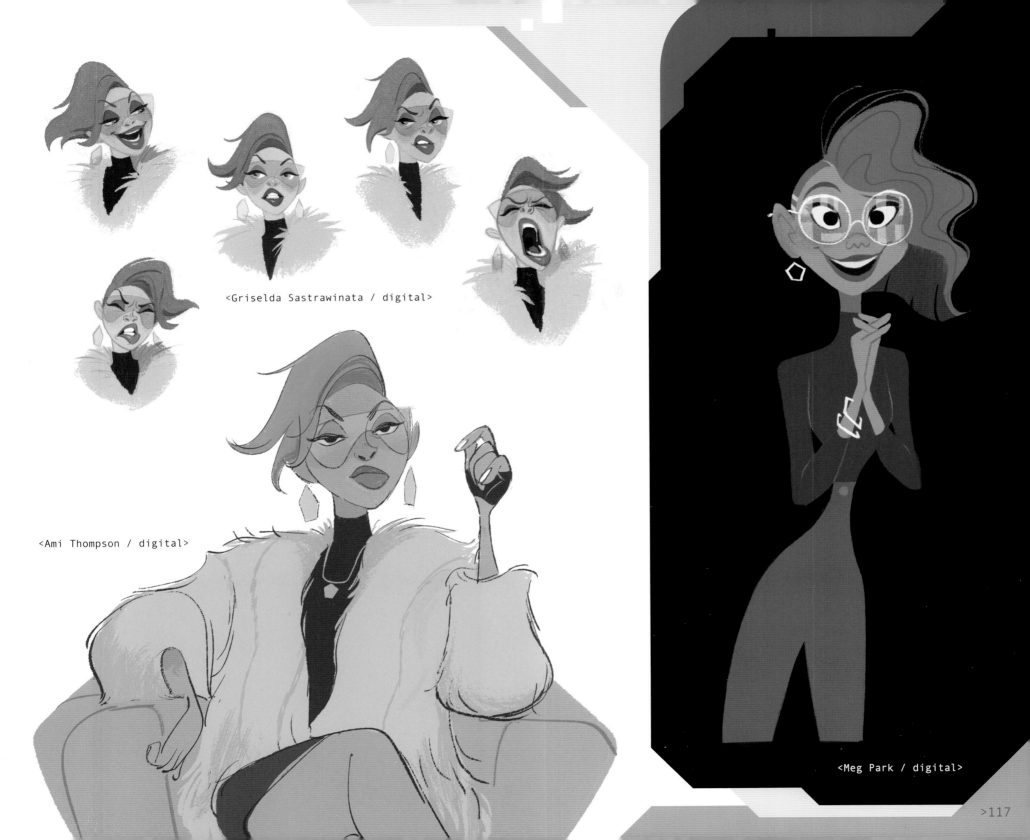

<Griselda Sastrawinata / digital>

<Ami Thompson / digital>

<Meg Park / digital>

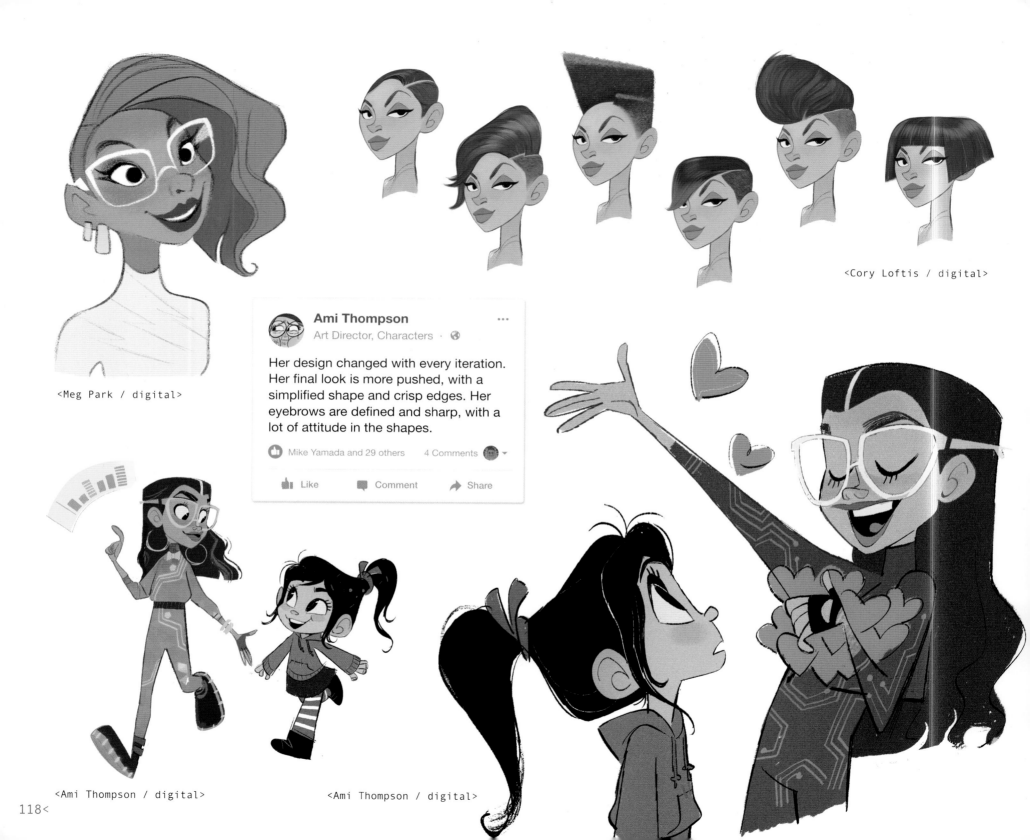

<Cory Loftis / digital>

<Meg Park / digital>

Ami Thompson
Art Director, Characters · 🌐

Her design changed with every iteration. Her final look is more pushed, with a simplified shape and crisp edges. Her eyebrows are defined and sharp, with a lot of attitude in the shapes.

👍 Mike Yamada and 29 others 4 Comments

👍 Like 💬 Comment ➤ Share

<Ami Thompson / digital>

<Ami Thompson / digital>

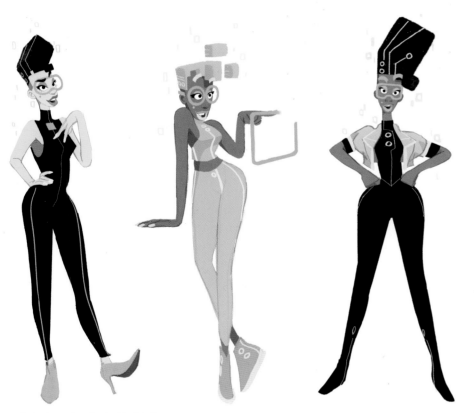

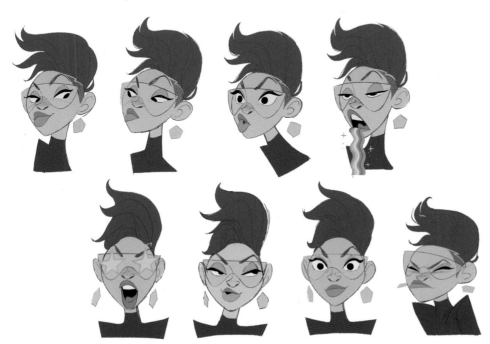

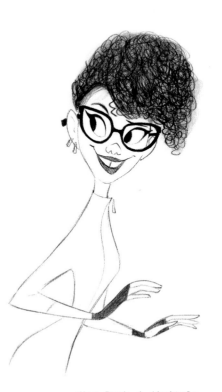

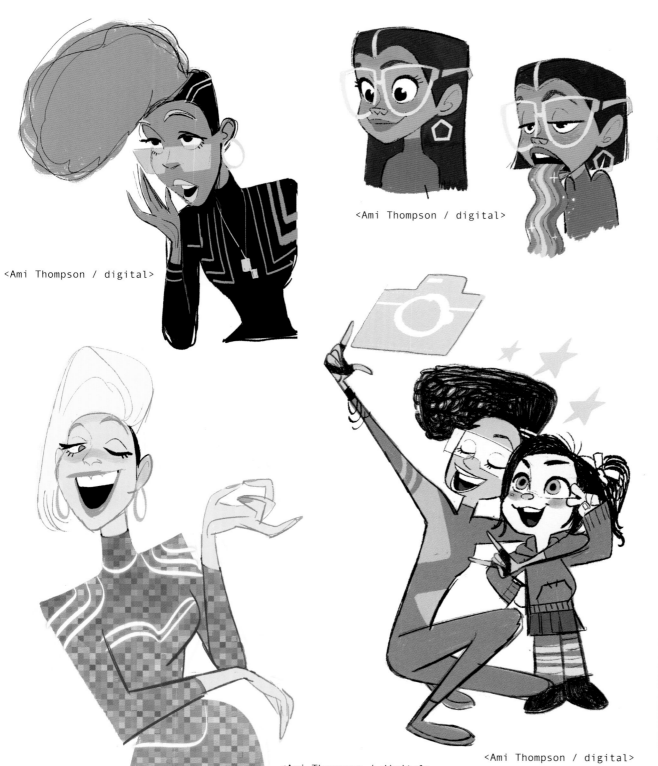

<Ami Thompson / digital>

<Ami Thompson / digital>

<Ami Thompson / digital>

<Ami Thompson / digital>

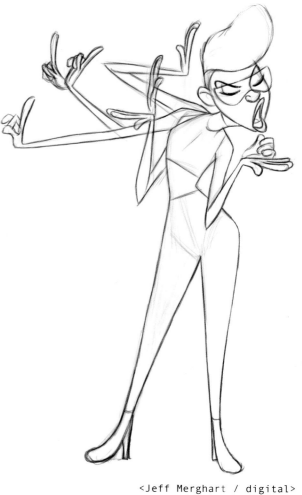

<Jeff Merghart / digital>

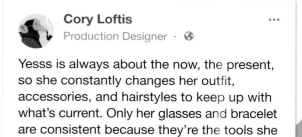

Cory Loftis
Production Designer · 🌐

Yesss is always about the now, the present, so she constantly changes her outfit, accessories, and hairstyles to keep up with what's current. Only her glasses and bracelet are consistent because they're the tools she uses to scan the Internet at all times.

👍❤️ Ernest Petti and 17 others 8 Comments 🔽

👍 Like 💬 Comment ➤ Share

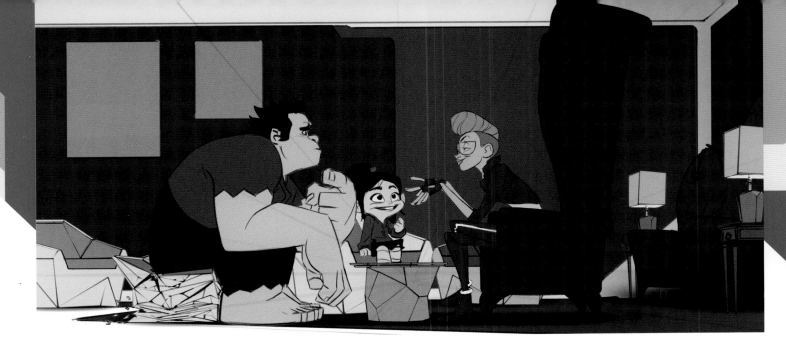

<Ryan Lang / digital>

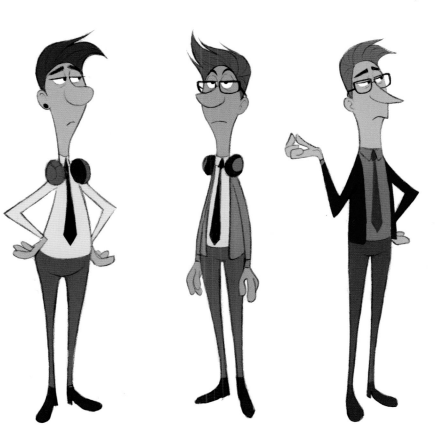

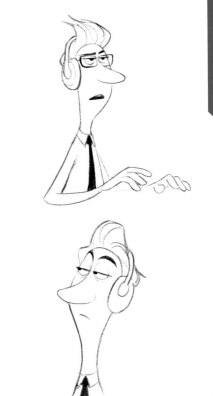

<Cory Loftis / digital>

<Meg Park / digital>

>121

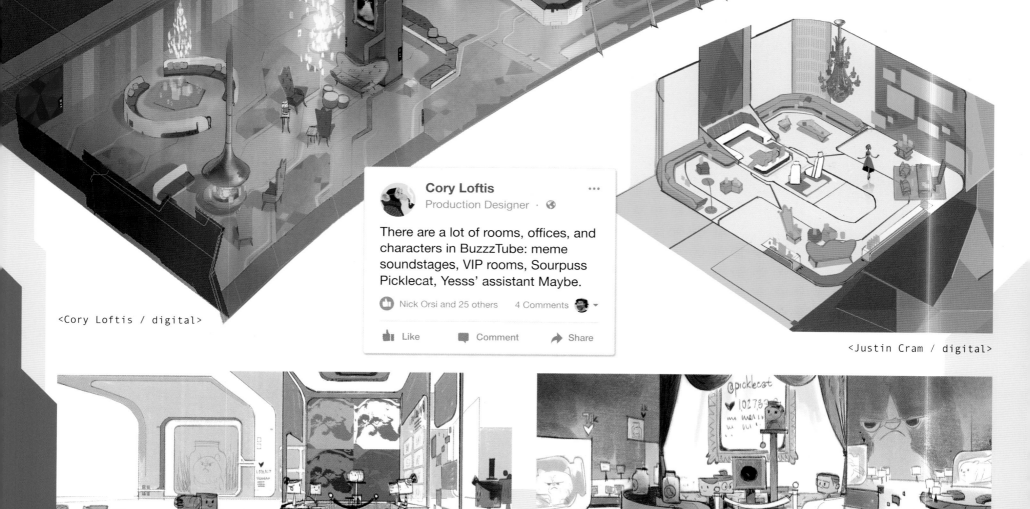

<Cory Loftis / digital>

Cory Loftis
Production Designer · 🌐

There are a lot of rooms, offices, and characters in BuzzzTube: meme soundstages, VIP rooms, Sourpuss Picklecat, Yesss' assistant Maybe.

👍 Nick Orsi and 25 others 4 Comments

👍 Like 💬 Comment ➤ Share

<Justin Cram / digital>

<Mike Yamada / digital>

<Mike Yamada / digital>

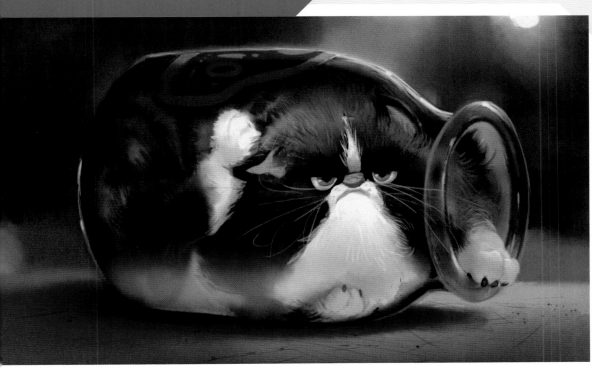

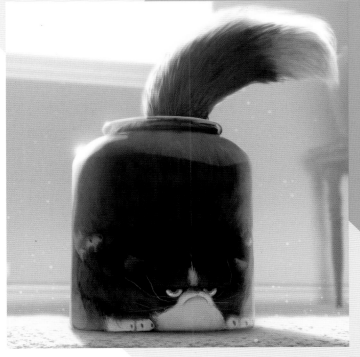

<Paul Felix / digital>

<Ryan Lang / digital>

<Justin Cram / digital>

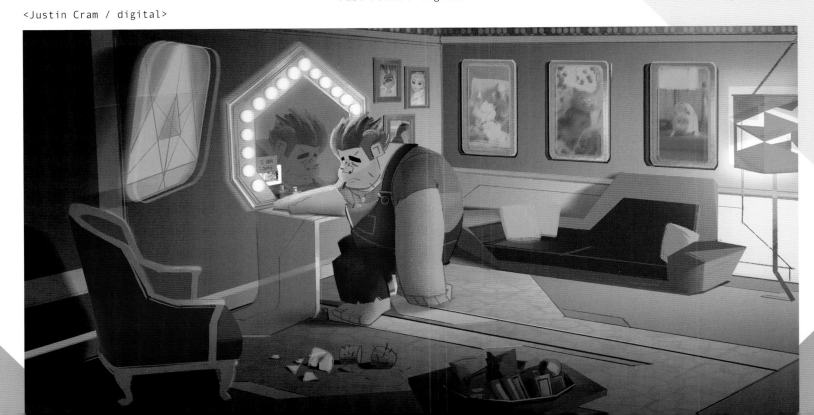

>123

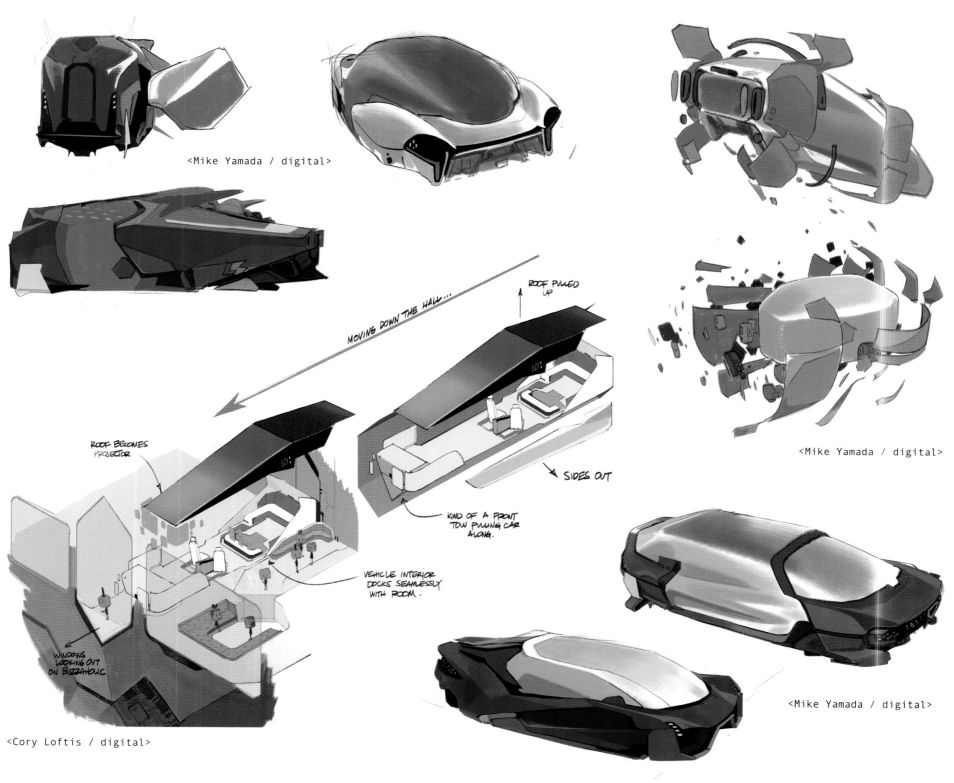

<Mike Yamada / digital>

MOVING DOWN THE HALL...

ROOF PULLED UP

ROOF BECOMES PROJECTOR

SIDES OUT

KIND OF A FRONT TOW PULLING CAR ALONG.

VEHICLE INTERIOR DOCKS SEAMLESSLY WITH ROOM.

WINDOWS LOOKING OUT ON BUZZAHOLIC

<Mike Yamada / digital>

<Cory Loftis / digital>

<Mike Yamada / digital>

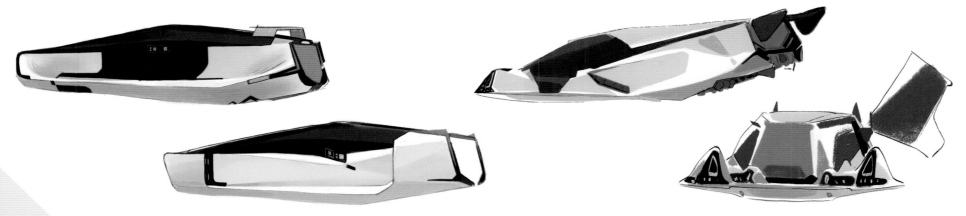

<Mike Yamada / digital>

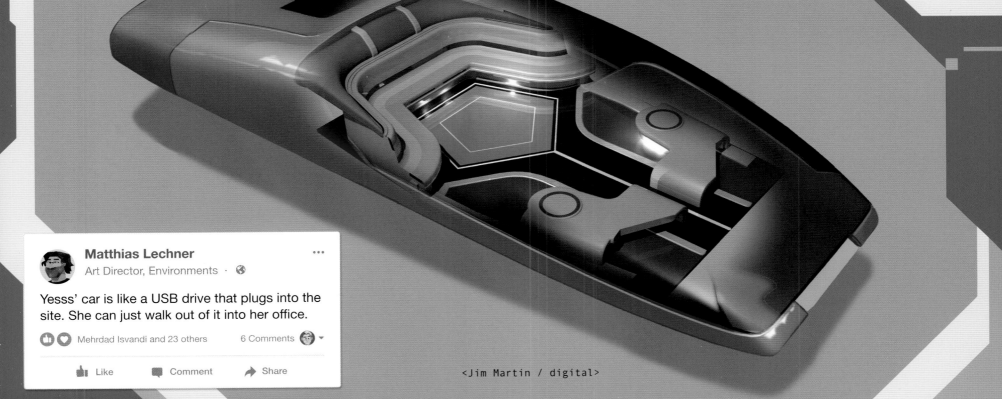

Matthias Lechner
Art Director, Environments · 🌐

Yesss' car is like a USB drive that plugs into the site. She can just walk out of it into her office.

👍❤️ Mehrdad Isvandi and 23 others 6 Comments ▾

👍 Like 💬 Comment ➤ Share

<Jim Martin / digital>

OHMYDISNEY.COM

Mingjue Helen Chen, Associate Production Designer

OhMyDisney is like D23 Expo and a Comic Con combined, an enormous convention hall where everything is focused on Disney. The exterior looks like Cinderella's castle, modified to fit the fantastical Internet world of the film. The color palette references the iconic pink and blue. But it's not a real building with screws and nails; if you were to switch the camera angle you'd see the pieces of it are just floating in space, almost deconstructed.

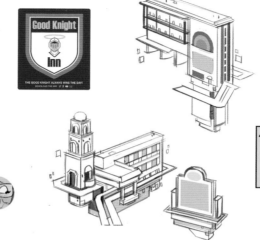

<Justin Cram / digital>

<Mingjue Helen Chen / paintover>

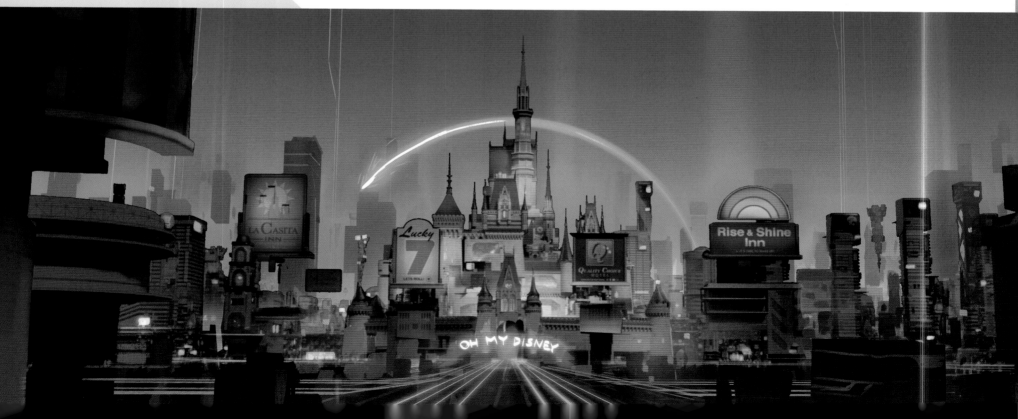

Cory Loftis, Production Designer

The OhMyDisney characters are like the teenage version of themselves. They are gangly, with bigger heads, feet, and hands. They have a simplified silhouette but are still recognizable as the characters from the films.

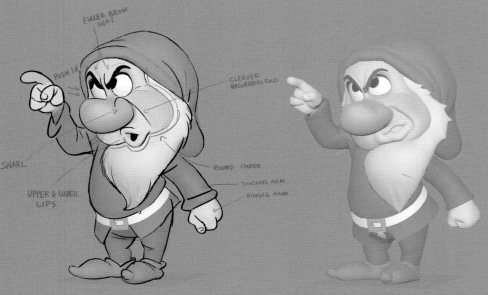

FULLER BROW MEAT

PUSH IN

CLEANER NASORABIAL FOLD

SNARL

ROUND CHEEK

THICKER ARM

BIGGER HAND

UPPER & LOWER LIPS

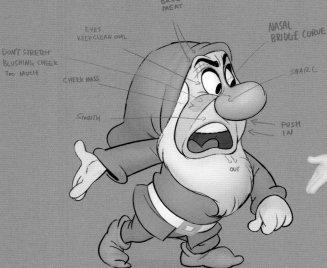

BROW MEAT

EYES, KEEP CLEAN OVAL

NASAL BRIDGE CURVE

DON'T STRETCH BLUSHING CHEEK TOO MUCH

CHEEK MASS

SNARL

SMOOTH

PUSH IN

OUT

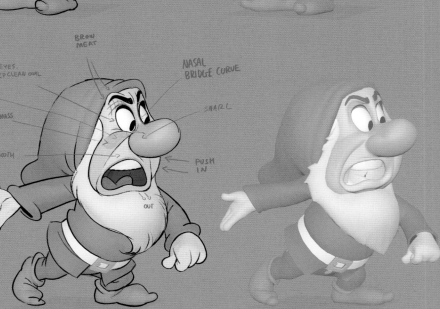

<Ami Thompson / digital>

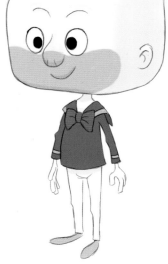

<Jeff Merghart / digital>

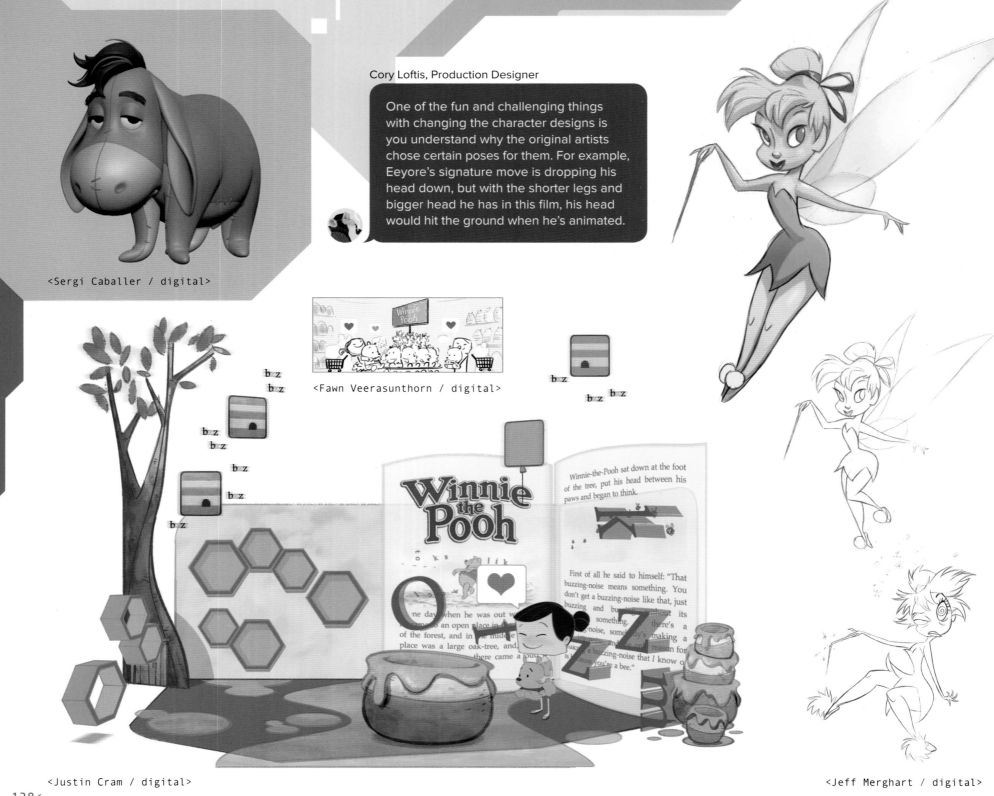

<Sergi Caballer / digital>

Cory Loftis, Production Designer

One of the fun and challenging things with changing the character designs is you understand why the original artists chose certain poses for them. For example, Eeyore's signature move is dropping his head down, but with the shorter legs and bigger head he has in this film, his head would hit the ground when he's animated.

<Fawn Veerasunthorn / digital>

Winnie the Pooh

Winnie-the-Pooh sat down at the foot of the tree, put his head between his paws and began to think.

First of all he said to himself: "That buzzing-noise means something. You don't get a buzzing-noise like that, just buzzing and buzzing, without its meaning something. There's a noise, somebody's making a buzzing-noise, and the only reason for making a buzzing-noise that I know of is because you're a bee."

One day when he was out walking, he came to an open place in the middle of the forest, and in the middle of this place was a large oak-tree, and, there came a loud

<Justin Cram / digital>

<Jeff Merghart / digital>

<Jeff Merghart / digital>

Matthias Lechner, Art Director, Environments

The interior is full of booths that highlight Disney, Pixar, Marvel, Lucasfilm, and so on. The Princess Room is the heavily guarded dressing room of the Disney Royal Court. It's a behind-the-scenes place where the princesses can hang out. We visited the "Dream Suite" at Disneyland for research.

<Mehrdad Isvandi / digital>

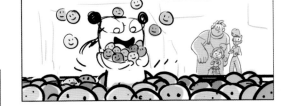

<Lissa Treiman, Jason Hand / digital>

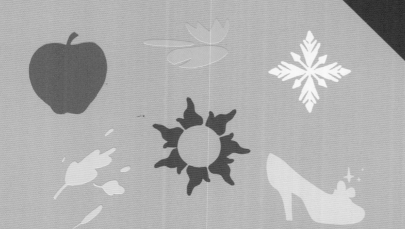

Kira Lehtomaki, Head of Animation

We met with each of the actresses who voice the princesses. They think about their characters in such a deep way. Jennifer Hale, the voice of Cinderella for the last twenty years, describes Cinderella as "the queen of coping"—she makes the best of anything you throw at her. Jasmine is used to more luxury than Cinderella, but she also fights for what is good and right, she will question authority when she needs to. We try to work those unique personality traits into each of the princesses. They each have their own set of wants, goals, and personalities, and we want that to shine through.

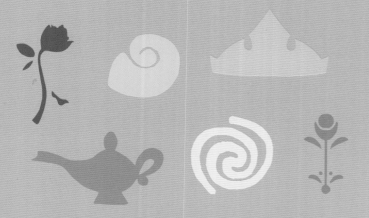

<Mehrdad Isvandi / digital>

<Lorelay Bove / digital>

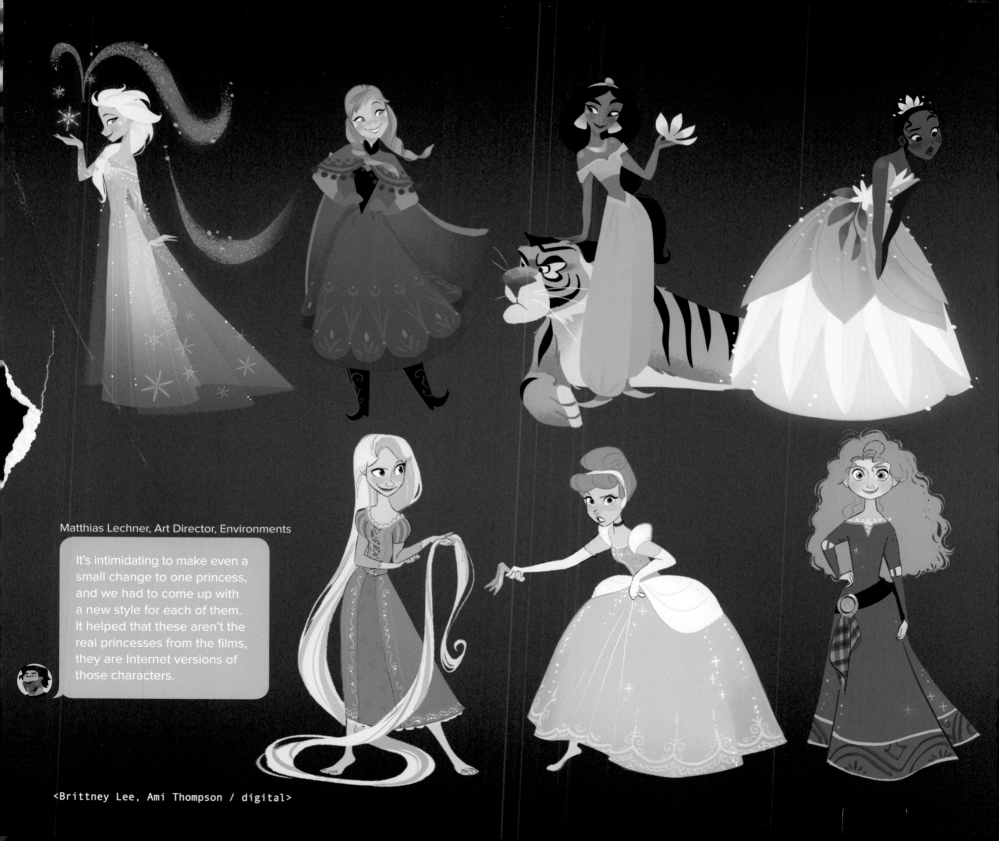

Matthias Lechner, Art Director, Environments

It's intimidating to make even a small change to one princess, and we had to come up with a new style for each of them. It helped that these aren't the real princesses from the films, they are Internet versions of those characters.

<Brittney Lee, Ami Thompson / digital>

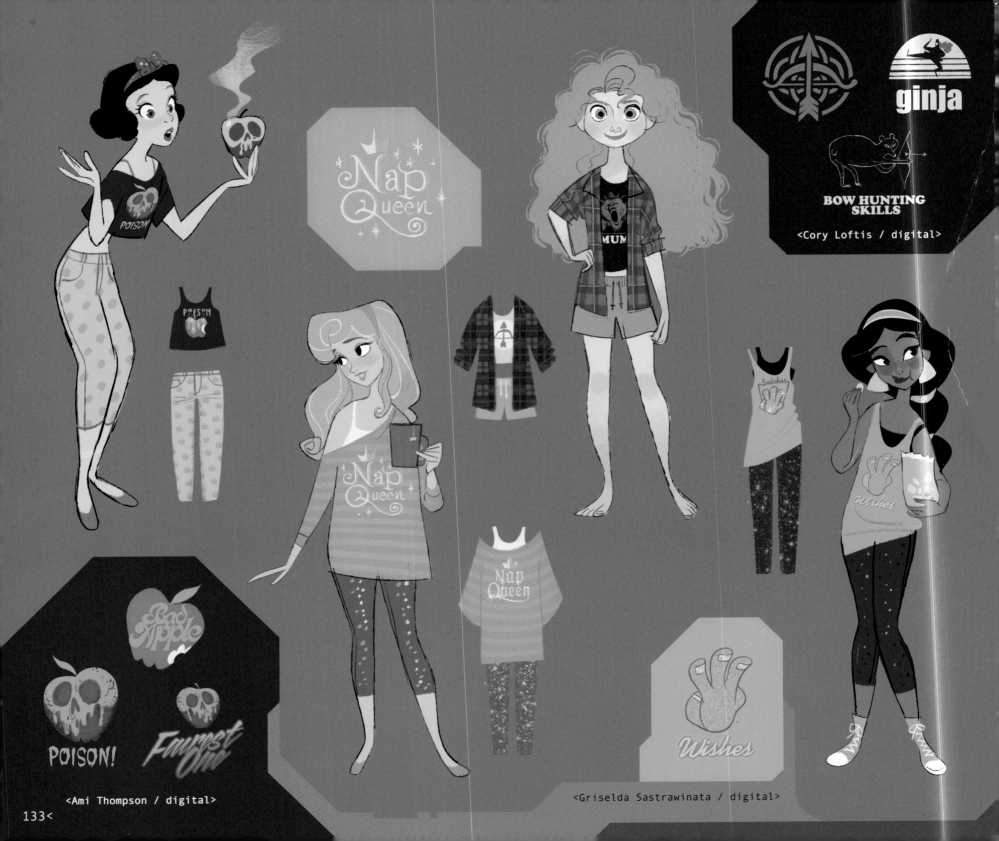

ginja

BOW HUNTING SKILLS

<Cory Loftis / digital>

Nap Queen

POISON! Fairest One

<Ami Thompson / digital>

133<

Nap Queen

Wishes

<Griselda Sastrawinata / digital>

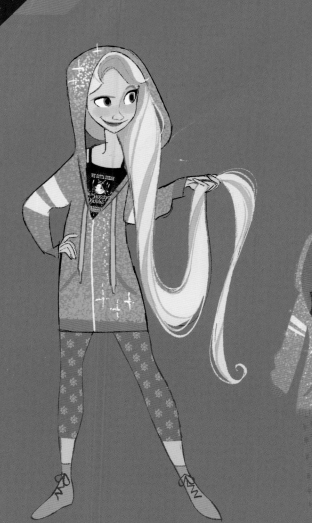

DEATH

#SHiNY

BEAST MODE

Beast FRIENDS Forever

READING IS NOT WEIRD

Friends 4 eva

<Ami Thompson / digital>

FRAGILE

BFF

BEAST FRIENDS FOREVER

Ami Thompson, Art Director, Characters

Their casualwear is something they could wear relaxing at home, inspired by Vanellope's comfortable clothes. Each outfit's design relates to the Internet version of them.

#SHiNY

GIMME MORA KAKAMORA

UR

Welcome

<Griselda Sastrawinata / digital>

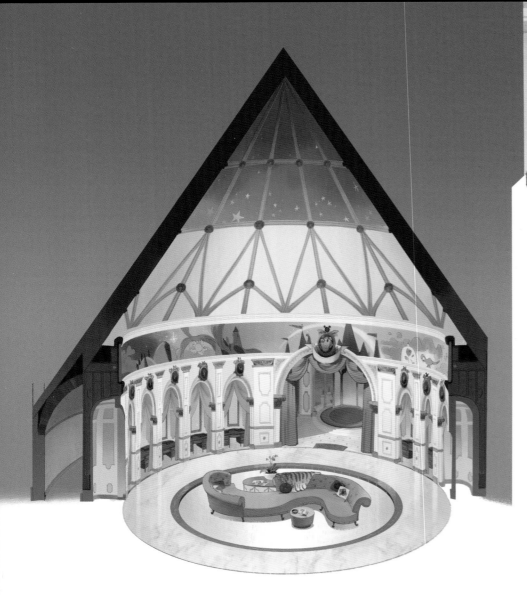

Matthias Lechner, Art Director, Environments

Each princess has her own cubbie filled with personal items: Belle's books, Mulan's sword, the picture Tiana ripped out of the magazine, Ariel's collection of thingamabobs. Some are jokes: Aurora has coffee, Cinderella's clock is frozen at midnight.

<Mike Yamada / digital>

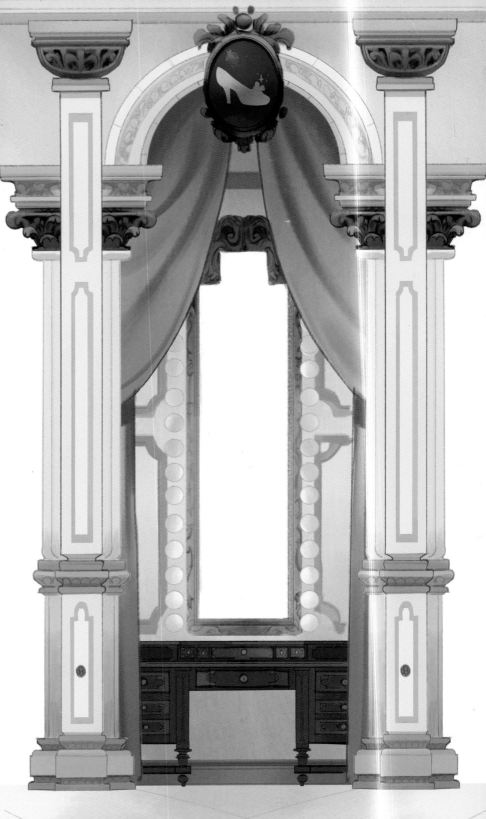

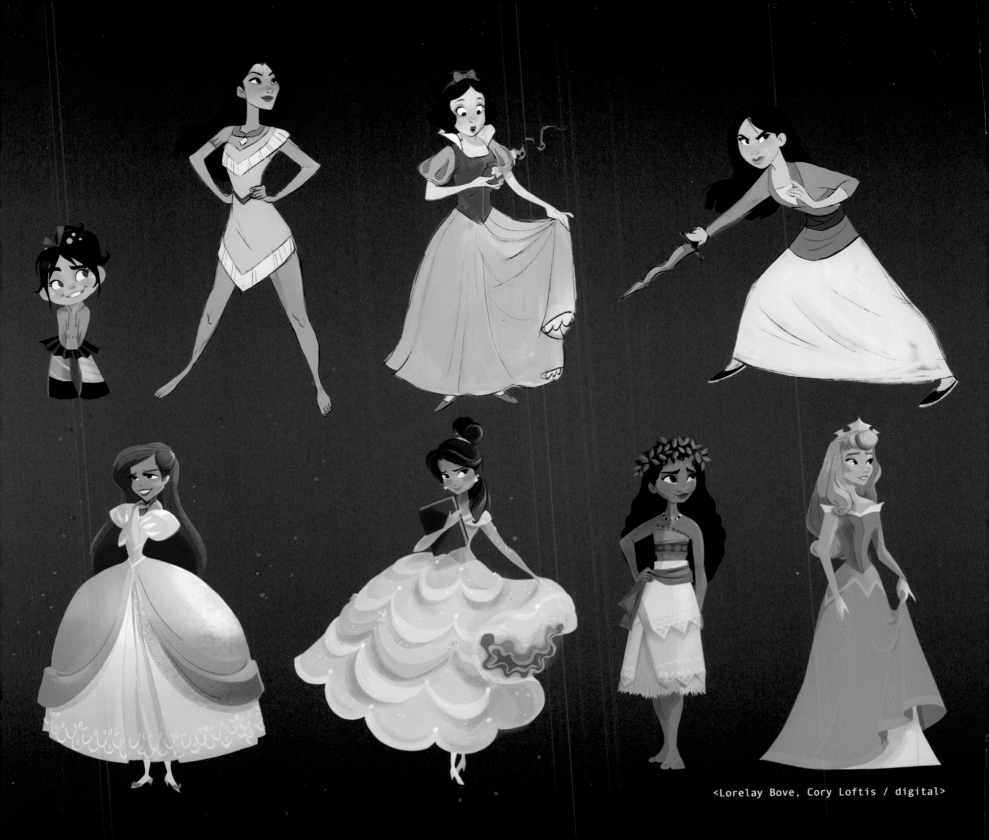

<Lorelay Bove, Cory Loftis / digital>

<Griselda Sastrawinata / digital>

It's not often an animator gets to revisit a past character; I hadn't animated Ariel since the original film in 1989. One challenge was trying to find a balance between traditional animation and the digital world of *Wreck-It Ralph 2*. I animated a few test scenes to show how the new designs could be fully animated for this film while still maintaining the integrity of the original designs. And it was such a treat to host a meet-and-greet discussion for the animation team with each of the voice talents as they came in to record their lines.

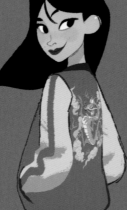

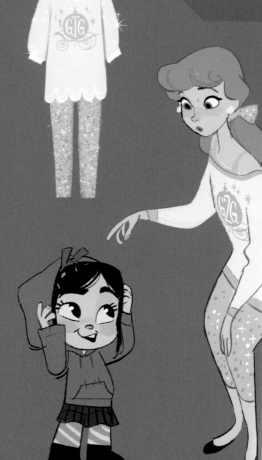

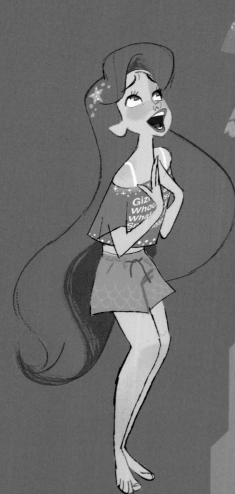

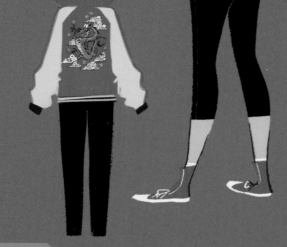

Ami Thompson, Art Director, Characters

The OhMyDisney version of the princesses is more cartoony, with bigger eyes and ears, a graphic mouth shape. But we kept the color schemes from their iconic dresses, and maintained something close to their original hairstyles even when they're in comfy outfits.

<Cory Loftis / digital>

NOLA
<Griselda Sastrawinata / digital>

FINISH EACH OTHERS

FINISH EACH OTHERS

FINISH EACH OTHERS

<Cory Loftis / digital>

FINISH EACH OTHERS

NOLA

PWND

JUST LET IT GO

JUST LET IT GO

JUST LET IT GO

BLUE CORN MOON

COLORS OF THE WIND

BLUE CORN MOON

<Character Art: Ami Thompson / digital>
<Clothing: Griselda Sastrawinata, Ami Thompson / digital>

<Cory Loftis / digital>

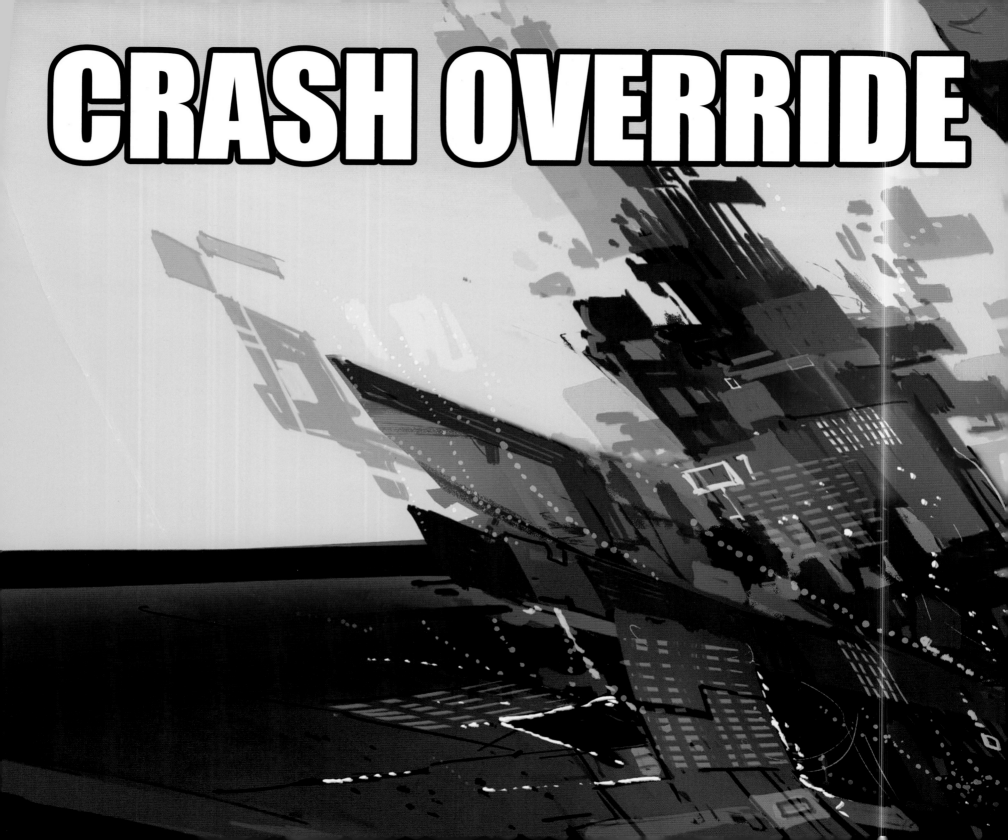

CRASH OVERRIDE

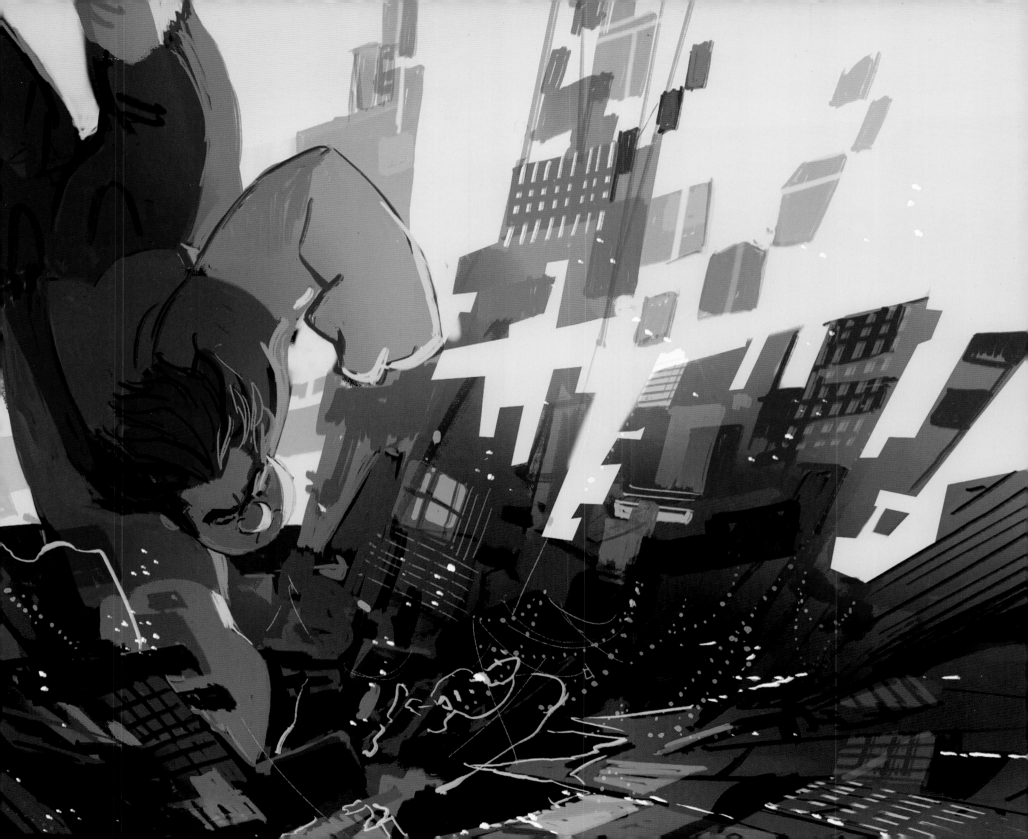

 Jessica Julius Author
Ralph very nearly takes down the Internet in this film. How does that happen?

permalink embed

 [−] **Phil Johnston** Director
After Ralph eavesdrops on Vanellope telling Shank she wants to stay in Slaughter Race, he decides to release a virus into the game that would slow it down enough that she'd want to leave. It wasn't supposed to hurt anyone but it gets out of control. As the game crashes around them, Ralph accidentally touches the virus, which then begins to replicate him, manifesting as millions of Ralph clones.

permalink embed parent

 [−] **Rich Moore** Director
We were inspired by the last line of the first movie— "If that kid likes me, how bad can I be?" It's a great sentiment but it can also be really dysfunctional. Ralph is defining himself by how Vanellope feels about him, and when she starts to pull away his insecurities are aggravated. Viruses prey on vulnerabilities, which is why this one grows so strong after being in contact with Ralph. The clones are the personification of Ralph's insecurities. While desperately searching for Vanellope, the clones jam up websites so users can't get in, which to the outside world looks like a denial of service attack. Inside the Internet, the clones create havoc and destruction, causing sites to literally crash.

permalink embed parent

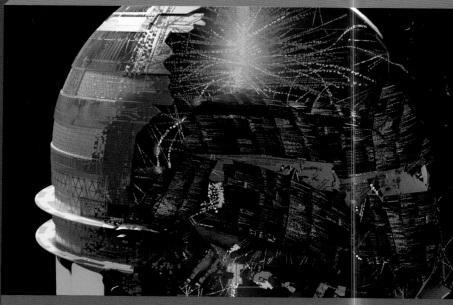

<Sara Cembalisty / digital>
<Pages 138–139: Paul Felix / digital>

 [−] **Jessica Julius** Author
Were there any specific design challenges to wrecking the Internet?

permalink embed

 [−] **Cesar Velazquez** Head of Visual Effects
Destroying our assets is not a trivial task. We had to institute a whole new tool set to handle all the destruction that happens in this film. We have characters with hair, environments with vegetation, buildings made out of glass, all designed and modeled to look good from certain camera angles. When they're destroyed, they still have to look right from an art standpoint while also being structurally accurate. Instead of breaking a wooden beam or brick in half we're breaking it on a digital level.

permalink embed parent

<Paul Felix / digital>

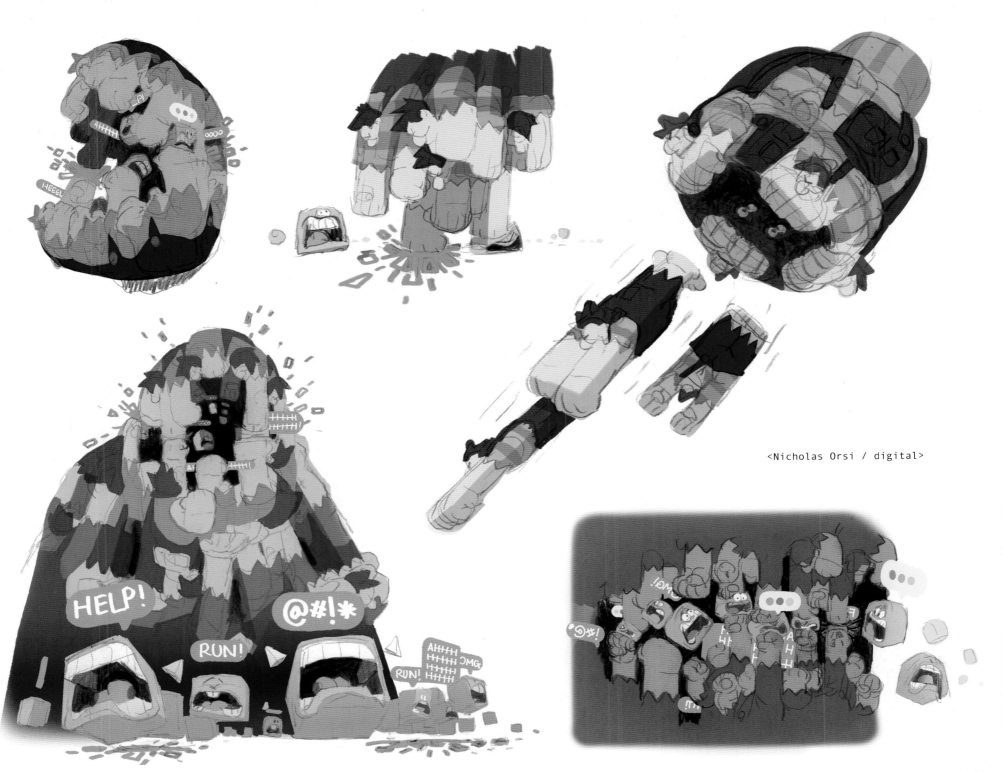

<Nicholas Orsi / digital>

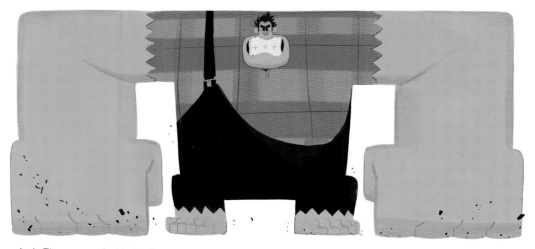

<Ami Thompson / digital>

Phil Johnston
Director · 🌐 · · ·

The giant Ralph is a gross, roiling blob made up of millions of individual Ralph clones.

👍 😮 Mingjue Helen Chen and 29 others 12 Comments 🖼 ▾

👍 Like 💬 Comment ➤ Share

<Cory Loftis / digital>

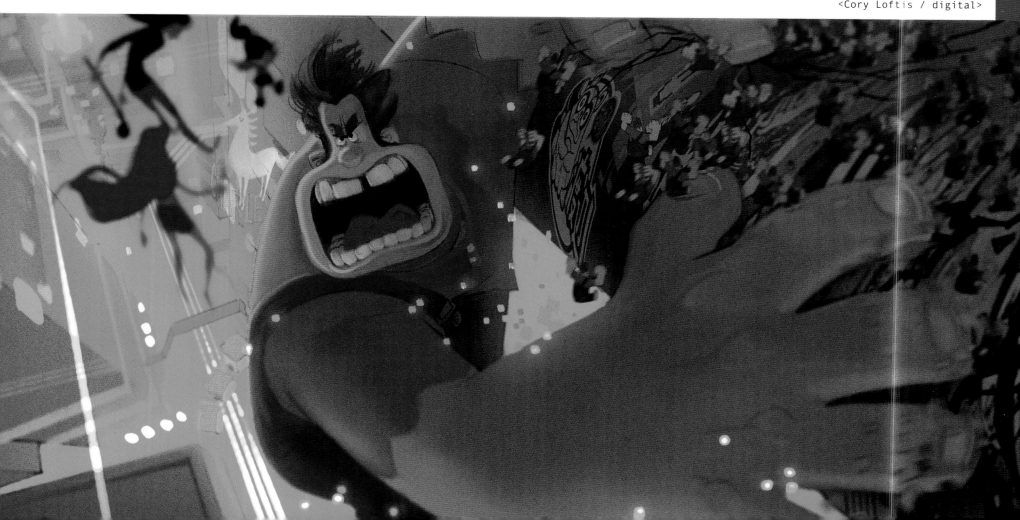

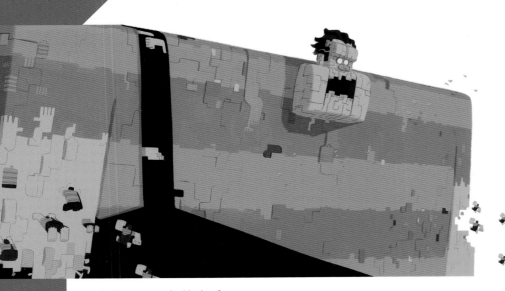

<Ami Thompson / digital>

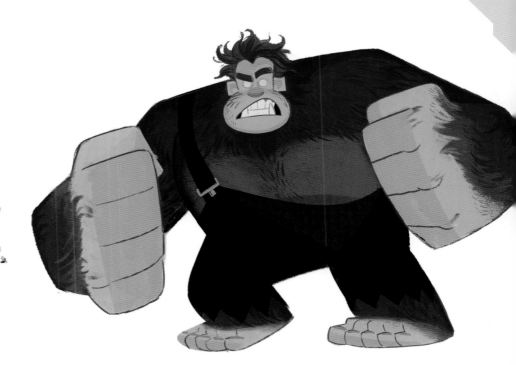

<Ami Thompson / digital>

<Ami Thompson / digital>

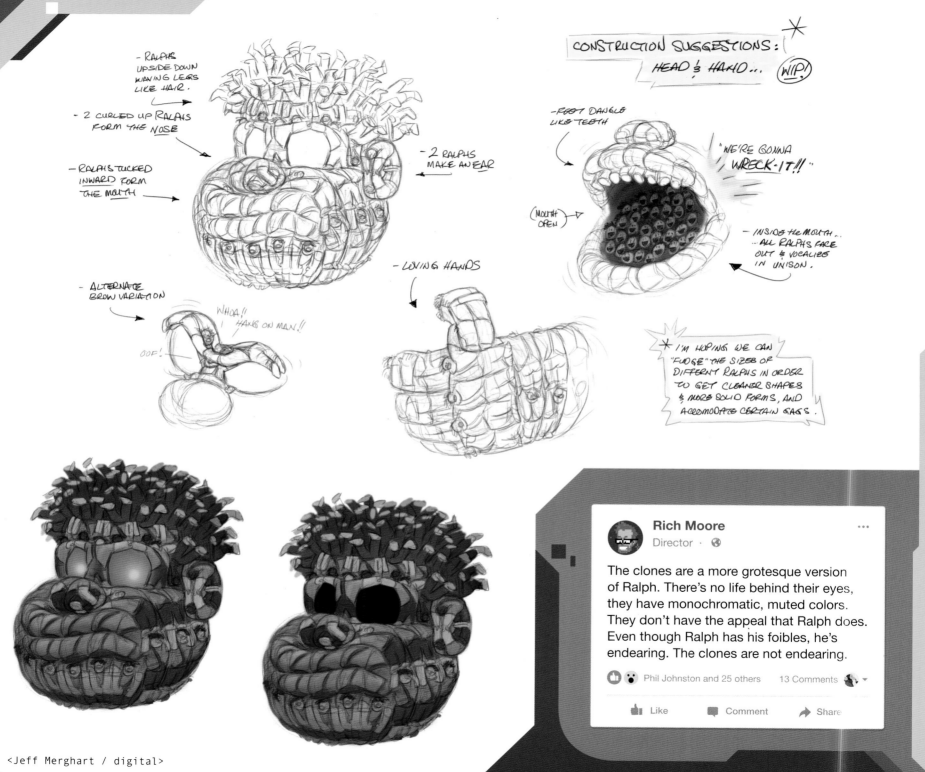

- RALPHS UPSIDE DOWN WAVING LEGS LIKE HAIR.

- 2 CURLED UP RALPHS FORM THE NOSE

- RALPHS TUCKED INWARD FORM THE MOUTH

- ALTERNATE BROW VARIATION

- 2 RALPHS MAKE AN EAR

- LOVING HANDS

WHOA!! HANG ON MAN!!

OOF!

CONSTRUCTION SUGGESTIONS: HEAD & HAND... (WIP!)

- FEET DANGLE LIKE TEETH

"WE'RE GONNA WRECK-IT!!"

(MOUTH OPEN)

- INSIDE THE MOUTH... ...ALL RALPHS FACE OUT & VOCALIZE IN UNISON.

* I'M HOPING WE CAN "FUDGE" THE SIZE OR DIFFERENT RALPHS IN ORDER TO GET CLEANER SHAPES & MORE SOLID FORMS, AND ACCOMODATE CERTAIN GAGS.

Rich Moore
Director · 🌐

The clones are a more grotesque version of Ralph. There's no life behind their eyes, they have monochromatic, muted colors. They don't have the appeal that Ralph does. Even though Ralph has his foibles, he's endearing. The clones are not endearing.

👍😮 Phil Johnston and 25 others 13 Comments

👍 Like 💬 Comment ➤ Share

<Jeff Merghart / digital>

144<

(SKIN MASS) →

→ UP-CLOSE...
..THIS LIL' RALPHS ARE MORE SIMPLIFIED FORMING A MORE UNIFORM MASS, LIKE FUSED MARSHMALLOWS.

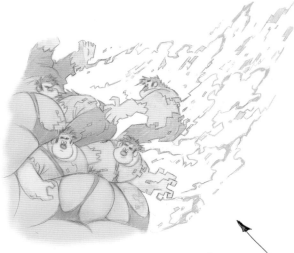

... WHEN THEY BREAK FROM THE MASS THEY RE·DIGITIZE & BREAK·UP UNTIL THEY RE-CONSTITUTE.

"RALPH·BITS" CONSTANTLY BREAK OFF.

<Jeff Merghart / digital>

fire ants can lock together to form towers, bridges, and even rafts!

<Natalie Nourigat / digital>

 Phil Johnston
Director · 🌐

We had to make sure the clones didn't feel like sentient beings because ultimately, we have to get rid of them. It was a challenge to make them look like Ralph, yet have the audience root for them to be deleted.

👍❤️ Kira Lehtomaki and 18 others 6 Comments

👍 Like 💬 Comment ➤ Share

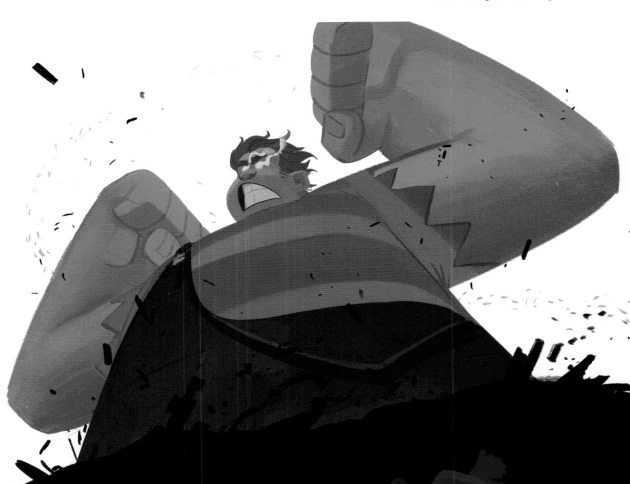

<Ami Thompson / digital>

THE DARKNET

 [−] Jessica Julius Author
At one point, Ralph ends up in the Darknet. What is that exactly?

permalink embed

 [−] Matthias Lechner Art Director, Environments
There are multiple levels to the Internet. There's the surface web, which is the part users mainly interact with. Beneath that are areas less easily accessed, like data storage and content behind paywalls, which have a more industrial design. And under that is the Darknet, where the questionable stuff happens.

permalink embed parent

 [−] Cory Loftis Production Designer
Up on the surface web you see users and netizens. But the Darknet is mostly netizens. The average user can't get there. Everyone down there wants to remain anonymous, so their hoods are up, they wear masks. And the environment changes depending on the encryption level, so some things aren't visible until you get special glasses or an access card to see them.

permalink embed parent

 [−] Ami Thompson Art Director, Characters
Ralph only gets to the Darknet because the netizens Spamley and Gord help him.

permalink embed parent

Jim Martin, Visual Development Artist

The original idea for the Darknet was that it was the foundation of the Internet. It was made up of discarded sites, with new sites built on top of the old ones from the ground up.

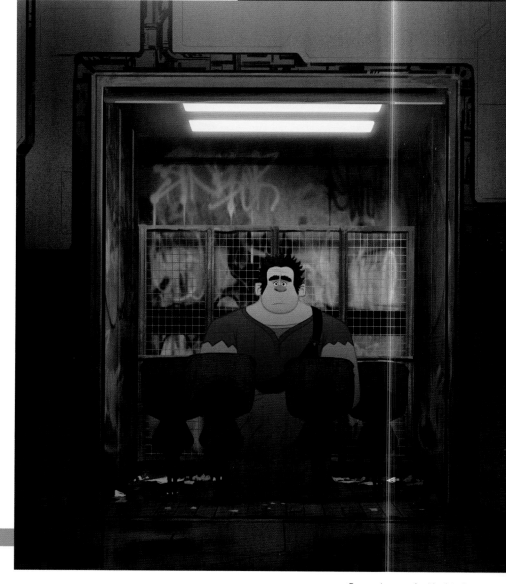

<Ryan Lang / digital>

<Ryan Lang / digital>

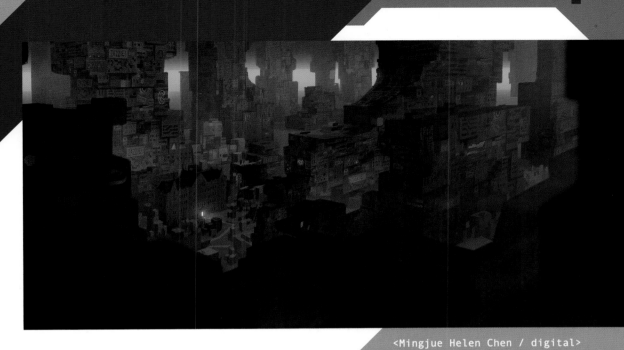

<Mingjue Helen Chen / digital>

Matthias Lechner, Art Director, Environments

Originally we called it the Oldernet and it was basically the 1990s version of the Internet. The Netscape symbol is there but it has fallen down, a Y2K ticker is stopped at midnight, there are old chat rooms, and users travel by the super slow Dial-Up Express.

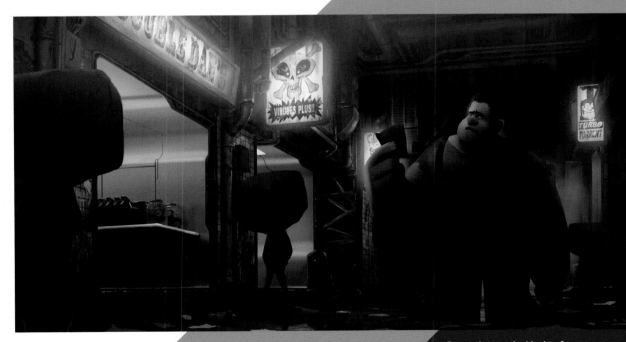

<Ryan Lang / digital>

>147

JP SPAMLEY & GORD

ARE YOU PAYING TOO MUCH?
Take advantage of this special offer!
Click here

SOME LIKE IT **FAST** vs **RAPID SPEED INTERNET**

<Ami Thompson / digital>

<Ami Thompson / digital>

Cory Loftis, Production Designer

Spamley was inspired by salesmen that can't make a sale. He's a fragile character, hanging on by a thread. In his mind, he's trying to run an honest business but no one is clicking on his links. He's annoying but he's not trying to cheat people, which is why he's so touched when Ralph pays attention to him.

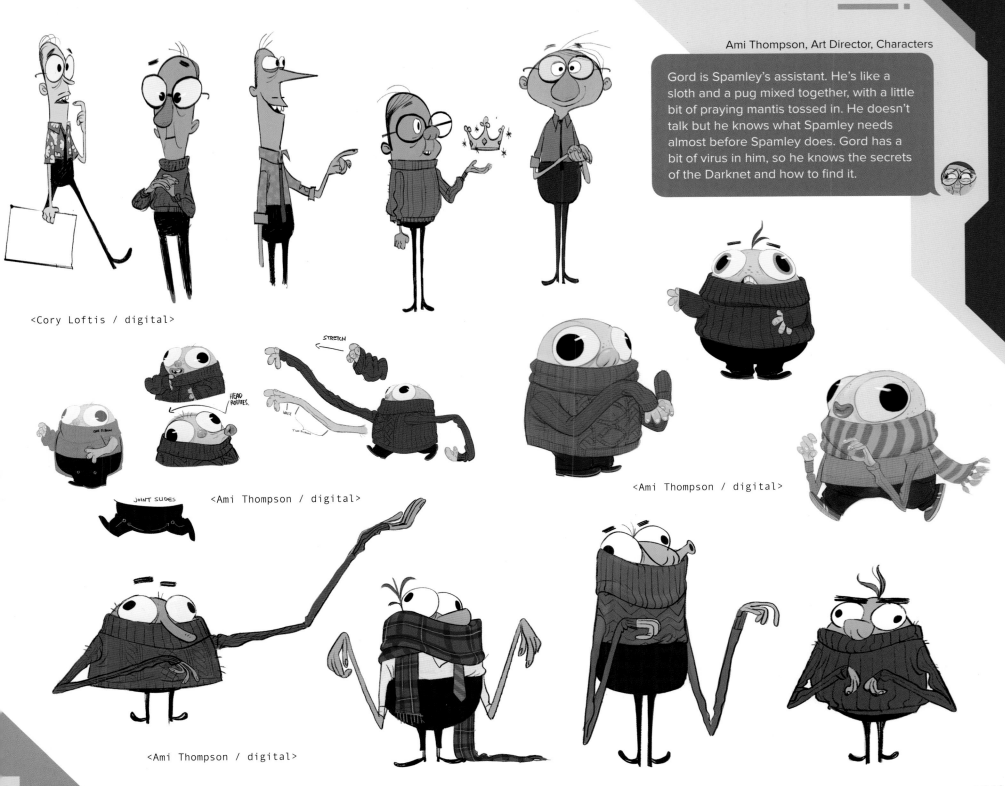

Ami Thompson, Art Director, Characters

Gord is Spamley's assistant. He's like a sloth and a pug mixed together, with a little bit of praying mantis tossed in. He doesn't talk but he knows what Spamley needs almost before Spamley does. Gord has a bit of virus in him, so he knows the secrets of the Darknet and how to find it.

<Cory Loftis / digital>

<Ami Thompson / digital>

<Ami Thompson / digital>

<Ami Thompson / digital>

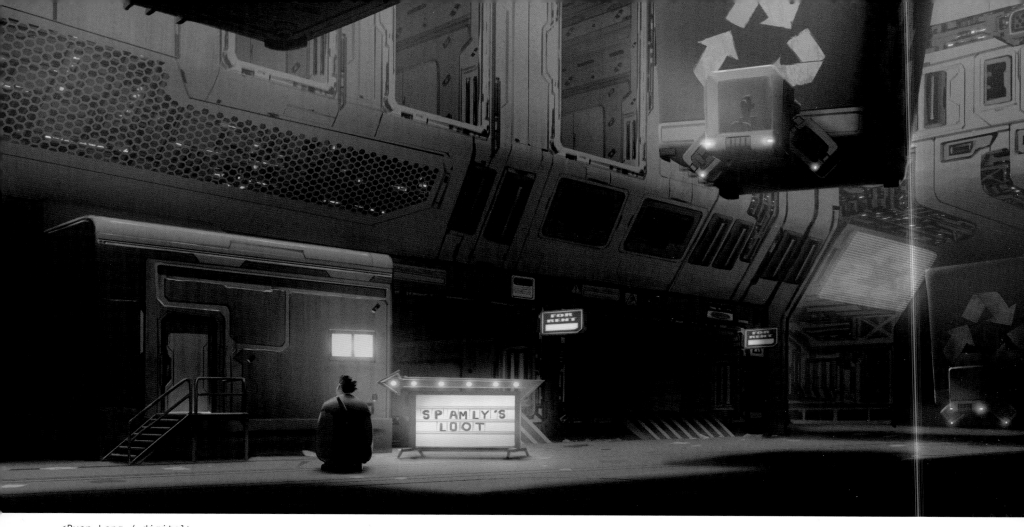

<Ryan Lang / digital>

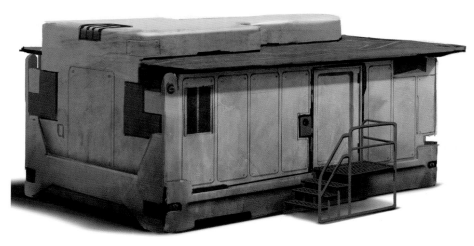
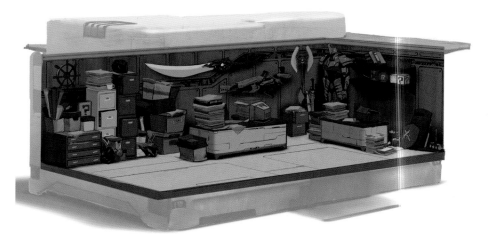

<Ryan Lang / digital>

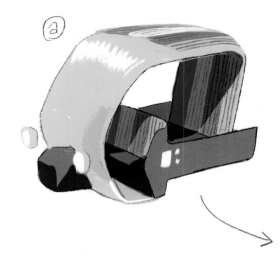

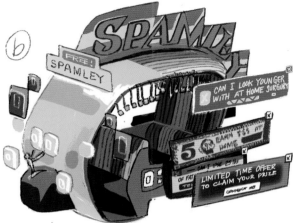

<Cory Loftis / digital>

when Ralph + Venellope enter, all of the exterior attachments pop up on the surface

<Kevin Nelson / digital>

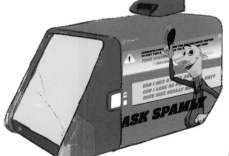

<Kevin Nelson / digital>

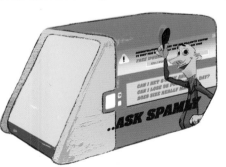

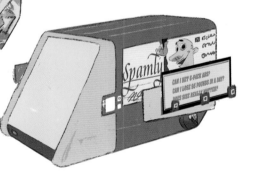

CAN I HET 6-PACK ABS?
CAN I LOSE 95 POUNDS IN A DAY?
DOES SIZE REALLY MATTER?

CONGRATULATIONS! YOU ARE THE ONE BILLIONTH VISITOR TO VISIT THIS SITE! WOULD YOU LIKE TO CLAIM YOUR

FREE IPHONE?

YES I WOULD LIKE THAT VERY MUCH!

...ASK SPAMLY

<Kevin Nelson / digital>

DOUBLE DAN

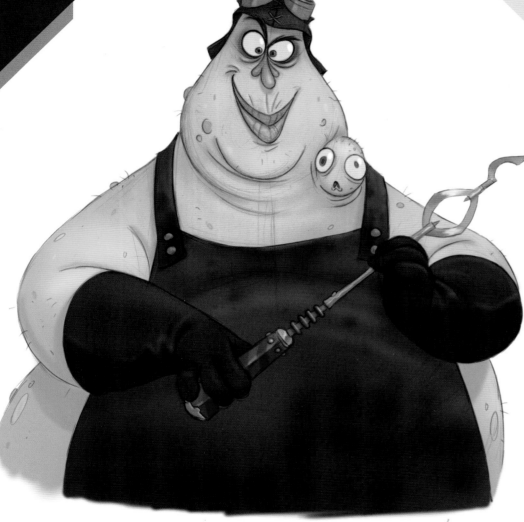

— DOUBLE DAN/DION

<Jeff Merghart / digital>

<Cory Loftis / digital>

<Cory Loftis / digital>

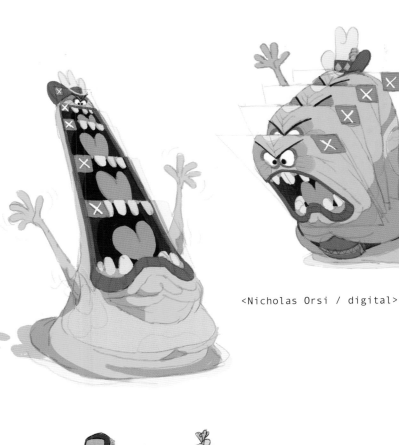

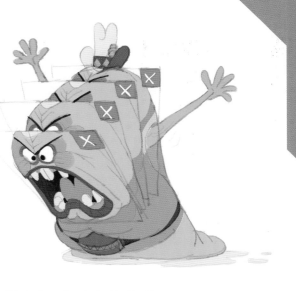

<Nicholas Orsi / digital>

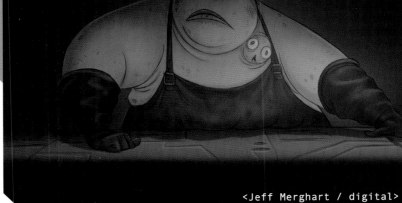

<Jeff Merghart / digital>

Cory Loftis ✓ @ProductionDesigner

I never intended Double Dan's design to be chosen, I was just trying to gross out the directors while playing around with ideas for the look of the villain. But they loved it! Something gross can still be appealing if you get a sense of personality. Most people know a guy like Dan somewhere.

💬 16　　⟲ 9　　♡ 26

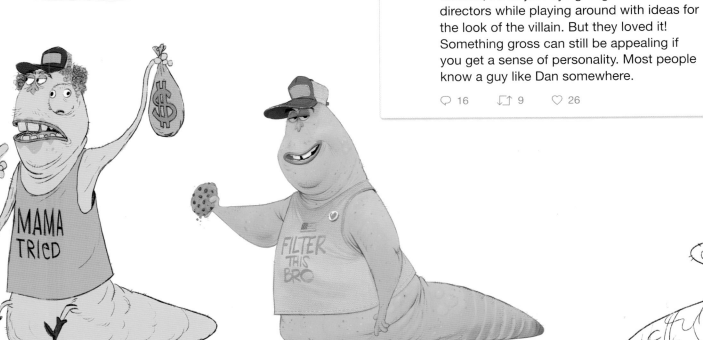

<Cory Loftis / digital>

<Cory Loftis / digital>

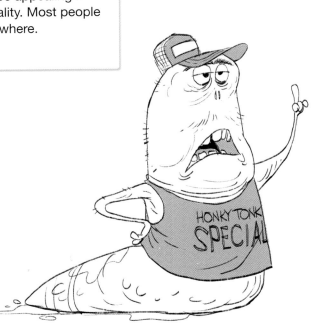

<Cory Loftis / digital>

>153

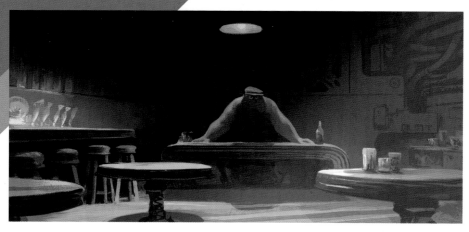

<Kevin Nelson / digital>

<Scott Watanabe / digital>

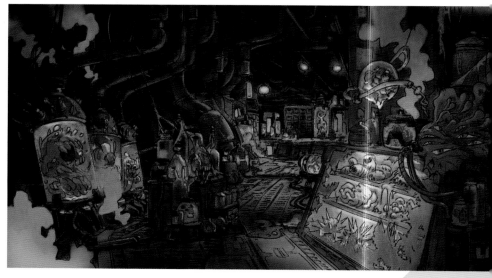

<Scott Watanabe / digital>

<Scott Watanabe / digital>

<Scott Watanabe / digital>

<Scott Watanabe / digital>

<Scott Watanabe / digital>

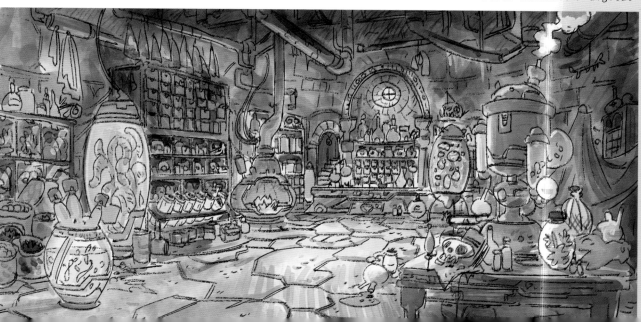

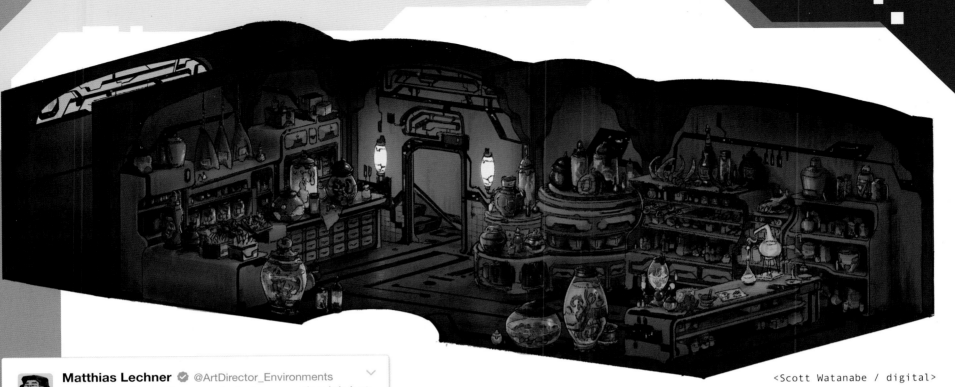

Matthias Lechner ✔ @ArtDirector_Environments

Double Dan's apothecary started as a potion lab but it became more like a proper shop, with boxes and shelves and drawers crammed with dangerous stuff that Dan finds valuable: malware, viruses in leaking canisters, bad code.

💬 10 🔁 4 ♡ 38

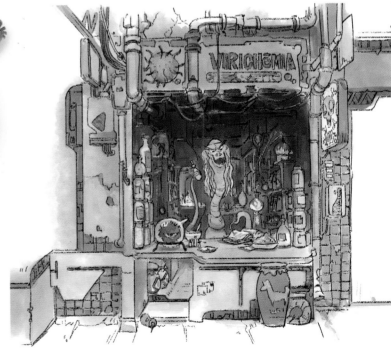

ERROR 404

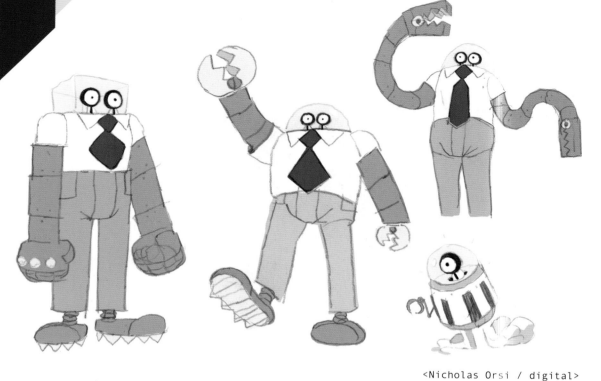

<Nicholas Orsi / digital>

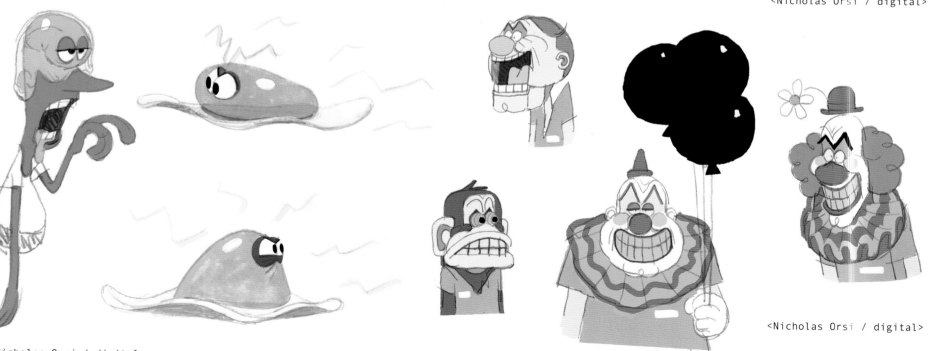

<Nicholas Orsi / digital>

<Nicholas Orsi / digital>

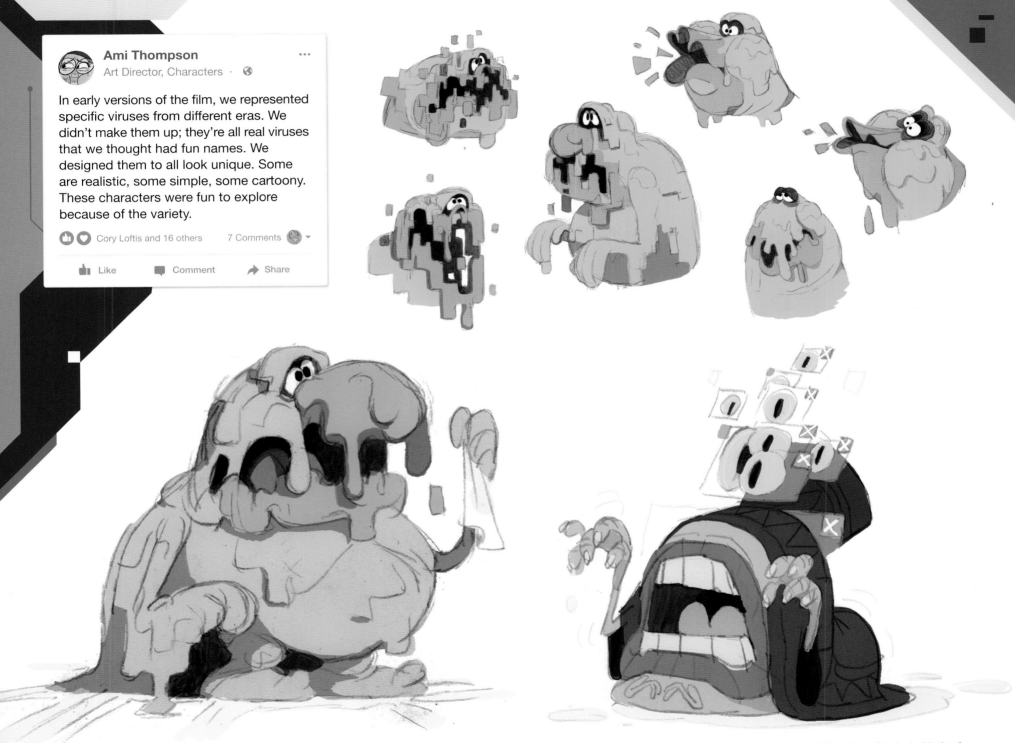

Ami Thompson
Art Director, Characters · 🌐

In early versions of the film, we represented specific viruses from different eras. We didn't make them up; they're all real viruses that we thought had fun names. We designed them to all look unique. Some are realistic, some simple, some cartoony. These characters were fun to explore because of the variety.

👍❤️ Cory Loftis and 16 others 7 Comments 🌐 ▾

👍 Like 💬 Comment ➤ Share

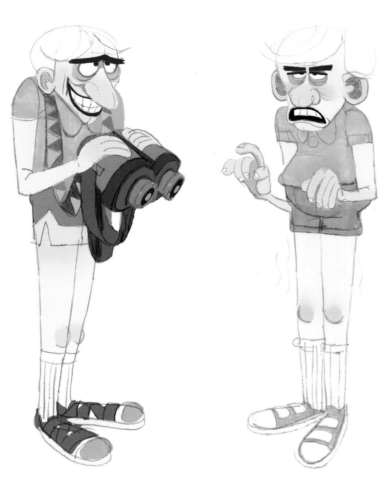

<Nicholas Orsi / digital>

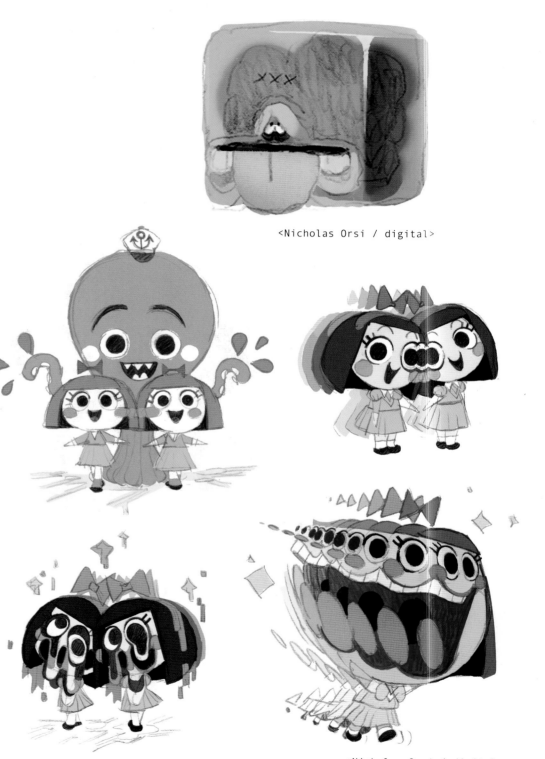

<Nicholas Orsi / digital>

<Nicholas Orsi / digital>

Nick Orsi
Visual Development Artist · 🌐

There are specific ways data is corrupted, and we designed each virus based on its capability. The I Love You virus is a heart-shaped box that has a monster living inside. The Worm Virus is shaped like a worm. The Creeper is a super creepy guy from the 1970s.

👍 😄 Scott Kersavage and 33 others 14 Comments

👍 Like 💬 Comment ➡ Share

<Nicholas Orsi / digital>

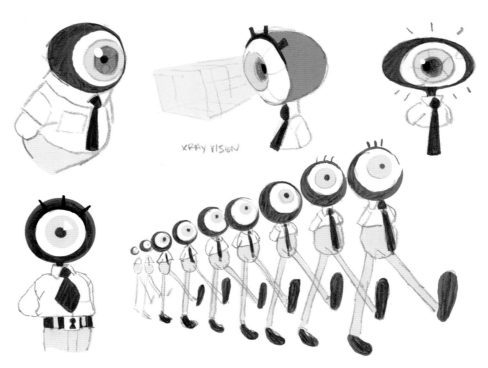

XRAY VISION

<Nicholas Orsi / digital>

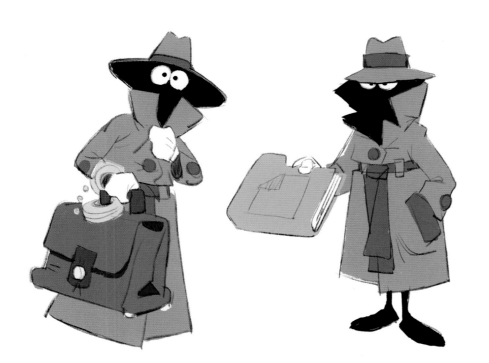

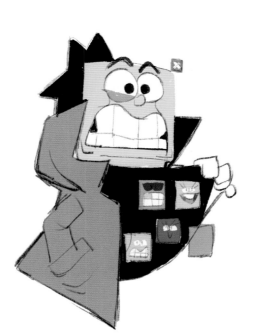

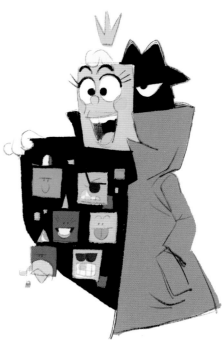

<Nicholas Orsi / digital>

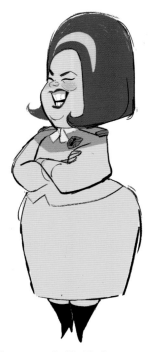

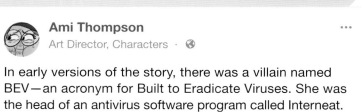

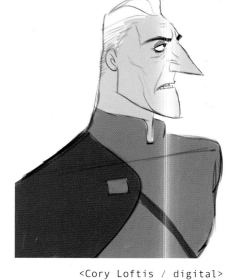

<Cory Loftis / digital>

<Ami Thompson / digital>

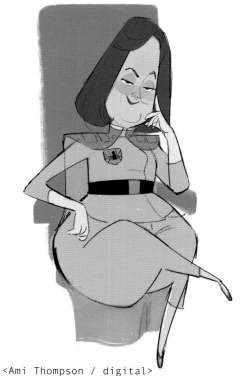

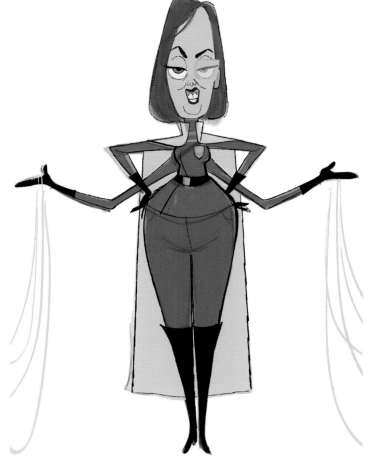

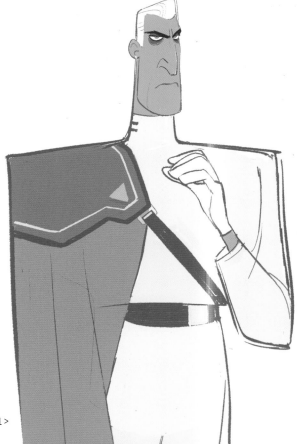

<Ami Thompson / digital>

<Ami Thompson / digital> <Ami Thompson / digital>

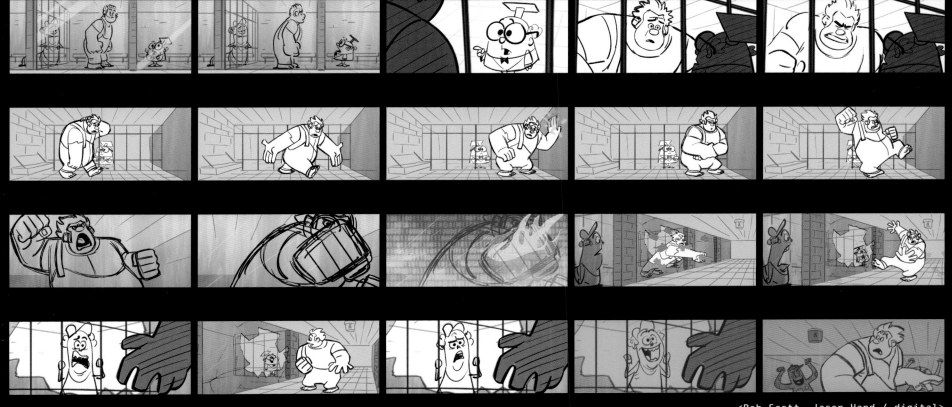

<Bob Scott, Jason Hand / digital>

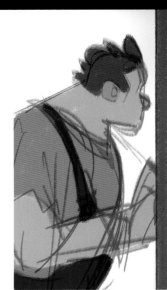

Matthias Lechner
Art Director, Environments · 🌐

When BEV caught a virus she would send it to quarantine, basically a cell surrounded by a firewall. Instead of a literal wall of fire, it was more like a membrane that became really hot and glowed when touched. If a virus tried to press through it, it broke into flames. In early versions of the story, Ralph was sent to quarantine but because his code is so simple he could break right through the firewall.

 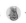 Rich Moore and 24 others 7 Comments

👍 Like 💬 Comment ➤ Share

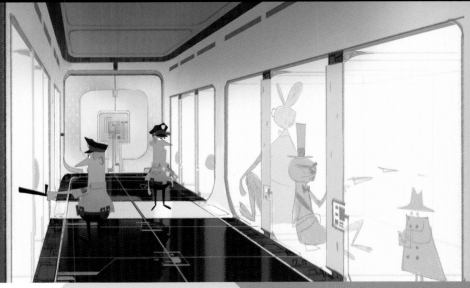

<Mike Yamada / digital>

PANCAKE MILKSHAKE

<Mac George / digital>

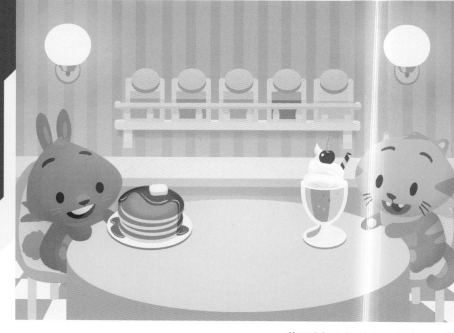

<Matthias Lechner / digital>

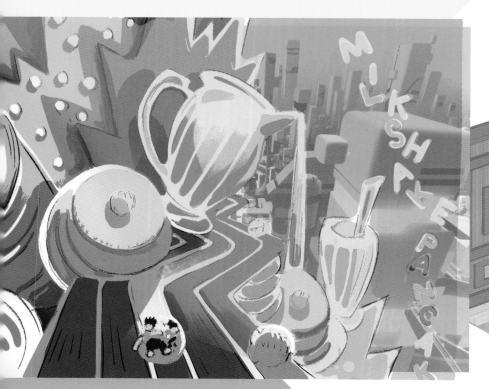

<Kevin Nelson / digital>

<Justin Cram / digital>

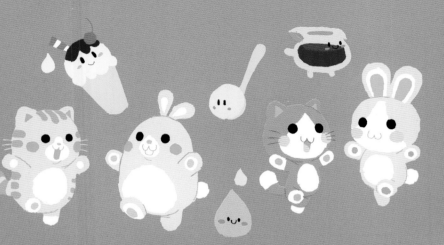

<Nicholas Orsi / digital>

<Nicholas Orsi / digital>

<Matthias Lechner / digital>

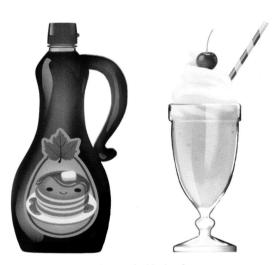

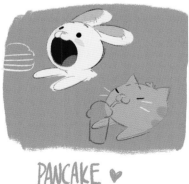

PANCAKE ♥
♥ MILKSHAKE

<Ami Thompson / digital>

ACKNOWLEDGMENTS

 [–] Jessica Julius Author

It's a privilege to share the story of how *Ralph Breaks the Internet* evolved visually from nascent idea to the beautiful final film. Thank you, Clark Spencer, Rich Moore, and Phil Johnston, for entrusting me with the task.

Cory Loftis, Matthias Lechner, Ami Thompson—you are creative wizards and I am in awe of your talents. You and every artist interviewed for this book has my eternal gratitude for taking the time to sit with me and share your thoughts on your art and process.

There can never be enough huzzahs for Alison Giordano, Stevi Carter, Lindsay Henry, Brittany Kikuchi, David Thibodeau, Val Sanchez, Ruth Strother, Nathan Curtis, Eileen Aguirre, Ainsley Shannon, and the entire *Ralph Breaks the Internet* production management team. Thank you so much for everything you do.

Thank you to my gracious and discerning editor, Beth Weber, and designer extraordinaire, Glen Nakasako. I'm so glad I got to work with both of you again. Scott Hummel and Michael Hebert, I couldn't have made this book happen without you. Thank you as well to my amazing work family, the incomparable development department of the Walt Disney Animation Studios.

To Mom: Thank you, always and everyways. And to my husband, Shannon: My world would be wrecked without you.

permalink embed

<Kevin Nelson / digital>

COLOR KEYS

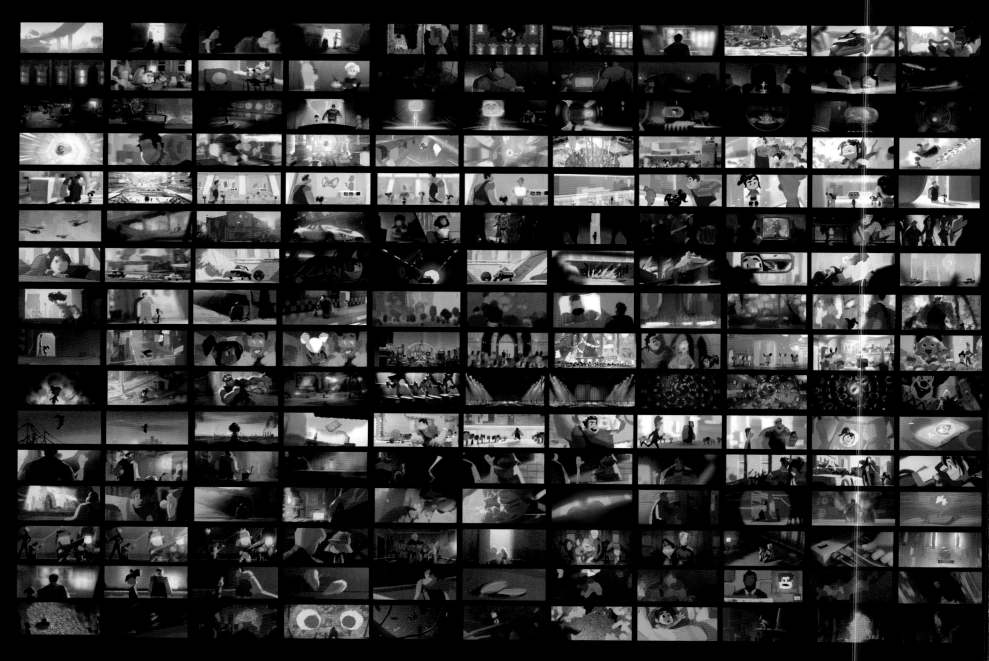

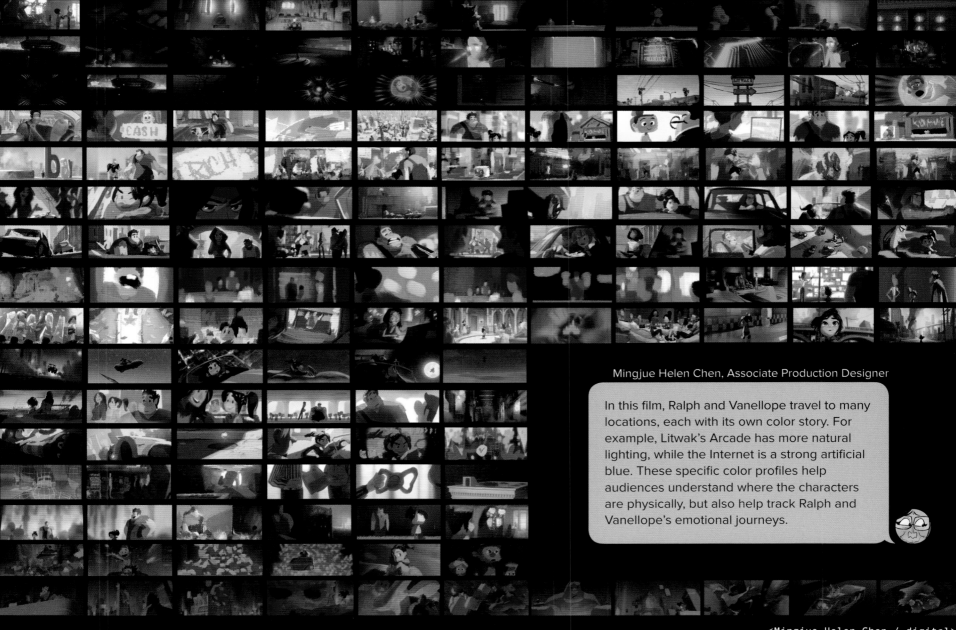

Mingjue Helen Chen, Associate Production Designer

In this film, Ralph and Vanellope travel to many locations, each with its own color story. For example, Litwak's Arcade has more natural lighting, while the Internet is a strong artificial blue. These specific color profiles help audiences understand where the characters are physically, but also help track Ralph and Vanellope's emotional journeys.

<Mingjue Helen Chen / digital>

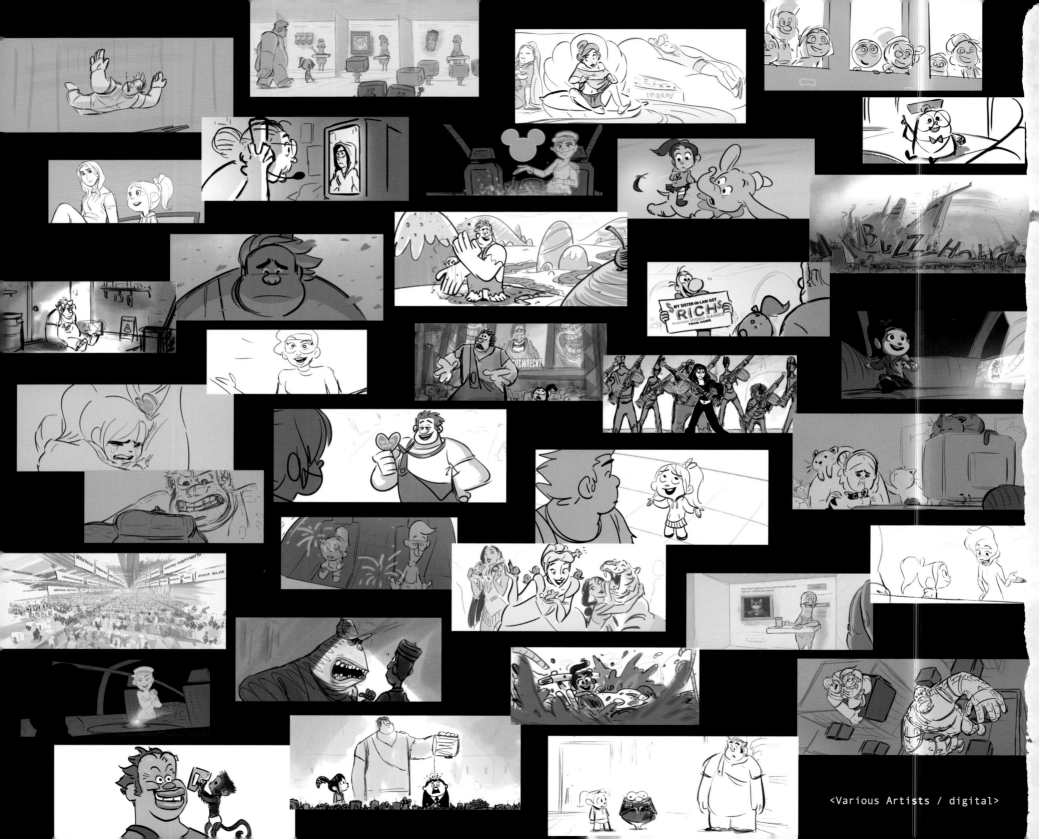

<Various Artists / digital>

AUDIO BOOKS

高速インターネット
Go

TAKA SPURNINGALISTA OKKAR

FOODPILES
ratings, reviews, and more.

I'm really indecisive when it comes to dinner. Foodpiles thinks for me, and I'm never disappointed!
Belvedere Foodpit

SEARCH FOR YOUR
SEE MORE

SOMETIMES THERE'S JUST NO SCHOOL LIKE THE OLD SCHOOL.

WIMBERBOTTOM
Don't crumber for crimber again...
SEARCH

WHEN YOU HAVE ABSOLUTELY NO IDEA WHAT TO DO, AND IT SHOULD HAVE BEEN DONE YESTERDAY...
YOU GO WITH YAMADA.

YAMADA
creating worlds

TRADITIONAL
2D

FOLLOW US ON

FLY TOPZ

TRENDY DESIGN STUDIO

ラーメン
オンライン評価

THE DAILY BOAST

NIGHTOWLZ
JOIN OUR AFTER HOURS COMMUNITY

CHATTRFAHST
SEARCH
FOLLOW US ON

the LABORATORY
ONLINE TOOLS

ami

A'A I KA HULA, WAIHO I KA MAKA'U I KA HALE

20 17
ENGELHARDT FURMANCZYK and BUTTERS
SHOP OUR ONLINE CATALOG

GO WITH
GO WITH

BF

THE PEAK

TRENDY DESIGN STUDIO
WE'RE JUST TRYING TO HIDE BAD DESIGN.
SEE MORE SIGN UP
DON'T JUDGE US TOO HARSHLY.

LEVEL THAT MAGIC UP IN
School of Wizarfolks
MULTIPLAYER ONLINE
ENROLL!

BLOOMING GROVE
DOWNLOAD FOR FREE ON

CAN YOUR INTERNET KEEP UP WITH YOU?

HASI
server ma

blabb

bivt

WEEKEND

sr

Fiber-optic
GIGAZOT
HI-SPEED INTERNET
GET STARTED TODAY